THE ENTHUSIAST'S GUIDE TO TRAVEL PHOTOGRAPHY

55 Photographic Principles You Need to Know

JORDANA WRIGHT

THE ENTHUSIAST'S GUIDE TO TRAVEL PHOTOGRAPHY: 55 PHOTOGRAPHIC PRINCIPLES YOU NEED TO KNOW

Jordana Wright

Project editor: Jocelyn Howell
Project manager: Lisa Brazieal
Marketing coordinator: Mercedes Murray
Copyeditor: Elizabeth Welch
Layout and type: WolfsonDesign
Design system and front cover design: Area of Practice
Front cover image: Jordana Wright

ISBN: 978-1-68198-342-4
1st Edition (1st printing, June 2018)
© 2018 Jordana Wright
All images © Jordana Wright unless otherwise noted

Rocky Nook Inc.
1010 B Street, Suite 350
San Rafael, CA 94901
USA

www.rockynook.com

Distributed in the U.S. by Ingram Publisher Services
Distributed in the UK and Europe by Publishers Group UK

Library of Congress Control Number: 2017948356

This book is printed on acid-free paper.
Printed in China

ACKNOWLEDGEMENTS

WRITING A BOOK is a serious undertaking. It is only through the support and assistance of a truly exceptional collection of friends and family that I made it to the finish line.

Thanks to the fantastic team at Rocky Nook: to Lisa Brazieal and Mercedes Murray for your help and hard work along the way; to Ted Waitt for inviting me to join the Enthusiast's Guide series; and to Jocelyn Howell and Elizabeth Welch for your help in shaping my ramblings into something that makes me proud.

To everyone who welcomed and assisted me along the way during America By Rail, I owe you big time. That journey was the start of a new, more intrepid era in my life and in my photography career. Dawn Carl, Mark Kitanga, Adam Jesberger, Mark Esguerra, Ben Latterell, Brian Gailey, Steve Gubin, Lotus Carroll, and Thomas Hawk, I can't thank you enough for making that adventure such an incredible success!

To those who extended opportunities to a young photographer just beginning on her path, I so appreciate all you've done for me. Thanks to Temple Emanu-el, Rabbi David Posner, and Mark Heutlinger for granting me photographic access to the sanctuary that has meant so much to me throughout my life. Thank you, Ray Larson, for that first introduction to Sunset Watch and all the amazing visits since. Thanks to Ajit George for your hospitality in BVI, access to two wonderful food festivals, and the chance to share my story at TEDxWilmington. Thanks to Paola, Dwite, Gino, and Cecilia for making me feel so welcome in Virgin Gorda and for creating such a special place in Mango Bay Resort. Thanks to Kyle Harrigan and the BVI Tourism Board for your support, friendship, and hundreds of beautiful moments in BVI. Thank you to Nicanor Barrios for showing me countless places of beauty in Nicaragua and for being a reliable and supportive friend. Thanks to Michael Bonocore, Resource Travel, and Resource Magazine for my first professional writing credits. Thanks to all of the wonderful folks at Richard Stromberg's Chicago Photography Classes for welcoming me into your community and making me feel like part of the family. Many thanks to the team at Gerber+Scarpelli Photography: Kurt Gerber, Mike Scarpelli, Nick Gerber, and Belen Aquino for making the life of a freelance photographer so much more consistent and secure, and for your friendship. I love being a part of the team.

To Jay Dusard, I can't thank you enough for letting me weasel my way into your life. I've admired your work from afar for so long and I'm proud to know you and be influenced by your experience, affability, and incomparable talent. It's rare to find someone whose work inspires you and have that person not only give you the time of day, but become your friend. Love and chaos to you, sir.

I have been blessed with a wildly supportive group of coconspirators and I owe so much of the work I've been able to create and the journeys I've taken to them. Brandan DeLaney, Rachel and Daymon Ruttenberg, Matthew Moore, Benny Young, Meghan Winch, Nelson Ruger, Michael Bogart, Abby Glogower, and Joshua Boydstun. I would have given up on my crazy dreams long ago if not for you. I hope you know how much you are loved and appreciated. To Emily Bogart, my sister by choice and second soulmate, thank you for helping me become the brave, happy, person I am, and for asking, "But what if you fly?"

Great parents are everything and I've been blessed with not only an amazing set by birth, but by marriage. Michael and Sharon Wright, thank you for every encouragement, for loving me like your own child, and for raising the wonderful son who is the love of my life and my best friend. To my incredible parents, Robert and Suzanne Boydstun, thank you for enduring and encouraging my every creative whim. You are the most nurturing and supportive parents that a girl could ask for. I remember telling you that I wanted to give this photography thing a try, and there was no doubt in your mind that I could do it. Your confidence gave me confidence and every success feels so much sweeter when I get to see how proud it makes you.

To my husband, Cassius Wright, there aren't words. If there were words, they wouldn't even scratch the surface of what you mean to me. I believe I can do anything because you seem to think I can. Every time I hesitate, you give me the push I need. From signing me up for ambitious photoshoots that terrify me, to suggesting I travel solo for 45 days, every little bit of what I've accomplished can be traced back to you. You are everything to me. Luf.

If you're still reading this, I have one last thing to tell you and one small request. When I started writing the manuscript and compiling the photographs for this book, the British Virgin Islands were thriving because of an incredible tourism product and unparalleled natural locations. In the summer of 2017, Hurricane Irma hit them hard, leaving many of the people I love so much struggling to rebuild. If you have enjoyed the photos of BVI in these pages, please plan a trip to visit. BVI needs tourism to rebuild and the sooner you go, the sooner you'll fall in love with it just like I did. I can't wait for you to experience one of my favorite places on the planet. Thanks for reading; I hope you've had as much fun as I have!

CONTENTS

Introduction viii

INTRODUCTION

"What kind of photographer are you?"

Since the early days of my photography career I have loathed this question and usually suppress the urge to snarkily reply, "a damn good one." In photography, I've observed a common expectation to choose a specialty, but I have zero intention of being only a wedding photographer or only a nature photographer. Both are excellent and worthy pursuits, but the expectation to specialize reminds me of something my college professor and mentor, Dr. Jim Peck, once told me, "When you make a decision, you murder all of the other possibilities." So to me, specializing in one type of photography kills so many potential photographic opportunities that I want the chance to take. If I specialize, I close doors. Maybe I'm the next Pete Souza or the next Joel Sartore—maybe I'm both at the same time—and I just don't know it yet.

WHEN I FOUND my way to travel photography something clicked into place for me because it abolished the need to specialize. Travel photography is perhaps the most sweeping genre of photographic art because it encompasses practically every other genre. The travel photographer can be a portrait photographer and a nature photographer, a photographer focused on architecture, on landscape, and on the many minute details that fill the world around us. Shoot a destination wedding and, yes, wedding photography is travel photography, too.

Previous eras revered pursuits that spanned multiple disciplines. Leonardo da Vinci never chose engineering over painting or sculpting over math. He didn't need to. He saw all things as connected, so his creative pursuits were equally intertwined. Each of his creations was evidence of a forever curious and innovative way of living. Travel photography offers a similar opportunity—a chance to connect a visual art form with the acts of exploring, learning about, and experiencing the world.

Regardless of each photograph's subject matter, one central goal is likely to embody the majority of all travel images: to celebrate the uniqueness of a location and inspire the viewer to step mentally through the frame into the world of the image. That's a noble and achievable goal. So whether you intend to travel in the pursuit of creating photographs, or you travel for the experience and photographs are a happy side effect, your travels will deepen your understanding of and connection to the world. Each place you visit and each type of photography you practice will enable you to tell deeper and more comprehensive stories as you develop your inner creative genius.

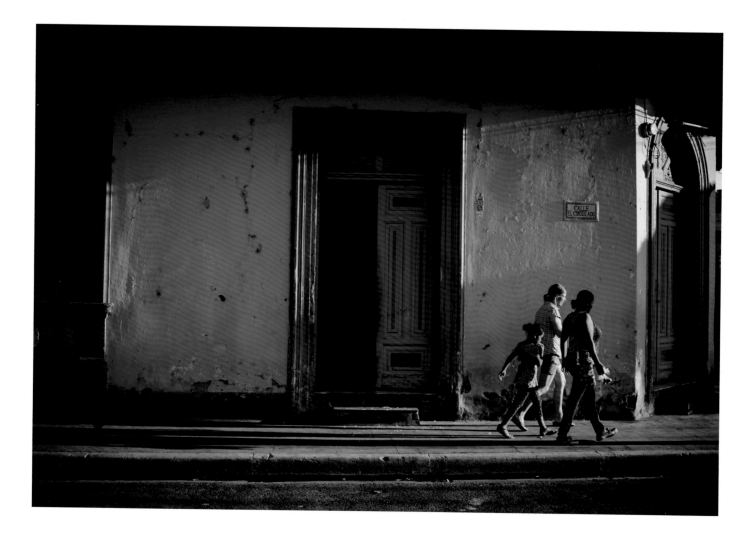

1

THE PHILOSOPHY OF TRAVEL PHOTOGRAPHY

CHAPTER 1

We live in an era of images. Though photography has existed for nearly 200 years, the advent of digital photography and the relative affordability of high-resolution screens give us universal access to billions of photographs. We're exposed to hundreds of images on a daily basis, from billboards and bus stops to a constant stream of Instagram posts.

At the same time, travel for pleasure is bigger than ever. The result: a world that has seemingly grown smaller. Photographs of far-flung places are more available and more numerous than ever before. Enticing travel photography begets travel as we become inspired by the images we see and the knowledge that visiting these places is easily achievable. We travel to locations we've seen in pictures, make our own photographs, and share them online. The cycle of wanderlust continues.

But travel photography isn't all rosy filters and floppy hats on the Riviera. For photographers, the flip side of wanderlust is hard work and intimidation. Most locations have been photographed time and time again, so creating powerful travel photographs can be daunting. Ultimately, the strongest images will emerge from a photographer who not only possesses technical skill, but also has a deep understanding of why we travel and how each moment in a new destination gives us deeper stories to tell.

1. EXPLORE VISUAL STORYTELLING

VISUAL STORYTELLING IS one of the oldest forms of communication in human history. Images transcend language and time by providing perspective and narrative in a clear and universally accessible way. Today, we see visual storytelling so often in advertising campaigns because images remain the most influential, impactful, and concise method of spreading ideas. Consider the failures in the beginning of infomercials. Remember those pathetic, struggling "Does this happen to you?" slobs, followed by the obvious problem-solving product? That's visual storytelling in all its glory. Advertisers know

you're much more likely to buy a Slap Chop if you identify with the guy who severed his fingers chopping carrots. Artists and writers are taught to show rather than tell because humans believe and relate to what we see plainly. A strong photograph or sequence will sell an idea more quickly and convincingly than paragraphs of profound explanation.

Creating Thousand-Word Pictures

By now you've heard it said that "a picture is worth a thousand words," and that is certainly true *some* of the time. We've all experienced those thousand-word images:

successful photographs that draw us in, instantly telling us what exactly is happening and why. These images engage us, make us feel, and maybe even cause us to question our beliefs or investigate new perspectives. Picture Alfred Eisenstaedt's famous V-Day photo of a sailor and nurse sharing a celebratory kiss. That photograph embodies a simultaneous sense of proud success, joy, excitement, and relief. Such images speak to us instantaneously, but not all images are so effective. Less substantive photographs are closer to a sentence fragment than a thousand-word manifesto. They might catch

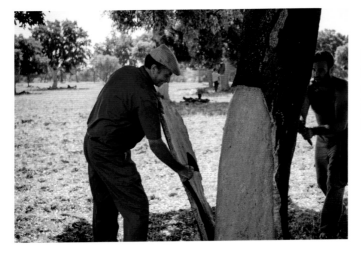

1.1 Cork Harvester, Extremadura, Spain
ISO 100; 1/200 sec.; f/4.5; 33mm

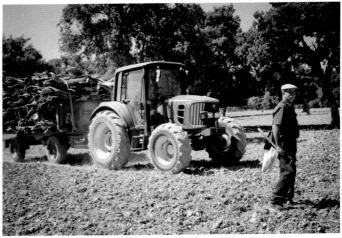

1.2 Cork Harvester, Extremadura, Spain
ISO 100; 1/400 sec.; f/5; 35mm

our eye initially but provide very little to keep our attention or inspire any thought at all.

So how do you deliberately infuse visual storytelling into your travel photography? Start by considering that not every photograph from your travels needs to be worth a thousand words. Look at any travel magazine and you'll see that there are often one or two main images per article that convey the most information or emotion while other "fragment" photos provide additional context and support.

The first step of creating compelling travel photography is to understand what makes those thousand-word photos so special and effective. Take, for example, **Figures 1.1** and **1.2**, which show a Spanish cork harvester in the midst of his work. Because they are active images depicting the process of harvesting cork, they provide much more story and intrigue than **Figures 1.3** and **1.4**, which merely depict the harvested cork itself. By examining and recognizing these kinds of distinctions in the images of others, you'll begin to think more like a visual storyteller yourself.

Finding Inspiration

To rejuvenate and inspire my vision as a travel photographer, I always look to the work of photographers I admire. Try visiting a few travel websites or perusing travel magazines and create a Travel Photography Morgue—a term used in design to describe a digital or physical collection of images that inspire you. Collect the images that speak to you. Try to find photographs that offer compelling perspectives and techniques you hadn't considered. Look for images that work together to tell a story. Look for single images that tell a clear thousand-word story on their own. By becoming deeply familiar with the photographs in your morgue, you'll develop a clearer sense of effective visual storytelling and what appeals to you as an artist.

As you travel, practice creating those thousand-word photos by asking yourself when you approach a scene, "What's going on here?" What is the first thing that strikes you? What attracts you to the scene visually or compels you to compose a shot of it in the first place? Will the image tell a human story? An environmental story? By identifying the scene's meaning from your perspective, you'll be better prepared to represent that scene for your viewer. Soon you'll feel confident in seeking out and capturing thousand-word moments that are not only beautiful, but provide deeper connections for your viewers as you travel the globe.

1.3 Harvested Cork, Extremadura, Spain
ISO 125; 1/125 sec.; f/5.6; 85mm

1.4 Cork Harvester, Extremadura, Spain
ISO 100; 1/60 sec.; f/5; 17mm

2. PORTRAY THE ESSENCE OF PLACE

THE EASIEST WAY to explain what essence of place is, is to explain what it isn't.

At this point, you've been exposed to so many photographs, stories, and movies in your life that you have vast libraries of mental images for locations all over the world. If I asked you to picture Paris, you can imagine it easily. You might see an outdoor café with a view of the Eiffel Tower in the distance. Maybe you imagine a bustling scene outside the Louvre or two lovers in berets sharing a cigarette and a quiet nighttime stroll down cobbled streets. If I suggest Amsterdam, you might picture fields of tulips, people riding bicycles, or smiling women in Dutch bonnets and wooden shoes. You can probably imagine a scene just about anywhere, even if you've never visited. These imagined scenes might seem perfectly accurate because they include such common tropes. Yet anyone who's been to Paris or Amsterdam knows such notions are just postcard snapshots and cultural stereotypes. True essence of place is so much more.

As travel photographers, our mission is to go beyond the postcard, beyond the surface attributes, beyond the clichés and create meaningful and authentic images that capture a deeper sense of mood, culture, and identity. If we do our job well, we'll create images that make past visitors nostalgic and potential visitors long to go.

Finding the Essence

Whereas writers have the benefit of a vast and descriptive language, photographers are bound by the confines of the still image to embody a location's essence. Instead of carefully chosen adjectives, we rely on timing, color, texture, energy, movement, line, shadow, and subject to give the viewer a holistic sense of a location.

When you arrive someplace new, you can immediately begin to observe and collect impressions to get a feeling for its essence, but through longer exploration you'll begin to notice the unique nuances of a location. Over time and by examining the convergence of cultural and environmental influences, you'll begin to hone in on what makes a place so special. Only then can you begin to capture a place's essence in photographs.

A location's essence is subjective. As a visitor (no matter how familiar), your understanding of a location is going to be different than that of a local. Moreover, your impressions will be influenced by your style of travel. If you stay in five-star, all-inclusive resorts and take curated excursions, you'll have a totally different perspective than a backpacker staying in hostels and choosing activities on a whim.

No matter how you travel, or where you point your camera, your vision of a location's essence will be influenced by your interests, your itinerary, and, in many ways, your personality. As a documentarian, it is nearly impossible to remain totally neutral or provide every potential perspective, so you should strive to approach the story of your personal experiences with openness and honesty. The more you allow your experiences to inhabit your images, the more impactful they will be.

Depicting the Essence

To practice portraying essence of place, begin with a location you know well, such as your hometown or a frequent haunt. Come up with a list of five or six adjectives to describe your experience of that location. Is the location peaceful? Energetic? Chaotic? Friendly? Think about what particular sites are most representative of those adjectives and seek them out. Let the representative events unfold around you and photograph them. Because of your familiarity with the location, you'll be equipped to suss out the best times of day to capture essence of place as you see it.

Before visiting Nicaragua, I imagined it as a third-world country filled with wandering chickens, garbage in the streets, filthy barrios, poverty, and danger. My mental image library was based on the political conflicts of the past and stereotypes I had absorbed over the years. What I found when I arrived was something

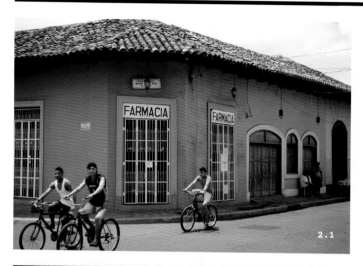

2.1

entirely different. From the abundant Spanish colonial architecture to the carefully protected rainforest habitats and parks, Nicaragua was a welcoming, enchanting place filled with hidden wonders and pride in its heritage.

The images I created on my first trip to Nicaragua speak to the essence of place I witnessed and came to love. Architecture on colorful, bustling streets (**Figure 2.1**), communities living in connection with nature (**Figure 2.2**), and a sense of peaceful relaxation even in the heart of the city of Granada (**Figure 2.3**) became the focus of my photographs to help depict the essence of place I had found. For me, Nicaragua became a place I long to revisit, and that desire shines through in my photographs.

2.1 Granada, Nicaragua
ISO 100; 1/40 sec.; f/2.8; 24mm

2.2 Las Isletas, Nicaragua
ISO 100; 1/250 sec.; f/5.6; 85mm

2.3 Mombacho Volcano, Nicaragua
ISO 800; 1/30 sec.; f/4; 17mm

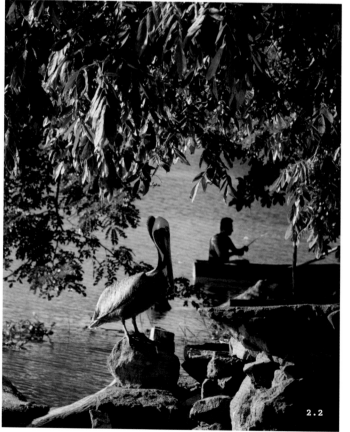

2.2

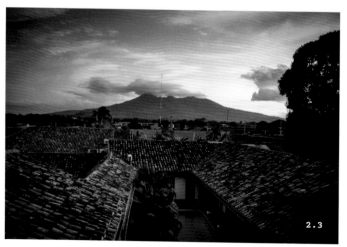

2.3

3. ARE YOU AN OBSERVER OR AN INFLUENCER?

COMING FROM A background in anthropology, I have long felt that photographers can be easily compared to anthropologists. We are all students of the scenes unfolding before us, attempting to understand, analyze, and describe the world through a lens based on human consciousness. We also share an odd attraction to tiny notebooks and vests with too many pockets. One distinct difference is that whereas anthropologists receive extensive training in the potential pitfalls and biases of interacting with subjects, many photographers might not give this concept a moment's thought. After all, we are raised with an expectation of changing our behavior for the camera. How many times did you hear the words "smile" or "say cheese" as a child and stop what you were doing to look directly at the camera? We grow up thinking that it's better to pose and smile, but the resulting expressions can feel forced. The act of posing removes the spontaneity and authenticity of the moment, which is much more effectively captured in candid images (**Figure 3.1**).

A Standard for Truthfulness

Photojournalists are the one subset of photographers who historically have been held to task by a set of industry standards. They are taught to consider their inevitable effect on a scene in a way that most disciplines of photography simply don't address. In travel photography, as in anthropology and photojournalism, it's important to ask, "Are we mere observers or influencers of the scene?"

As a photographer, it is inherently impossible to remain a completely passive or neutral observer. The act of releasing the shutter isn't random—it is a choice made by an artist to select a specific moment to record from a specific perspective. By releasing the shutter, you've made your statement on the scene. The important distinction of observer versus influencer is determined by your intentions and by how much you meddle in the scene itself.

Search the Internet for "staged photographs" and you'll come up with hundreds of examples of photographs that were deliberately composed, Photoshopped, or presented out of context. Reuters and the Associated Press reprimand and blacklist photographers all the time for image fakery. Awards are rescinded, and photographic heroes fall out of favor. To preserve a level of expected behavior in photojournalism, the Society of Professional Journalists maintains a code of ethics based on the following principles:

1 Seek truth and report it
2 Minimize harm
3 Act independently
4 Be accountable and transparent

Each principle encourages photographers to maintain some semblance of objectivity when creating images that will help shape public opinion, influence legislation, and determine distribution of funding. Authenticity is the focus. In other genres, such as nature or travel photography, concern for authenticity is generally treated as less problematic. But is it really less of a problem?

Transparency Matters

I remember my sense of awe as a young photographer viewing a full-page image in an educational photography magazine. The photograph depicted a larger-than-life full moon at twilight with an enormous colony of bats flying in silhouette across the moon. The timing, the exposure, the framing, and the overall image were incredible and inspiring to me. I greedily read the caption hoping for some insight on how to take such a photograph and learned that the image was actually a composite of two images: one of the moon and one of the bats. I felt cheated. Irritated. It was a beautiful photo, but the moment depicted in it hadn't actually happened that way. To me, such an image undermined the work of all the photographers who painstakingly plan and stake out locations to capture similar moments authentically.

Based on the feeling of disappointment that image gave me, I challenged myself to be a truthful observer in my own work. The epic moments don't always happen when you

want them to, but that makes it even more special when you find the perfect place at the perfect time for a fortuitous opportunity. **Figure 3.2** was taken during a totally authentic "stop the car" moment. I wasn't hunting for a rainbow that day, and if one hadn't shown up over this particular landscape, I would never presume to Photoshop a rainbow into the scene. These moments don't happen often, but when they do, they are their own epic reward, reinforcing my desire for truthfulness in my images.

Over time, I've begun to feel that the concept of observer versus influencer exists on a spectrum. If you visit an area suffering from drought and see a cow skull lying on the cracked earth, is it wrong to photograph that skull to depict the effects of the drought? Probably not. But if you're photographing an area suffering from drought and you bring along a prop cow skull, which you then pass off as having been there, then yeah, that's significantly shadier.

Many photographers have waited for the precise moment when a beautifully dressed local walks through the precomposed frame. Even Pulitzer Prize-winner Jack Dykinga admitted to nudging a piece of driftwood a couple inches into the frame for compositional effect. Both interventions are relatively harmless and, in my mind, would fall closer to the observer end of the spectrum.

When talking about posing human subjects, the question of authenticity gets significantly trickier. In her essay "In Plato's Cave," Susan Sontag explains that celebrated portrait photographers of the Farm Security Administration Dorothea Lange, Walker Evans, Ben Shahn, and Russell Lee "would take dozens of frontal pictures of one of their sharecropper subjects until satisfied that they had gotten just the right look on film—the precise expression on the subject's face that supported their own notions about poverty, light, dignity, texture, exploitation, and geometry." This type of interaction places the photographer squarely in the role of influencer and is an issue that many travel photographers will likely find themselves dealing with in the field.

Are you using your subject to confirm your existing beliefs of a condition or situation? Are you manipulating the moment for heightened photographic drama? Ultimately, these questions are at the sole discretion of the photographer. You know your intentions and your hopes for your work better than anyone else, but it is vital that you consider the potential ramifications of acting as either an observer or influencer in the pursuit of your photographs.

3.1 My husband, the traveler. San Juan del Sur, Nicaragua
ISO 100; 1/640 sec.; f/4.5; 35mm

3.2 Monteverde, Costa Rica
ISO 200; 1/125 sec.; f/5.6; 85mm

4. CULTURAL, LEGAL, AND ETHICAL CONSIDERATIONS

IN MY TRAVELS, I have experienced almost every potential reaction to my camera. From teenagers happily posing and insisting that I take their picture, to locals who deliberately turn their back on the irritating tourist with a camera (**Figure 4.1**). At this point in our technologically homogenous world, there are very few populations who believe the camera steals a piece of your soul, but that doesn't mean that every culture out there is open to being photographed by a stranger.

Your travels are likely to introduce you to people who are wary of the camera. You may even encounter entire countries or regions where it is illegal to photograph without special permission. World travel means going outside your comfort zone and experiencing new cultural behaviors, and part of being a successful travel photographer (and a successful traveler in general) is preparing for a journey by researching the customs, laws, and ethics at play. Ideally you will have a good understanding of a culture's general belief system, behavioral expectations, standards of attire, and view toward photography long before you set foot in a location, freeing you to enjoy your experience and minimizing any potential conflicts with locals or law enforcement.

Practice Photographic Stewardship

So why is it so important to know the rules ahead of time? Isn't it easier to ask forgiveness than permission? Sure, you could potentially get away with photographing lots of things you're not supposed to, but one photographic misstep or an argument with a local could cause a major headache and potentially ruin your feeling toward a

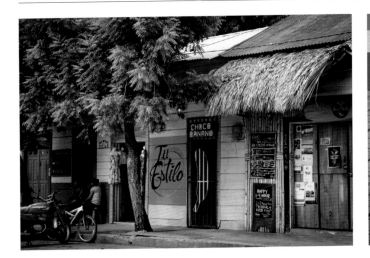

4.1 The woman in yellow deliberately turned away from the camera. San Juan del Sur, Nicaragua
ISO 160; 1/160 sec.; f/6.3; 47mm

4.2 Granada, Nicaragua
ISO 100; 1/200 sec.; f/4.5; 24mm

trip or even an entire country.

My hope is that if you're reading this, you want to be the *right* kind of travel photographer—the kind who seeks to leave the world better than they found it. I believe that photographers have an ethical responsibility of stewardship toward the subjects we photograph. That's not to say that we must always portray a place or situation in a positive light or hide the gritty details from view. The world is filled with beauty, but there is no shortage of ugliness either.

When visiting Nicaragua, I felt an ethical dilemma about the street dogs that seemed present on every corner. As I fell in love with the culture, the architecture, and the general atmosphere of the country, the homeless dog population weighed on me. I struggled, wondering whether to include the dogs in my photographs (their presence seemed to amplify the notion of Nicaragua as a third-world country) or selectively frame my shots to exclude them.

Ultimately, I decided that telling the story of Nicaragua means telling the *whole* story as I experienced it. Omitting the street dogs felt dishonest, but focusing on them alone wouldn't be an accurate depiction of reality either. I settled on a realistic dose of stray dog. If I framed a picture and a dog was in the composition, then I let it stay (**Figures 4.2** and **4.3**), but if there wasn't one in sight, I didn't seek one out. The stray dogs add interest to my travel photographs, telling the candid story of a developing nation.

Above all else, your images should be true to your experience. In the Internet age, it is important to remember that exploitative or irresponsibly acquired images have the possibility of being seen by many and could influence far more than just your own opinion of a place or situation. So before you travel, research the potential ramifications of your actions as a documentarian and gain permission when necessary.

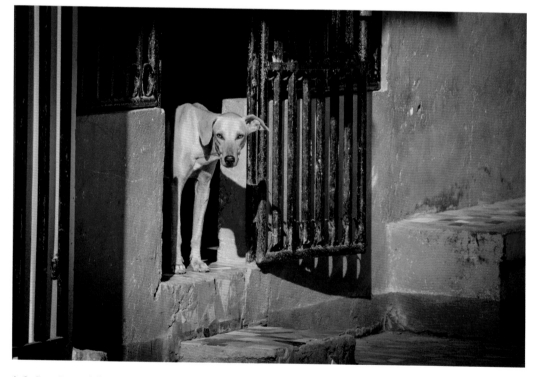

4.3 San Juan del Sur, Nicaragua
ISO 100; 1/200 sec.; f/4.5; 24mm

Photographers' Rights in the US

In the United States, we have fairly clear-cut laws about photographing in public:

- You can shoot anything in any public location, including visible private property.
- You cannot shoot on private property once asked to stop or if there are posted signs forbidding photography.
- You can photograph people in public without their consent, unless their location gives them reasonable expectation of privacy.
- In public, it's usually legal to shoot the following: fires, accidents, police, criminals, celebrities, children, infrastructure, public utilities, transit hubs, homes, stores, factories, and bridges. Military buildings are traditionally off limits.
- You don't have to explain your purpose or show identification (unless asked by a police officer in some states).
- Private parties can't harass you, detain you, or confiscate or damage your film or digital files. Police need court orders to take your property or delete your images.

If you're interested in getting more specific information about photographers' rights in the US, attorney Bert Krages has made a downloadable PDF available on his website (www.krages.com). I keep a copy in my camera bag and am very assertive when it comes to protecting my civil liberties as a photographer. This gets significantly trickier when you plan an international excursion.

Photographers' Rights Abroad

When planning a trip to a new country, take the time to find out:

- Is it illegal to photograph people without their explicit permission? (The photograph in **Figure** 4.4 is perfectly legal in the US, but might be less acceptable in other locations.)
- Is it legal but culturally frowned upon?
- Is it acceptable to photograph children without parental consent?
- Are there any religious considerations that you need to prepare for?
- Are there any current human-rights or animal-rights issues that your photographs could potentially highlight or relate to?
- Will you be photographing an endangered animal or a protected ecosystem?
- Do you need any specific permits or licensed guides to access an area?

Answers to these questions aren't always easy to come by, but like most things photographic, a quick Google search can get you on the right track. Other potential resources include the CIA *World Factbook,* locally run tourism agencies, foreign copyright acts, and WikiMedia Commons, which maintains a country-specific list of consent requirements.

Model releases are a valuable asset if you plan to sell or publish your work in the future. Many photography contests, magazines, and stock agencies require a model release even if the image was taken under circumstances in which a release was not legally required. Ideally, you should always present model releases to subjects in their own language, but I wouldn't recommend just plugging an English-language release into Google Translate. On their website, Getty maintains a list of downloadable foreign-language model releases. If you want to keep things digital, Easy Release – Model Release App is a great paid app that will translate your release into a number of languages and allow models to sign on your phone or tablet.

4.4 Riverhead, New York
ISO 500; 1/160 sec.; f/3.5; 18mm

5. INSPIRE WANDERLUST

MY HOPE IS that the photographs I create on my journeys will inspire other people to step away from their regular lives and go on an adventure. Whether viewers choose to visit the exact locations I did or just become inspired to take a vacation or explore their own backyard, I feel most successful when I get to hear about someone longing to travel or taking a trip in response to my photography.

So what separates a beautiful photograph from a photograph that calls the viewer to action? Take a look at your travel photography morgue and see what images give you the strongest desire to go out and see the world. What is it that specifically impacts you in the images? Do the images make you feel relaxed? Do they give you a sense of awe? Are you attracted to a sense of history and antiquity? Do you love chaotic photographs of bustling cities? Do you long for an outdoorsy adventure? The type of images that inspire wanderlust will vary from person to person and interest to interest, but there are a few key commonalities that will inspire most viewers:

- **Dramatic natural landscapes free of people** (**Figure 5.1**): Many of us long for solitude and will find comfort in an epic vista free from noisy crowds.
- **Dramatic natural landscapes with only one or two people:** A single person or a couple in the frame puts the viewer mentally in that person's shoes. It is easy to project yourself into that place and that moment, as with the surfers in **Figure 5.2**.

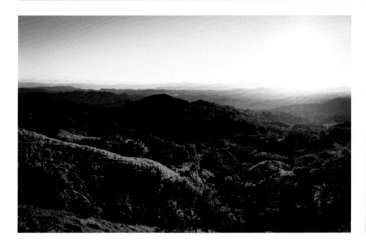

5.1 Monteverde, Costa Rica
ISO 100; 1/800 sec.; f/4; 17mm

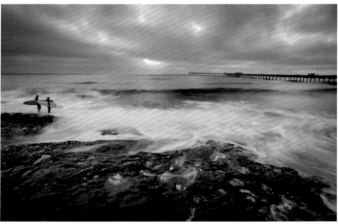

5.2 Sunset Cliffs, San Diego, California
ISO 100; 2 sec.; f/22; 10mm

- **Luxury on the cusp of nature:** Anyone who has seen a photograph of a luxurious pool overlooking a vast, clear body of water has instantly wished she were there (**Figure 5.3**).
- **A totally unique cultural experience:** Travelers long to experience something completely new. An image of a bustling street market in China or the view from a Venetian gondola can inspire viewers to step out of their ordinary routine.
- **Seasonally specific opportunities:** Think northern lights or fall color. We are attracted to beautiful moments that are fleeting, so images that can be taken only under certain conditions or during certain times of year have a distinct appeal (**Figure 5.4**).

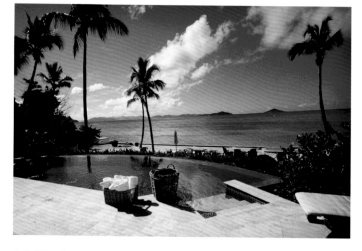

5.3 Virgin Gorda, British Virgin Islands
ISO 400; 1/8000 sec.; f/3.5; 12mm

5.4 St. Germain, Wisconsin
ISO 250; 1/400 sec.; f/1.8; 50mm

Photography is a major focus for me when I travel, but photography is also my profession. For me, traveling anywhere without a camera feels strange and uncomfortable. Even leaving my camera at the hotel when going out for a short walk or a meal makes me feel nervous. I worry that I'll miss something incredible. I feel guilty that I'm not dedicated enough to the work. Over time and over my travels, I had gotten so used to experiencing things through the viewfinder, that I was making the camera a priority ahead of my own ability to observe and experience, which resulted in less impactful images.

A couple of years ago I came to realize that the camera is the least important part in the equation. I know this sounds counterintuitive in a book about photography, but it wasn't until I began writing about my journeys that I realized the photogenic moment has occurred because of the places and the situations in which I have placed myself. I chose to go out walking in my first major Chicago snowfall for the experience (**Figure 6.2**). The fact that I walked away with a few stellar photographs is a happy side effect. With or without a camera the experience still happens and the story is still there. It is mine to experience and, should I so choose, to document and share with others.

Now when I travel, I focus on my experience. I focus on the moment. I approach each day with an open desire to meet new people and experience new flavors. I bring the camera along, but not at the expense of my discoveries along the journey. I concern myself with awareness of my surroundings—the sounds, the smells, the feeling I get from a place, and the enjoyment I get from sharing those surroundings with my husband, friends, or family.

I found that by tasking myself to be more present and more aware as I traveled, my images improved because my experiences improved. Deeper awareness and understanding enhanced my visual storytelling and led to a more compelling and accurate essence of place in my images. Without a camera constantly separating me from the world, I could make better connections with locals, spend more time chatting, more time enjoying, and more time observing. When a truly photogenic moment came along, I could capture it more effectively because it had more meaning and more personal significance.

There are a great many photographic "rules" and lessons in the world—not to mention in this book—but if I had to boil them all down to one concise message, this would be it:

Travel to expand your horizons and to become a better version of yourself. Photograph those travels to capture the memories of how you felt when you were at your best.

Share Your Best Travel Memories!

Once you've captured your best image featuring a special memory from your travels, share it with the *Enthusiast's Guide* community! Follow @EnthusiastsGuides and post your image to Instagram with the hashtag *#EGTravel.* Don't forget that you can also search that same hashtag to view all the posts and be inspired by what others are shooting.

6.2 Chicago, Illinois
ISO 100; 1/60 sec.; f/4; 17mm

2

PLAN YOUR JOURNEY

CHAPTER 2

Not so long ago travel agencies took the guesswork—and homework—out of planning any trip. These days, many of us prefer to arrange all the details ourselves. Fortunately, through social media and the omnipotent force that is Google, you'll have a much easier time answering your own questions, packing and preparing effectively, and setting yourself up for a fantastic travel experience.

7. SET PERSONAL GOALS

THE REWARDING BUT elusive art of photography presents a lifelong learning curve for me. Every time I think I've mastered something, I realize that I've only leveled up to a point where I can take on new challenges. Sure, some things remain consistent and I have a foundation of knowledge and experience to rely on, but every level is a little bit harder than the last.

Becoming a more nuanced and sophisticated artist takes significant effort, but it offers an even more significant payoff, so I push myself, experiment, and explore. That is why travel is an unparalleled gift for a photographer. You never know what lies around the next corner to challenge or inspire you. My journeys have granted me unique opportunities, tested my existing knowledge, and required me to improvise to get my perfect shot. Travel hands you a set of circumstances and says, "Okay, let's see what you can do." So you adapt. You grow.

Sometimes I can choose my travel locations or activities with specific images or types of photography in mind. I was determined to make an early-morning long exposure of the tides at Virgin Gorda's Baths, so I deliberately built time for it into my schedule (**Figure 7.1**). Other times, usually when clients are footing the bill, I have absolutely no say in what I'm doing, so I have to plan around the opportunities I'm given. Most of my images

in a shoot for a resort had to be improvised in the moment with the location and props available (**Figure 7.2**).

Regardless of the location or type of travel you are about to embark on, the very first step is determining your photographic goals for the journey. Are you desperate to capture the magic of the northern lights? Do you hope to photograph the iconic net fishermen of Burma? Is your goal simply to perfect your exposure? Do you hope to make family vacation photos that feel more candid and engaged? Do you want to get better at remembering to take the lens cap off?

Whatever your goals, they will shape your travel experience—not only because they will affect the excursions you plan, but because they will influence the gear you carry, the way you view the world, and the moments to which you attune yourself.

Sometimes it's hard to even put your finger on what your specific goals are, so here are some ideas to get you started.

Look Back

Before a journey I like to look at photographs from my previous travels—not just the winners I'm proud of, but the turds I couldn't bring myself to polish in Lightroom. Photos that missed the mark are important, because I want to know why they didn't work. Critical introspection is necessary but tenuous. You

don't want to drive yourself to bouts of drunken sobbing, but you also don't want to miss opportunities or repeat past mistakes. So after you've congratulated yourself on some amazing photos from old trips, power-walk down disappointment lane for a brief and humbling look at what you want to improve. Then look at the good photos again. Always end on the good photos.

Make Lists

I'm a list maker. Shot lists, to-do lists, lists of ideal settings, you name it. Knowing I have a plan in list form is reassuring, and checking things off lists just feels good. Sometimes I even write things that I've already accomplished on my lists so I can check them off (which is totally normal). I prepare for travel with a multitude of lists, and you should too.

Here is a list of potential lists, both photographic and otherwise, that will get your list-making juices flowing:

- Skills you feel confident about
- Skills you want to improve
- First-choice places along the way that you're absolutely desperate to photograph
- Second-choice places along the way that you'd like to photograph if you have the time
- Ideal camera settings for situations that have proven difficult in the past or that you've never tried before

7.1 Sunrise at the Baths, Virgin Gorda, British Virgin Islands
ISO 100; 1/2 sec.; f/22; 10mm

7.2 Colorful chairs at Mango Bay Resort, Virgin Gorda, British Virgin Islands
ISO 250; 1/125 sec.; f/7.1; 30mm

- Photographic gear you want to bring
- Travel/life gear you want to bring
- Key phrases in the language of your destination
- Things you have to accomplish before you leave on the journey

Even if you never use all the lists you've made, you've started the conscious effort of organizing your thoughts in preparation for your travels, which is always helpful.

Seek Inspiration

When I first settle on a location for a trip, I scour the Internet for research about where I'm headed. Start with the people you know. Put a post out to your social circles asking for their favorite spots along your planned journey. Visit official tourism websites for ideas of what an area has to offer (**Figure 7.3**). Check out TripAdvisor for "off the beaten path" ideas and visitor experiences (**Figure 7.4**).

Gather as many potential locations as possible, and then do a Google image search to see what shots other people have gotten in the spots you want to visit. Image searches are the best way to see what places look like in various weather conditions, times of day, times of year, and so forth. Searches on Google Earth will even provide GPS coordinates for great photo locations. Compile a location-specific image morgue with photos you find that inspire you.

If an image you like has EXIF data attached, review the data to get a better concept of why it works and settings to try. If the image has no data to study, try to analyze the image and figure out what settings may have been used. The more you understand the images that appeal to you, the better prepared you'll be to create your own.

Plan Now, Improvise Later

Traveling is expensive, so you'd be crazy to spend any of your precious time during the journey planning or organizing. The beauty of advanced research is that you've prepared yourself while you're at home and your costs

are fixed. Also, just because you've researched a list of places to check out, that doesn't mean you can't check out a different spot on a whim or based on a local's recommendation (**Figure 7.5**). Even if you don't end up directly utilizing all the research you've amassed, you've familiarized yourself with your surroundings and put yourself in a better frame of mind to improvise on the journey and achieve all of those goals you've listed for yourself.

7.3 I learned about Kofa National Wildlife Refuge in Arizona through Visit Yuma, the official local tourism website.
ISO 100; 1/80 sec.; f/5.0; 160mm

7.4 A quick search on TripAdvisor introduced me to the bluest water I've ever seen: Costa Rica's Rio Celeste.
ISO 125; 1/30 sec.; f/3.5; 11mm

7.5 On a pit stop in Washington's Makah Indian Reservation, a friendly chat with a local led to an incredible recommendation. This overlook of Cape Flattery is not something I would have found on my own.
ISO 100; 1/100 sec.; f/5.6; 24mm

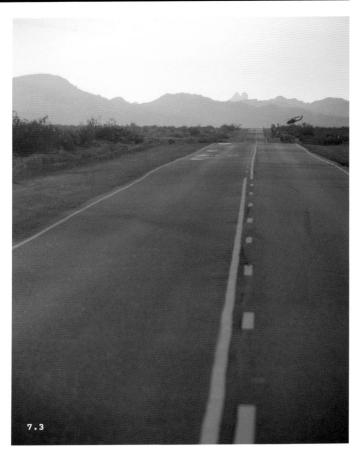

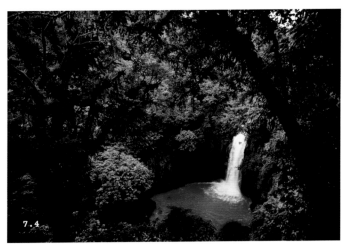

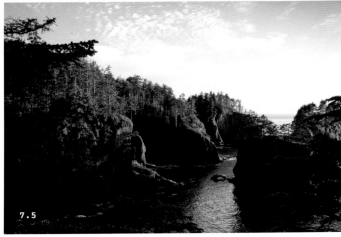

8. SET YOURSELF UP FOR PHOTOGRAPHIC SUCCESS

ONE OF MY first photography jobs was the unglamorous position of preschool portrait photographer. It was both wonderful and terrible. I worked for a national company with a consistent style and clear expectations of how the final images needed to look. Every single day, I photographed anywhere from forty-five to three hundred kids between the ages of six weeks and six years. There were props, heavy backgrounds, hot studio lights, and an endless stream of snotty noses to wipe. It was, by far, the most exhausting and thankless gig I've ever had.

The primary strength of this mostly terrible, gut-punching job was what I learned. I learned to create consistent photographic results in inconsistent environments. I learned to work quickly with dozens of tiny impatient eyes trained on me. I learned to manage crises in real time. I learned to roll with whatever came my way. That job exposed me to so many things, and I learned that you can't plan for everything so you need to be practiced and prepared with the variables you can usually control—the gear.

By the end of that year of toddler torment, I was a machine. I knew every millimeter of that camera. Every button. Every setting. And every photographic success I've had since was built off that foundation. Hopefully your travel experiences won't be as loud, overwhelming, and chaotic as photographing 300 tiny, leaky humans before lunch, but you should prepare for it just as hard and know your camera just as well.

Long before you travel, put yourself through a self-directed boot camp. Grab your gear and practice all the maneuvers you're likely to do in the field. See how fast you can get your tripod set up and broken down. Practice swapping lenses quickly and safely (always point the sensor down toward the ground to minimize dust). Make sure you feel comfortable attaching and detaching any accessories.

Don't just go through the motions mindlessly—design a mental system for any action that you can repeat again and again. Create good habits. Practice switching between settings you know you'll commonly use. Educate yourself on all the buttons, functions, dials, and menus in your camera. Eventually your gear will feel like an extension of your arm. When you hit that point, keep practicing.

Your travels will give you many opportunities to experiment with new subjects and new conditions, but consider practicing tricky situations under similar conditions at home—especially if those conditions will be fleeting. A friend of mine recently visited Iceland. She had just purchased her first DSLR and had her heart set on photographing the Northern Lights. Before she left, I talked her through the settings she would want to consider, and she practiced adjusting the camera settings accordingly. While she was still at home, she went out at night to practice photographing with a tripod under the night sky. Through preparation and repetition, she set herself up mentally and physically to get the best possible images of the Northern Lights in the short-lived opportunities that awaited her. When she arrived in Iceland, she was able to enjoy the experience and photograph the Northern Lights free of anxiety or self-doubt.

So, if you're going to shoot coral reefs, take the underwater housing out for a test drive in a lake or even a bathtub to get comfortable making adjustments underwater. If you're going to shoot exotic wildlife, practice your settings and techniques with the squirrels and birds in your neighborhood. I photographed my in-laws' horse, Roy (**Figure 8.1**), many times over the years, which prepared me and gave me confidence to approach open-range horses in Montana (**Figure 8.2**).

If you're planning on doing some street photography on your travels, go to a busy place near home and practice shooting quickly to capture passing moments. Practice shooting from the hip. Practice holding your breath during longer handheld exposures. Just practice. Create similar shooting conditions and work out the kinks at home. When the pressure is on and you're working with limited time in a location, you'll be glad you did.

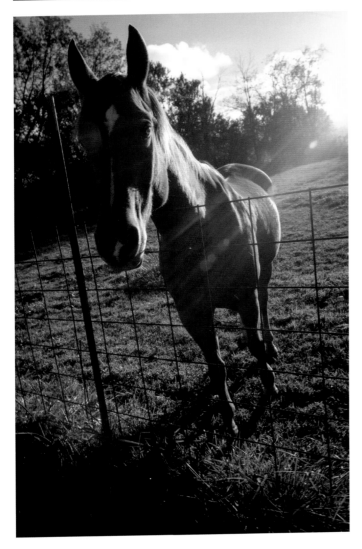

8.1 Roy, the mustang. Paris, Illinois
ISO 160; 1/40 sec.; f/10; 17mm

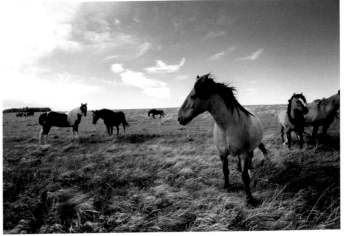

8.2 Open-range horses near the Blackfeet Reservation in Browning, Montana
ISO 100; 1/80 sec.; f/7.1; 10mm

9. TRAVELING SOLO

MY FIRST SOLO travel experience happened unexpectedly. My husband and I had spent months planning and preparing for a massive forty-five-day photographic project and journey across the western United States by train: America by Rail. In both scope and ambition, it far surpassed anything we'd done or planned before. Every little detail was organized, from the places we planned to visit, to the photographs I was longing to take in each location. We had gear sponsors. We had private donors. We had meetups and photowalks planned in eight cities. We had special access to amazing locations. Everything was set: I was the photographer and he was the logistician.

Three weeks before our departure, my husband got a job offer he couldn't pass up, which directly conflicted with the dates of the journey. I was deeply disappointed but started going through the mental checklist to cancel our travel plans, refund donations, and let everyone know that the trip was off. I told my husband that I was sad we couldn't go. He looked at me incredulously, shook his head, and laughed. "Oh, you're still going. You have to go. It's too big and too important to miss, so you'll do it solo."

Well, crap.

I was an independent woman, but I wasn't "backpack across the country for forty-five days by myself" independent. At least I didn't think I was. Turns out I was wrong. What followed was the single greatest personal experience I have ever had. Did I miss him? Like crazy. Was it outside of my comfort zone? Hell yes. Is it exactly what I needed to grow mentally and artistically? You know it.

Solo travel is the single greatest gift you can give yourself. A journey taken alone simultaneously forces you and gives you permission to be completely independently motivated. Every decision is your decision. You don't have to worry about consensus or pleasing other people. There's no more asking for input or apologizing for what you want. Want to wake up in the middle of the night to shoot the sunrise in a remote spot? Go for it. Want to sleep late? That's cool, too. Need a break? Stop. Hungry? Eat. Want to focus on your photography as you travel? Well, there's no one else to annoy by pausing to shoot every thirty seconds.

Figures 9.1 through **9.3** were all taken as a result of being spontaneous and able to choose my own photographic agenda, despite long drives and early mornings. Traveling solo makes you think long and hard about what makes you happy. It identifies what matters to you and gives you the freedom to follow your whims.

Before America by Rail, I was terrible at self-promotion and talking about my photography. I had never needed to do it myself because my husband was the salesman. I lived with a little voice inside me saying that I wasn't doing anything special or different, so having him there to talk me up began as a comfort and, over time, became a crutch.

Though I'd been shooting professionally for years, I still struggled with anxiety before every shoot with a client. I wasn't shy, by any means, but I wasn't the type to strike up a conversation with random strangers. Then came my trial by fire: forty-five days of solo travel. I came home with a renewed artistic vigor and a greater sense of who I am. I had an easier time talking to strangers and felt a deeper sense of purpose in my day-to-day life. Professionally, I was able to have deeper and more complex conversations about my passions, my accomplishments, and my goals. Every hurdle was a gift. Every unexpected challenge was an opportunity to grow.

Now, I travel alone at least once a year. I love traveling with my husband, or friends and family, but America by Rail ignited a spark in me that demands a solo adventure every so often, so I set out on my own to feed the flames.

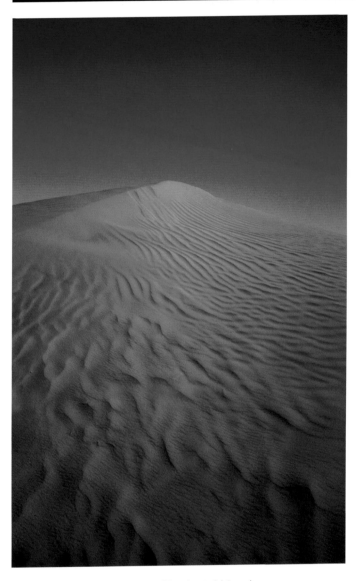

9.1 Imperial Sand Dunes, Niland, California
ISO 400; 1/4000 sec.; f/4.5; 20mm

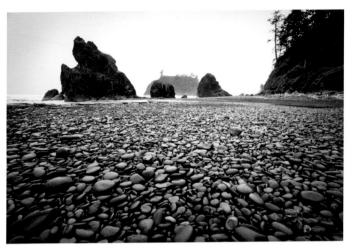

9.2 I changed my travel plans at the last minute to add a day in Olympic National Park, allowing me to visit Ruby Beach in Jefferson County, Washington.
ISO 500; 1/160 sec.; f/3.5; 10mm

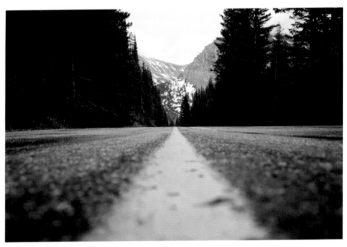

9.3 Going to the Sun Road, Glacier National Park, Montana
ISO 200; 1/200 sec.; f/4.5; 26mm

10. TRAVELING WITH FRIENDS AND FAMILY

TRAVELING WITH OTHER people is tricky enough before you add a camera and photo-based priorities into the mix. People you get along with easily at home can become your worst nightmare during a far-off trip. I speak from experience. Some of my favorite journeys have been taken with friends, but I can't ignore the couple of friendships that were irreparably broken by time spent together under the wrong conditions abroad.

Travel is often exhausting, uncomfortable, expensive, and full of uncertainty. Add to that different personalities and different ways of dealing with crises or decision making, and you can create a pretty volatile situation for a friendship. Most, if not all, of the benefits of traveling solo become challenges when you add more people to the mix. Fortunately, through organized planning, communication, and careful selection of your travel mates, it is totally possible to share a bucket list–worthy trip of a lifetime with one of your friends—one on which your photography doesn't have to take a back burner.

Even as a travel photographer, there are times when I travel with friends or family who have zero interest and little patience for my photographic whims, and that's okay. Photography is my priority but it doesn't have to be theirs. It's their adventure too, so I carefully navigate the situations as much as possible to please everyone. Here's what works for me...

Travel with Other Photographers

Generally, photographers travel well together. They swap ideas with enthusiasm, expose each other to subjects and techniques they might not have considered alone (**Figure 10.1** was taken while painting with light on the suggestion of a photographer friend), and share the unspoken philosophy that the images take priority on a trip. That's why I love photowalks and workshops. I relish any opportunity to make photography a more collaborative art and enjoy participating in the long artistic tradition of working together and pushing each other to grow and meet new challenges.

When I'm out with another photographer, I love observing their artistic process. It's fascinating. Everyone has their own way of doing things and their own specific vision (I took the photo in **Figure 10.2** under the influence

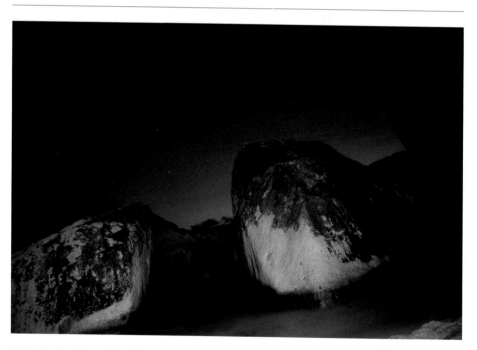

10.1 Spring Bay, Virgin Gorda, British Virgin Islands
ISO 200; 30 sec.; f/5.0; 17mm

of talented photographer Bill Ellzey). My work benefits from their experience and theirs from mine. You have someone to bounce ideas off of, someone to swap gear with, or someone to step into the frame as a model. You don't need to explain why you're getting up long before the sun or why the harsh light of midday is a great time for a nap. You don't need to defend your desire to stand in the same spot for a while, perfecting your shot or capturing a long exposure.

Generally, when traveling together, photographers provide an ebb and flow. A give and take. The perfect artistic symbiosis.

Frame Your Passion as a Benefit for Them

For non-photographers, traveling with a photographer has its perks. If your companions are interested in photography but have no experience, offer to help them and talk them through what you're doing. If they couldn't care less about making their own photographs, offer to be the documentarian of the journey. You are going to carry your camera everywhere anyway, so take plenty of photos of your friends and family along the way.

Make selfies a thing of the past by using your expertise to create flattering, dynamic travel portraits for your companions. Everyone wants a super cool, artistic profile picture in an exotic locale. People will be more patient when you want to stop and shoot, and you will have the added bonus of willing models. That said, do respect their privacy and remember that the incessant click of a shutter can be infuriating. They are traveling with you for the pleasure of your company, so put the camera away some of the time to better share travel experiences.

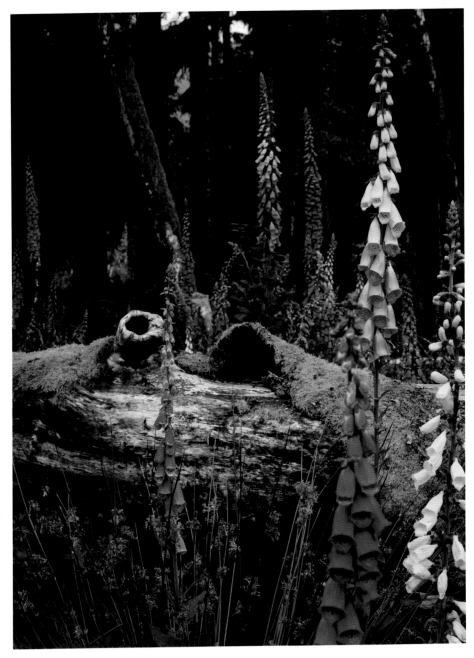

10.2 Foxgloves in Olympic National Park, Washington
ISO 400; 1/160 sec.; f/13; 50mm

Make Decisions Before You Go

Things like money, dietary restrictions, ideal amenities, and time priorities are extraordinarily important to discuss while planning your trip. Whether you travel with friends or family, it's a good idea to get the awkward conversations out of the way ahead of time and make sure everyone is on the same page. It's not enough to make a list of things you're all interested in doing or seeing. Go into detail about how active you plan to be each day, what your budget is for meals, and how you plan to split checks.

Most of your accommodations are likely to be set ahead of time, but just in case, discuss what conditions are acceptable for each of you. Some people are fine in hostels; others require at least three-star hotels. Once, on a long overnight drive to Florida, a group of friends and I decided we needed to stop and sleep for a few hours. Because we disagreed on what level of hotel to stay in (two friends wanted as cheap a bed as possible, and the other two of us preferred to avoid contracting lice or hepatitis), we ended up in a very unfortunate roadside Scottish Inn for less than $30. I slept in my clothes on top of a beach towel and spent the whole next day fuming about it.

Resentment snowballs easily when you spend twenty-four hours a day with someone in an unfamiliar place. Communicate as much as possible ahead of time and the whole experience will benefit.

Don't Make It About You

Most of traveling successfully with anyone, let alone with non-photographers, comes down to the golden rule: don't be a jerk. Treat others how you want to be treated and remember that your priorities are not necessarily everyone else's. If you have your heart set on that sunrise boat tour, then go for it, but don't expect everyone else to tag along. If you're on a guided hike, don't make everyone else wait for you to get your shot.

Don't monopolize the best vantage points. Don't expect anyone else to be responsible for your gear. Don't be inconsiderate about someone else's enjoyment of the journey. Take turns making decisions, and be willing to go to places or do activities that don't inspire you photographically. I had low expectations for the photographic opportunities on a night hike in Costa Rica, but I managed to get up close with a variety of wildlife (**Figure 10.3**).

If you realize that you have been a jerk, then own up to it and buy a round of drinks or desserts. The golden rule will get you far.

Strike Out on Your Own

Just because you're traveling with other people doesn't mean you have to spend every second of every day with them. When your interests diverge, split up. Even if you're on the same page, it's a good idea to have some downtime to yourself. Go for a walk or a meal alone. Explore for a couple of hours on your own—it will provide something to talk about when you reunite and will give you a taste of the benefits of traveling solo.

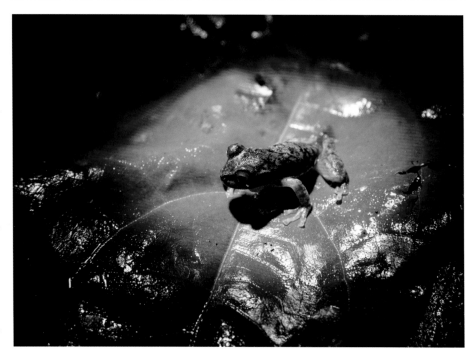

10.3 A red-eyed tree frog in Monteverde, Costa Rica
ISO 100; 1/200 sec.; f/5.6; 85mm

11. PREPARE YOUR MIND, BODY, AND SOUL

WHILE DAY-TO-DAY MINUTIAE at home can lead to stress, anxiety, and a loss of mental balance, slipping into a new routine on the road can be just as taxing. With constantly shifting variables, it's easy to wear yourself out on a journey, no matter how much you plan ahead. I've found that focusing on wellness—physically, mentally, and spiritually—before and during a trip not only improves my experience on the road, but also deepens and intensifies the quality of images I create. Generally, I identify more as a cynic than a yogi, so I realize this all sounds very kumbaya *Eat Pray Love*, but the same way you carb up the night before a marathon, you should Zen up in the days before a potentially life-altering journey.

Mind

Feeling tense or nervous about a particular planned activity, tricky shoot, or just the whole trip in general? Studies have shown that planning for a trip leads to a boost in happiness, so now is the time to psych yourself up for the incredible potential that awaits you. Before you leave on a trip, revisit the research that helped you select your itinerary. Review the photographs of past visitors that wowed you, or read about the epic locations you'll soon see with your own eyes. Talk yourself through the images you hope to make and remind yourself that you're absolutely capable of photographic success, and you will feel artistically inspired when the time comes (**Figure 11.1**).

Right before a journey, my primary issue is worrying about the what-ifs. What if I drop my camera in the ocean? What if an airline demands that I check my carry-on bag? What if I need something and I don't have it?

Give yourself valuable peace of mind by ensuring you're prepared to handle any issues you're worried about. Pack one or two weeks in advance so you can be certain you have everything you need and can make adjustments with plenty of time to spare. Purchase trip insurance to help cut your losses in the wake of unfortunate travel snafus. Buy the bear spray you've been fixating on and pack the antidiarrheals. Better to have it and not need it, than need it and die by mauling in soiled pants. Do everything you can to embark on your journey knowing you've considered the worst things that could happen and prepared for them.

Do your best to minimize potential points of friction on the road. For me, the biggest threat to my sanity and patience is hunger. I can rise above exhaustion, illness, or irritation, but a growl in my belly is a roar in my mind. When I travel, I eat three meals a day. I carry snacks; I horde carbs. On a trip to Spain, our local guides referred to me as a "little Spanish grandmother" because of the seemingly inexhaustible collection of crackers, breadsticks, and granola bars in my bag. Hanger is real. Prepare accordingly.

Body

Photographers, for the most part, aren't the type to travel via hop-on-hop-off guided bus tour. Only a small percentage of the legendary photographic sights in the world can be accessed from a roadside overlook. If you're traveling and you intend to get the very best shots, you have to be willing to put in some physical work. For those of us who prefer never to see the inside of a gym (as my husband says, "I don't lift weights, they're heavy"), travel puts demands on our bodies that we may not have to face at home.

Leading up to America by Rail, knowing that I would travel with a fifty-plus-pound backpack, I worked on endurance by riding my bike several miles each day with gear on my back. In the weeks leading up to your trip, take the stairs instead of the elevator. Park farther away so you have to walk more. Carry your camera around so it won't feel quite so heavy in the field. Little things that you may not expect can add up to serious exhaustion while you travel, so build up your stamina any way you can.

A few years ago on a visit to Rocky Mountain National Park, I discovered that I am not quite as buff as I had previously

believed. Traditionally I have fantastic stamina for hiking, but under the high-altitude conditions of the alpine tundra, a summit hike was legitimately kicking my butt. Though it was summer, the temperature at 11,000 feet was bitingly cold and stung my lungs as I huffed and puffed, trying desperately to make my way to the peak. My heart was pounding and my head was spinning, but I managed to make it to the top—with several substantial breaks. It was wonderful once I got up there (**Figures 11.2** and **11.3**), but torture along the way.

Don't make the mistake I made. If your travels will take you to higher altitudes, prepare specifically for those conditions. If you are going to heights where altitude sickness is a likelihood, work with an outfitter to get prepared. It's not enough to be in good shape for your regular life at home, you need to be in good shape for the journey's specific conditions.

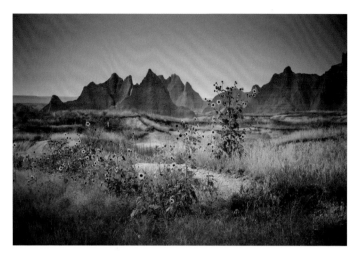

11.1 After worrying about the fifteen-hour drive to get there, it only took me a few moments in the Badlands to get excited by the wild landscape and create this photo. Badlands National Park, South Dakota
ISO 100; 1/250 sec.; f/5.6; 85mm

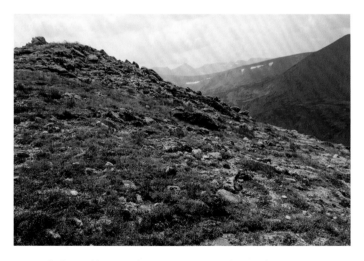

11.2 Alpine Ridge Trail, Rocky Mountain National Park, Colorado
ISO 100; 1/1600 sec.; f/4.0; 17mm

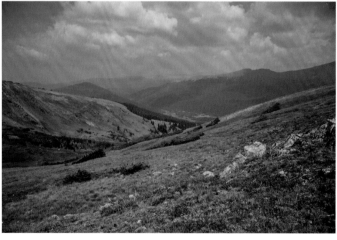

11.3 Alpine Ridge Trail, Rocky Mountain National Park, Colorado
ISO 100; 1/1250 sec.; f/4.0; 17mm

Over years of international travel, I've learned that not all physical challenges are based on athleticism. When it comes to jet lag, the struggle is real. After all your planning and preparation, to arrive in an exotic locale and immediately need to sleep is infuriating. You want to hit the ground running, ready to explore and experience. There are lots of different ways to combat jet lag, but these are the techniques that have been the most successful for me:

- Acclimate to your destination time zone while still at home.
- Hydrate like crazy—especially on the flight.
- Sleep on the plane even if it requires a sleep aid.
- If you can't sleep during appropriate sleep hours, rest with your eyes closed.
- Minimize screen time.
- Don't think about what time it is at home.

- Go outdoors right away to help your body get on schedule with the sun.
- Avoid caffeine toward the end of the day.
- Upon arrival, immediately seek out a photographic subject that motivates and excites you more than the concept of sleep. **Figures 11.4** and **11.5** were taken within an hour of my arrival in Spain. I was exhausted but the photo opportunities gave me new energy.

Above all else, know your limits. Pushing yourself is one thing, but overdoing it is another. Though you might feel tempted to stay out shooting for 18 hours to maximize your travel investment, the technical and artistic quality of your images will certainly suffer. Keep in mind that exhaustion is cumulative, and force yourself to rest, eat well, hydrate, and sleep. Your camera is not more important than your health!

Soul

Each person reacts to the challenges and rewards of travel differently. Traditionally, I am not a religious or meditative person, but I am at my most spiritual in far-flung and beautiful locations with a camera in my hand. For me, travel photography presents a distinct opportunity to be wowed by the incredible world in which we live. To amplify that effect, I tend to plan excursions that will present unique ecosystems or multisensory experiences. Nature is deeply therapeutic, but urban atmospheres can feed my soul as well. When you have a sense of whimsy about your surroundings (**Figure 11.6**), your images will certainly benefit, so approach travel with an open mind and a desire to expand your views and understanding of the world.

The sad truth is that not everything you find along your travels will be a feel-good

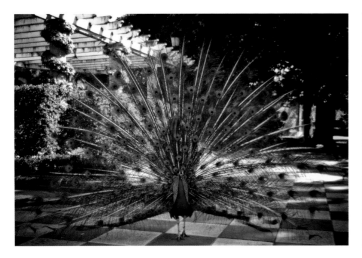

11.4 A peacock poses in Cecilio Rodriguez Garden, Madrid, Spain.
ISO 100; 1/80 sec.; 50mm

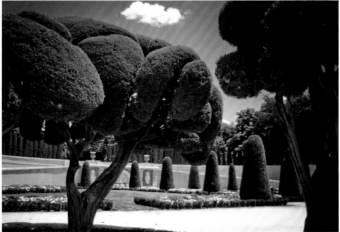

11.5 Plaza Parterre, Madrid, Spain
ISO 100; 1/500 sec.; 50mm

experience. Visiting incredible natural locations can also introduce you to sobering threats to climate, animal well-being, or human rights. Even if you've done your research, seeing something firsthand is a far cry from reading about it in the news. You will be affected. Remind yourself that you cannot solve all of the world's problems yourself, but make a distinct effort to leave everything you touch at least a little better than how you found it. Small acts like volunteering for a few hours to a local cause or carrying out trash you find along the trail will enrich your experience and provide a more balanced journey emotionally.

From the time of its inception, photography has been a powerful tool for increased awareness and social change. If you find an injustice, endeavor to capture it in a way that also embodies how you feel. Photographers are a huge asset for many nongovernmental organizations (NGOs) aiming to publicize their cause. Research potential partners before you travel to reap the most impact from your journey.

While I travel, every thought, every musing, every bit of good, bad, and ugly gets recorded in my travel journal. I began my long-standing ritual of travel journaling on a family road trip the summer I turned 12. Looking back on those first journals, it may seem like I was just a kid doodling and listing inconsequential details, but I was launching a lifelong practice of introspection through musings on the road. Throughout my teens and adulthood, from short trips to long journeys, I have found comfort, clarity, and personal development by maintaining a journal.

In many ways, keeping a travel journal is a present to your future self. I have been able to track personal and photographic growth, ambition, artistic intention, philosophies, and important stories that might have otherwise been blurred or completely forgotten over the years. I can more effectively tell rich anecdotes and write intuitive articles by going back to my notes, maps, and other saved mementos to relive the details of each adventure. Keeping an effective and useful travel journal is an art of its own. It takes practice and effort, but it will provide valuable background for the images you create on your travels and help capture the meditative state that you feel on the road.

11.6 Sunrise at Mer Bleue, Ottawa, Ontario, was a magical experience. As the sun rose and filled the bog, it beautifully illuminated remaining fog and haze.
ISO 100; 1/125 sec.; f/6.3; 22mm

12. WORKING AROUND UNCONTROLLABLE CONDITIONS

SOMETIMES ALL YOUR planning will go to hell. Your Caribbean vacation will be overwhelmed by strong surf and heavy rains, or your visit to a city will be overshadowed by protests or riots. Don't be discouraged. Make the most of what's around you to create compelling travel photographs anyway.

Ill-mannered Herds of Tourists

You wake up long before the sun, pack your gear, and head to what you hope will be an epic sunrise, only to find at least fifty photographers who had the very same idea. Hopefully, the photographers will be generous with the prime shooting spots and welcome you to join them. Realistically, they'll be just as annoyed by your presence as you are by theirs. Tourists can be pushy and self-centered, and can become a major obstacle to work around. Take a breath. There's no reason to give up or pack it in. When you are faced with a sightseeing horde, you have options—join them, wait them out, or find greener pastures.

If you choose to join them, and they are swarming in and around your ideal shot, the obvious answer is to use a tripod and neutral density filter to take a long exposure to help blur them out of the image. Similarly, you can take ten to twenty images of any exposure length and Photoshop the tourists out by stacking images to make a composite later. Also consider how you want to represent the scene—the most honest shot would include the tourists, demonstrating the popularity of the spot. In very crowded scenes, I like to take a longish exposure (3 to 20 seconds depending on the general speed of the crowd) to keep them present in the frame but still blur their features enough to avoid making them the focus of the image (**Figure 12.1**).

If I have the time and am feeling particularly Zen about it, I prefer to simply wait them out. It took a long time to get a clear shot at Oak Alley Plantation (**Figure 12.2**), but it was worth it. In my experience, groups of tourists tend to cycle through an area after ten or twenty minutes—especially if they all came from the same bus. By waiting, you'll have the opportunity to more deeply observe your surroundings and potentially find more images in the same vicinity that interest you.

In select situations, if I'm on assignment or am particularly inflexible in what shot I'm trying to achieve, I will politely ask people to step out of the frame for a moment while I get my shot. I've had the most success offering to take a photo of their group with their camera or phone before they clear out—that way it feels more like a reciprocated favor and both sides are happy.

If none of these techniques feel ideal, then I will move on to a new spot. Many times a fresh perspective, free from tourists, can be achieved with a little mobility and effort. Walk farther down the path, or hike higher up the hill, or just keep driving in pursuit of something that grabs you.

On a visit to Mount Rushmore for golden hour, I was stuck in a massive line of waiting cars to reach the monument. I knew that the light wouldn't wait, so I kept driving. First I found an unexpected perspective of Mount Rushmore (**Figure 12.3**), which I quickly photographed, before moving on and discovering an incredible overlook with a view of Black Hills National Forest (**Figure 12.4**). By choosing to abandon the lines and crowds, I lucked into several photographs that have become favorites in my portfolio.

12.1 Temple of Dendur, Metropolitan Museum of Art, New York, New York
ISO 100; 4 sec.; f/18; 18mm

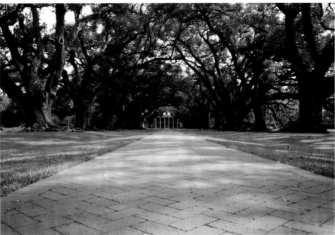

12.2 Oak Alley Plantation, Vacherie, Louisiana
ISO 100; 1/4 sec.; f/22; 20mm

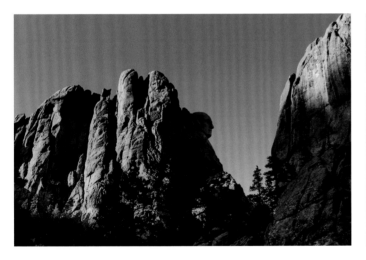

12.3 Mount Rushmore, Keystone, South Dakota
ISO 160; 1/400 sec.; f/5.0; 35mm

12.4 Breezy Point, Keystone, South Dakota
ISO 160; 1/200 sec.; f/5.6; 61mm

Bad Weather

Nasty weather for being out and about can still be beautiful weather for photographing. I travel with rain gear for myself and my camera, so I won't be tempted to hide indoors when things get sloppy. I've shot in heavy rain and massive snow, and both conditions resulted in incredible photographic opportunities. Plus, you're less likely to fight crowds if the weather is particularly gross.

Trips to tropical locations can feel particularly wasted in bad weather. My first instinct on a rainy Caribbean day is to hide inside with a book, but, as they say, fortune favors the brave. I've had great luck with the dramatic skies of heavy storms in the tropics. Dark, ominous clouds can still yield great, contrasty light (**Figure 12.5**), and fast shutter speeds help capture the violence of strong waves crashing on rocks. Nighttime long exposures can pick up some serious lightning off the coast. Puddles can result in amazing perspectives through repetition and reflection.

On one trip to the British Virgin Islands, a continuous, uninteresting drizzle made a day of shooting seem pointless, but through a little exploration, and by driving to a higher altitude, I found an atmospheric sweet spot—a rare, tropical fog befitting a fairy tale (**Figure 12.6**). I've visited the same spot many times, and I've never seen it that way again. So get used to the idea of being physically uncomfortable for a little while, prep your camera for wet conditions, and capture the rare atmosphere bad weather brings.

Boring Light

Uninteresting lighting can be one of the more difficult conditions to work around. Uniformly overcast skies yield flat, boring light for traditional landscapes. Rather than resorting to Photoshop sky swapping, I like to shift my subject matter slightly to accommodate the light. Even lighting from an overcast day can be perfect for shooting in woods (fewer hotspots and deep shadows) or portraiture (even lighting is quite flattering). Instead of shooting the overall scene, I like to focus on the textures, patterns, and details when the light is boring.

I had high hopes for a late afternoon shoot in the marshes of the Hudson River near Cold Spring, New York, but when I finally got through the woods to the boardwalks of the marsh, the day had grayed out considerably (**Figure 12.7**). Traditional vistas and landscapes were out. Instead I focused on the colors below the horizon line.

12.5 A fast-moving storm front over Lake Nicaragua lit up beautifully as the sun set. Ometepe, Nicaragua
ISO 1250; 1/160 sec.; f/5.0; 18mm

12.6 North Sound, Virgin Gorda, British Virgin Islands
ISO 400; 1/100 sec.; f/8.0; 30mm

12.7 Constitution Marsh Audubon Center and Sanctuary, Philipstown, New York
ISO 160; 1/125 sec.; f/7.1; 30mm

12.9 Constitution Marsh Audubon Center and Sanctuary, Philipstown, New York
ISO 1000; 1/125; f/9.0; 90mm

12.8 Constitution Marsh Audubon Center and Sanctuary, Philipstown, New York
ISO 250; 1/125 sec.; f/7.1; 30mm

By cropping out the sky entirely, I was able to create unique, compelling images that focus on nuances of color, depth, and texture (**Figures 12.8** and **12.9**). On overcast days, greens are always greener, so seek out compelling natural areas and reduce your focus to a smaller, more detailed view.

Racing the Clock

During sunrises and sunsets I always feel crunched for time, but when I visited Nicaragua's Masaya volcano I experienced a different kind of time constraint. When planning my visit, I anticipated having plenty of time to explore the viewpoints. I wanted a wide range of shots, from tight closeups on the active volcano's boiling lava, to wider shots showing the glow reflected on visitors' faces. I wanted video, I wanted a selfie with a volcano, I wanted photos taken with my phone that I could post right away.

Unfortunately, active volcanoes are notoriously unpredictable. Leading up to my visit, the park had been closed for several days because of dangerous gas emissions. The day I went, the park reopened for only a couple of hours and each visitor was limited to fifteen minutes at the crater because of the fumes. I was lucky to get to see it at all.

Knowing I would have limited time, I opted to focus on the closeups and got all my gear ready to go in the car on the way up. I shot with my zoom lens and a tripod to stabilize my camera, and concentrated on getting one good shot of the lava below (**Figure 12.10**). Fifteen minutes felt like the blink of an eye, but by preparing myself mentally with a game

plan, I managed to make a photograph that pleased me in limited time.

Erupting volcanoes, breaching whales, rainbows, lightning, eclipses—all the coolest natural phenomena offer a narrow window for photography. Revisit your mental preparation techniques, focus on getting one good shot, and make the best of what's in front of you.

12.10 Masaya Volcano National Park, Nicaragua
ISO 3200; 1/125 sec.; f/6.3; 600mm

3

GEAR AND EQUIPMENT

CHAPTER 3

In the current photographic arms race, there's pressure to jump from gadget to gadget or from brand to brand, as megapixels multiply, lenses get smarter, and we increase our collective expectations for how finished photographs should look. Before you invest in an accessory you've been coveting, try borrowing it from a friend or renting it from a gear rental house to get the hang of it and see if it lives up to your expectations. Regardless of trends, upgrades, or Ashton Kutcher's endorsement, the best gear for travel photography is the gear you have with you and know how to use.

13. WHAT DO YOU REALLY NEED?

THERE ARE TWO distinct schools of thought when it comes to gear for travel photography: *Travel Light* and *Bring Literally Everything You Own*. Traditionally, I belong to the first group, for reasons that will become clear shortly, but there are a few specific occasions when it makes sense to bring a ton of equipment...

The More, the Merrier

Photographers on assignment often have massive gear requirements. If you're planning an extensive journey with complicated or highly specific shoots, then it makes sense to pack a lot of gear. A friend of mine recently traveled to the Bahamas for a multiday resort and island photo shoot. To make sure he could achieve the full gamut on the client's shot list, he showed up with quite a haul (**Figure 13.1**). From underwater shoots requiring waterproof housings to interior setups requiring full-size studio lights, stands, and umbrellas, his shoot expectations demanded that he check multiple bags of gear. The idea of carrying that much gear across the street, let alone through airports and on ground transit, is exhausting, but he assessed the needs of the shoot and made sure he covered his bases.

In that sort of situation, you should absolutely bring whatever will help you do the best job possible. Back in my traveling preschool photography days, I had at least four large bags of gear with me for every shoot, plus my own luggage! It was enough stuff to fill the trunk of my car to the brim every time I went to work.

If you are a photographer who regularly shoots time lapses, drone aerials, or complicated panoramas, or a photographer who relies on lots of artificial lighting or backgrounds, then you should plan to travel heavy. Find a system that works for you and pack it the same way every time.

If you're like me and portability and simplicity are key, then...

13.1 Photographer Nick Gerber, encumbered by stuff.

Travel Light

I always travel carry-on only. I believe that to best enjoy your travel experience, your luggage should be a help, not a hindrance. Packing light will save you from lost checked luggage, from missing out on spontaneous opportunities, and hopefully from that rage-inducing sound wheeled luggage makes on cobblestones. Packing light will allow you to keep shooting and experiencing throughout your journey, even on travel days. If you keep it light, you can shoot every step of the way while heavier packers are distracted and frustrated, coordinating piles of luggage at every turn.

I have two different gear setups that I have come to rely on when traveling. Both are relatively lightweight and can be managed easily on my own. I don't want to be beholden to anyone along the way, so it's essential that I be able to muscle my own gear into the overhead bin.

For ten or more days on the road, or for more photographically complicated trips, I travel with a Pelican 1510 and a backpack. During travel days I keep most of my gear in the Pelican and all of my clothes and other sundries in the backpack. Once I get where I'm going, the Pelican stays safely locked away in my hotel with my clothes and the gear I won't need that day, and the gear I do need goes into my backpack.

For me, the key is utilizing modular storage bags inside both the Pelican and the backpack. That way the cases are pretty interchangeable on the fly. Also, if I do end up needing to check the Pelican on a flight, I can hand carry my most important and expensive gear easily. To contain photography gear, I use padded camera inserts and neoprene sleeves and cases. For clothes and other essentials, I love Rick Steves' Packing Cubes.

On shorter trips, I slim things down even further to a backpack and a medium-sized messenger-style camera bag. Either way, I keep things simple and portable. Your luggage and gear shouldn't be an added stress on any journey.

The next few lessons will cover detailed thoughts and techniques about specific gear options for travel photography, so for now, let's focus on the non-photographic essentials and space-saving techniques:

- **Plan to do laundry:** I have been known to bring half as many outfits as there are days and hand-wash clothing in the sink if laundry facilities are unavailable. This is generally easier to accomplish in warmer climates and with casual dress.
- **Two pairs of shoes:** Regardless how comfortable your shoes are, your feet will need a break from the monotony. I travel with two pairs. No more, no less.
- **Notebook and pen:** I like the old-school feel of writing stuff down. I take tons of notes both before I leave and on the journey. Having a pen handy also helps when you need to fill out customs paperwork or jot down an address.
- **Raincoat:** A raincoat can be a pillow, an extra layer for warmth, something to wrap your gear in during an unexpected storm, or an added layer of waterproofing in your camera bag. Find a good one and pack it. Generally the more breathable the raincoat, the less waterproof, so heads-up.
- **Permethrin spray:** For any tropical journey, I hang my clothes in the shower and spray them down with permethrin before packing. Mosquitos treat me like an all-you-can-eat buffet, and because I'm allergic to their bites, I take bug repellent very seriously. I've tried practically everything on

the market and permethrin has been the most successful repellent I've ever used.

As much as I love to unplug from my cell phone when I travel, it is the second most frequently used piece of gear I have (the first is my camera). Before a trip, I like to load my phone with lots of digital must-haves to help keep my journey running smoothly. Here's some of what I keep in my phone:

- **Maps** (**Figures 13.2** and **13.3**): Several similar apps are available, but I prefer Google Maps. Before a journey I make color-coded maps with addresses for hotels, "must see" photo locations, and "if I have extra time" locations. I download the regions to which I'll be traveling with my custom pins as offline maps so that I can get turn-by-turn directions without using any data internationally. Part of the fun of travel is getting a little lost and making new discoveries, but I like knowing I have a relevant map just in case.
- **Music:** When I travel, I prefer to have a soundtrack. Music gets me pumped, helps me relax, or keeps me going on long travel days. I always make sure I have a very full playlist for each journey.
- **ICE and medical info:** On most phones you can keep your In Case of Emergency contact info or any pertinent medical info accessible on your locked screen. That way, if you're unconscious or unable to unlock your phone, people will still know how to help you.
- **Camera manual:** There are literally dozens of menus and hundreds of potential settings in today's high-end cameras. Don't be embarrassed to look up how to do stuff you may not have tried before. Download your camera manual as a PDF to your phone so that you can access it on the road

13.3 I saved an offline map containing the regions in Nicaragua I planned to visit. It was a huge time-saver for navigating from point to point.

13.2 Before a visit to Indianapolis, I made a color-coded map with points of interest.

without putting extra weight in your bag. Make sure your installed PDF reader will allow you to search for terms to save time. The same thing goes for guidebooks.

- **Translation or phrase book app:** Google translate lets you download a language pack to use offline. You can translate to and from your native language on the fly and get help with pronunciation. I always program shortcuts for a few key phrases like "Where is the bathroom?," "Can I take your photograph?," and "May I have another glass of red wine?"

- **Kindle app:** I read a lot—especially on the road. Kindle or PDF-format books let you read on your phone or laptop with ease. (Bonus points if you are reading this book on your phone or laptop while traveling right now.)

- **Easy Release – Model Release App:** As I mentioned in lesson 4, model releases on the go are much easier with a well-designed, translatable app. The Easy Release app is worth the money.

- **Copy of passport and travel documents:** I like knowing that I have a copy of my passport in case of damage or theft. If you're wary of keeping vital personal information on the phone itself, save it to Dropbox or Google Drive so you can access it just in case. Other travel documents like flight, hotel, and activity confirmations should all be downloaded ahead of time so you can access them anywhere.

- **Kill switch:** Many phones come with a kill switch preinstalled, or there are a variety of apps and programs that you can download as well. The idea is that if someone steals your phone, you can wipe it remotely and/or render it useless. Pickpocketing happens all over the world, and it's nice to know that losing your phone doesn't mean losing your identity.

Packing doesn't have to be overwhelming. Just remember to pack a week or two before you depart so you have time to reorganize, cut things, or add any essentials you forgot. If you need a lot of stuff, then bring a lot of stuff. No judgment. But if you can at all manage to travel carry-on only, then get ready to enjoy the fruits of your liberation.

14. SELECT IDEAL LENSES

IN THE EARLY days of my career, I used to travel with every lens I owned. I figured that given my level of investment in glass, it was foolish to leave anything behind. As time went on, I realized that changing lenses on the go was a hindrance and that carrying fewer, more versatile lenses allowed me greater portability and flexibility. True, sometimes I have to compose a shot by moving closer to my subject or backing away to make the focal length work for the given scenario, but I have found that reducing the number of lenses I bring increases the creativity required for achieving my desired shot.

Unless I need a specialty lens, I usually limit myself to one zoom lens, one prime lens, and one wide-angle lens. All of the lenses discussed here are used on my Canon cameras (I'm not a rabid Canon evangelist—it's just what I happened to start with sixteen years ago, and if it ain't broke...), but there are equivalent lenses for most camera makes and models.

Zoom Lenses

My current go-to travel lens is the Sigma 18–300mm f/3.5–6.3 (for cropped sensor cameras). I bought this lens last year to replace two lenses I regularly used on my travels, a 17–85mm and a 70–300mm. It was the first third-party lens I ever purchased and I love it. It's not the fastest lens on the market, but it is definitely competitive in its price point. This is the lens I use most frequently because of its versatility. I've shot everything from macro (**Figure 14.1**) to architecture (**Figure 14.2**) with this lens. If I had to limit myself to just one lens when I travel, it would be this one.

My advice is to find a zoom lens you love, learn its nuances well (sharpest apertures, points of exaggerated distortion, whether or not you trust its image stabilization, etc.), and keep it as the default lens on your camera.

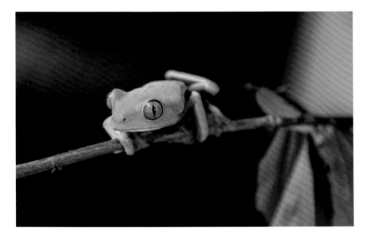

14.1 Red-eyed tree frog, Mombacho Volcano, Nicaragua
ISO 800; 1/125 sec.; f/6.3; 95mm

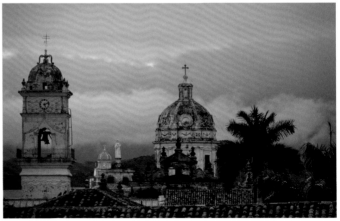

14.2 Granada, Nicaragua
ISO 100; 1/200 sec.; f/6.3; 171mm

Prime Lenses

It's hard to go wrong with a 50mm prime lens. A 50mm is lightweight, it's easy to get tack-sharp focus, it can be used for a variety of scenarios, and it's fairly true to what the eye sees naturally. You can find a variety of great 50mm lenses on the market, from Canon's cheap f/1.8 to their costly f/1.2. Buy the best glass you can afford. I opted for the f/1.8 long ago when I was still a newbie, and to this day I use it as a backup lens.

A couple of years ago I swapped out the 50mm for Canon's 24mm f/2.8 pancake lens as my go-to travel prime (**Figure 14.3**). I love how small, light, and unobtrusive it is. When I shoot street photography, food, or in crowds, I feel confident that I can get my shot without drawing undue attention to myself. It works beautifully for handheld low-light shots. Also, it can fit in a purse or a pocket if needed so I can always keep a backup lens on hand. With such a small-sized lens,

14.3 Canon 50mm f/1.8 (left) and Canon 24mm f/2.8 (right)

14.4 Arches National Park, Moab, Utah
ISO 640; 1/125 sec.; f/13; 10mm

14.5 One of the few shots I dreamed up ahead of time was this bizarre fisheye perspective of a cork donkey. Andalusia, Spain
ISO 100; 1/320; f/3.5; 8mm

14.6 A friend rented Canon's 8-15mm Fisheye for our trip to Virgin Gorda, British Virgin Islands.
ISO 100; 1/200; f/5.6; 8mm

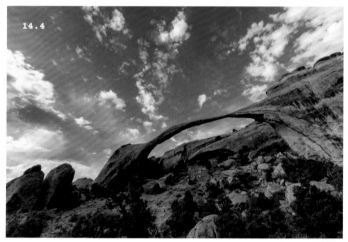

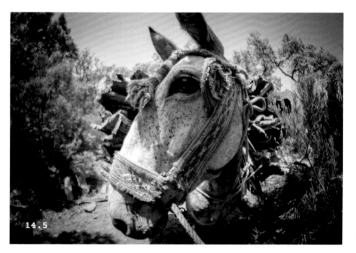

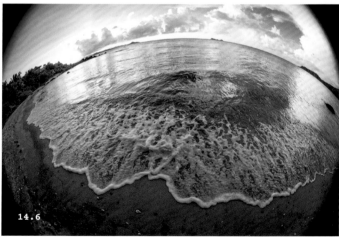

it's hard to feel bad about doubling up on the focal lengths I carry with me.

Wide-Angle Lenses

When I want to shoot wide angle on the road, I primarily rely on my Canon 10–22mm f/3.5-4.5. It's a fantastic lens offering a unique perspective on the world. The 10–22mm is great for capturing full scenes when crowds or structures don't leave me much room to back up (**Figure 14.4**). I love this lens for architecture, landscapes, and any situation where I want to work the inherent distortion issues to my stylistic advantage.

Many photographers swear by fisheye lenses, and I can't say I blame them. Over the course of a couple of years, I had joint custody of a friend's Rokinon 8mm f/3.5 and I used it on multiple trips. Though I love the lens for very specific types of shots I want to make (**Figure 14.5**), it isn't an ideal lens for every scenario. I can't see myself using a fisheye often enough to buy one, but it's a great option for a rental and very fun to use for unique travel images (**Figure 14.6**).

Other Options, Accessories, and Ideas

There are lots of no-brainer options for other must-have lenses in certain scenarios. Going on safari? Bring a telephoto. Obsessed with architecture? A tilt-shift is a great choice. Want that low-res Instagram look? Try a plastic toy lens like the Diana 20mm (**Figure 14.7**). Want to get uber-creative? Lensbaby has a wide range of fun, customizable lenses that offer beautiful bokeh, interesting distortion, and the tilt-shift look at an affordable price (**Figure 14.8**). Want to make your existing lenses more versatile? Investigate screw-on magnifiers and effect filters, or invest in an extension tube.

Regardless of your lens choices, treat them well on the road. Travel can lead to major dust and debris, so make sure you're using your front and rear caps when the lenses are in your bag. As the queen of smashing into stuff and falling down on trails, I take my lens protection very seriously! I invest in lens hoods and high-quality UV filters to protect my glass. Better a bruised bum and cracked filter than a busted lens!

Finally, with any lens, make practice your priority. A $13,000 investment in the nicest lens of all time is a poor use of money if you hit the road on a once-in-a-lifetime trip not knowing how to use it!

14.7 California Coast
ISO 500; 1/250 sec.; 20mm

14.8 Chicago, Illinois, with the Lensbaby Composer Pro II with Edge 50
ISO 100; 1/40; f/5.6; 50mm

15. TRIPODS AND STABILIZATION

TRIPOD MISHAPS CAN be epic. We don't really think about how much trust we're putting in those three legs until something awful happens, but you are literally entrusting thousands of dollars of gear to them. That's reason enough to take tripod selection seriously. I never realized until I sat down to write this guide just how much of my knowledge about photography comes from having made some sort of grievous error. Oh well. My loss is your gain...

For my first trip to Costa Rica I knew it was time to get a smaller, lighter weight travel tripod. Having done minimal research, I headed straight for a camera store (this was very early in my career and Internet reviews weren't as prolific as they are today). I selected an inexpensive ($60 or something equally ridiculous) but seemingly sturdy amateur-end tripod by SunPak. It was mostly plastic, which I now realize is why it was such a steal.

Fast-forward to travel day and my misery upon discovering that somewhere inside the airport X-ray machine the tripod (carefully strapped to my bag) had been decapitated. When I examined the break, I discovered that the piece of plastic connecting the head to the tripod had sheared cleanly off, along with my hopes of doing any kind of long exposure or low-light photography. I was now in possession of an utterly useless tripod and I hadn't even left my home airport. Rather than throw it out and travel unencumbered (I was angry enough to want my $60 back for the POS) I decided to lug the worthless thing all the way to Costa Rica and back—my pathetic souvenir for attempting to save a few bucks. That's when I first realized that when it comes to tripods, you absolutely get what you pay for.

If you're in the market for a travel tripod, you'll quickly find that they come in all shapes and sizes, from the classic three-legged concept to bean bags, clamps, plates, and whatever else they can think up. Tripod preference will vary from person to person and situation to situation, but when it comes to travel, lightweight and reliable are the magic combination.

Classic Tripod

Dozens of companies offer your classic telescoping, three-legged tripods. Though they may vary based on bells and whistles, they are mostly the same. Travel tripods generally feature an increased number of shorter leg segments so that they can have a smaller overall profile when collapsed. Here are a few things to consider when selecting a classic tripod:

- **Material:** Carbon fiber is the lightest, followed by aluminum, and then titanium. You can also find tripods made of plastic (nope) and wood (less compact and therefore less portable). Because carbon fiber is the lightest, it is also the most expensive. I've used aluminum tripods for travel almost exclusively and find them to have the best weight-to-price ratio.

- **Leg lock style:** Leg locks are the joints between leg segments. They are most commonly found in two types: twist and lever. Twist is easier to manage one handed, but over time or in very cold temperatures may loosen and start to slip. Twist locks also pose more of an issue if you get debris like sand or dirt in the joint itself. Lever locks are easy to tighten (most have a thumbscrew or hex screw), can be locked even with debris in the way, and are less likely to slip. Though lever locks can be noisy to close, or catch on things while you hike or

travel, I've always used them and have been happy thus far. Regardless of which type of lock you choose, be sure they're made of a strong durable material.

- **Feet:** Usually feet are made of rubber, but some models offer spiked feet for extra grip/stability in certain shooting scenarios. Some models also have spiked feet hidden within rubber feet, offering the best of both worlds.

- **Head:** The two primary options for tripod heads are ball heads and pan/tilt heads. I have used both and found ball heads to be more compact and more convenient for fast repositioning and specificity. Check the weight rating for a tripod head before you purchase to make sure it can handle your camera and the heaviest lens you could potentially use. Some ball heads have only one point of articulation—the ball itself— whereas others also have a point of 360° rotation at the base, which allows you to keep the ball position locked in while panning or rotating incrementally (useful for time lapses, stitching panoramas, or making incremental adjustments). Invest in a good tripod head and you will be able to use it across multiple sets of legs, or on other types of support systems.

Flexible Tripod

Many companies have made similar flexible products, but the GorillaPod by JOBY (joby.com) is the real deal. JOBY offers a variety of GorillaPod styles capable of supporting anything from a cell phone or point-and-shoot to a full DSLR with a lens attached. I often use the GorillaPod Focus with the Ballhead X for travel photography (**Figure 15.1**). It's a compact and lightweight rig, able to securely support my camera for a variety of situations. I've wrapped it around poles and fences, hung it under railings, and balanced it on precarious ledges.

I've been able to use my GorillaPod without incident in several settings that do not allow use of tripods, because it doesn't have the profile of a typical tripod. The Ballhead X is so sturdy that I can also use it on full-sized tripods. A GorillaPod is a great option for travel photography.

Plate Support

I first used a Platypod (platypod.com) for a restaurant shoot. I wanted a low-profile camera support option that would allow me to shoot at table level without blocking the path between tables at a busy restaurant. It was the perfect solution for food photography and quickly became my travel photography tripod backup.

The Platypod is inexpensive, sturdy, and more compact than anything else you'll find on the market, and it lets you use your preferred tripod head. I use the full-sized Platypod Max, which easily accommodates a full-sized camera and zoom lens. When I travel to locations with strict tripod policies, I can easily set the Platypod on the floor, a table, or flat railing or wall and get my shot. For uneven surfaces, threaded legs are included with spiked feet on one side and rubber feet on the other, adding further flexibility.

On a recent trip to NYC, the Platypod was the only tripod I brought with me and it saved me lots of unnecessary weight. I was really happy with the shots it allowed me to achieve (**Figures 15.2** and **15.3**). *Side note: I was flagged for additional TSA screening because of the threaded spike legs, but ultimately allowed to carry the Platypod on the flight.*

15.1 GorillaPod Focus with Ballhead X

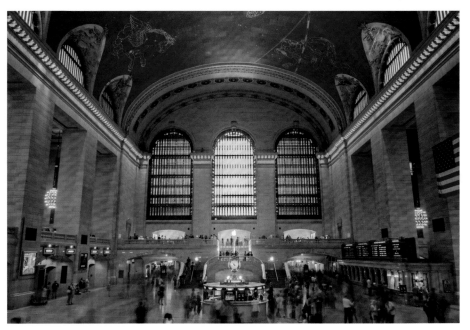

15.2 Using the Platypod Max at Grand Central Terminal, New York, New York

15.3 Resulting long exposure at Grand Central
ISO 100; 20 sec.; f/14; 18mm

Other Considerations

- Even the sturdiest tripod has its weaknesses. If you only need to partially extend a classic tripod, do it from the top down (the thicker segments first) since they are sturdier than the thinner segments. The center shaft or support column is generally the weakest option for extension.
- Solidify any tripod by moving the legs farther apart for better weight balance and stability.
- If your tripod gets wet, allow it to dry in the extended position to keep moisture from hiding in the leg locks.

- Keep any associated hex keys in your camera bag so that you can tighten joints in the field.
- It's a good idea to keep an extra camera mount plate in your bag in case you damage or lose a plate (that way, your whole rig isn't rendered worthless).
- Use a camera trigger or select a two-second shutter delay to help keep the camera and tripod absolutely still during the exposure.
- Use whatever stabilization you have available—I have been known to take off a shoe and prop my camera up with it in a pinch. Yes, it's weird. Yes, it works.
- If you are going on a long hike in bright

midday sun and you have no intention of doing panoramas, long exposures, or time lapses, then save yourself the extra weight and leave the tripod behind.
- A fully extended tripod can serve as a very helpful walking stick on rugged hikes.
- A fully extended tripod is also a great self-defense weapon. Bobcats and creepers, beware.

16. FLASHES AND LIGHTING

NINETY-FIVE PERCENT OF the time I utilize natural light or available light for travel photography. To me, something about introducing a foreign light source is more photographic intervention than I am comfortable with. That said, painting things with light can have badass results. I keep a few important lighting accessories in my camera bag when I travel, because subtle changes in lighting can mean the difference between a good photograph and a great one.

Reflectors

A small, collapsible reflector is a great accessory to have in the field. Whether you're attempting to fill in shadows for a portrait, bounce a bit of extra light on a dish of food (**Figures 16.1** and **16.2**), or block direct light from a flower or other macro subject, a small reflector can be invaluable. It makes the best of the lighting you have naturally. I travel with a 12-inch-diameter reversible (silver on one side, gold on the other) reflector that collapses down to about 5 inches. It's ultra-lightweight and ultra-handy.

16.1 A reflector was needed to fill in the shadows in a covered dining area at Guana Island, British Virgin Islands.

16.2 The resulting image of Goat Water (tastier than it sounds) at Guana Island, British Virgin Islands. **ISO 100; 1/60 sec.; f/5; 44mm**

Flashlights

For painting with light, a flashlight or headlamp will do the trick. LEDs offer the best battery efficiency for the most light output, so they are my go-to travel light. Because LEDs put off a cool cast (**Figure 16.3**), you may want to tape a small piece of amber gel over the light to warm it up a bit. Alternatively, you can utilize a wild, totally unnatural color to paint some eeriness into your photographs (**Figure 16.4**). Just keep in mind that gels can cut the amount of light transmission depending on how intense the color is, so you'll have to play with the length of your exposures to make it work.

You can also use a flashlight when shooting at night to help your camera's autofocus lock onto the subject (though you should make sure the camera isn't taking exposure readings off the autofocus point). Any sort of night shooting and light painting is a trial-and-error situation, so experiment and see what you can come up with!

Pop-Up Flash

We've all witnessed that one guy cluelessly firing his camera's popup flash into a sunset landscape. Don't be that guy. Your camera's integrated flash is rarely a good option if you want to make professional-quality images. Because of its positioning, size, and power, the light from the popup flash is generally harsh, overpowering, and unflattering for any nearby subject and totally useless for any distant subject. Figure out how to override your camera's flash and do it. If you feel like throwing caution to the wind and using the popup for a bit of fill light, then turn the power way down (if you can) and consider taping a diffuser over the flash to soften it a bit.

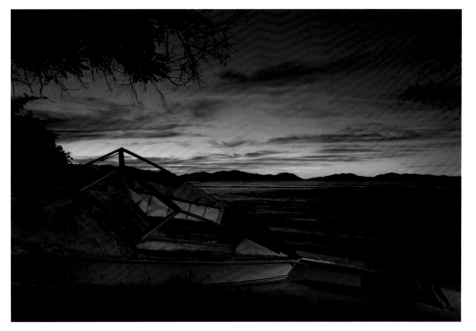

16.3 A cool flashlight was warmed up with gel to light paint a boat in Spanish Town, Virgin Gorda, British Virgin Islands.
ISO 100; 1.6 sec.; f/4.5; 17mm

16.4 Playing with red flashlights at the Coppermine, Virgin Gorda, British Virgin Islands.
ISO 100; 258 sec.; f/9; 8mm

Hot-shoe Flash or Strobes

For some travel portraits or for shooting interiors, a hot-shoe flash or studio strobe light can be useful. Harshness of light is still a concern, so the power output, direction of light, and relationship to ambient light levels are important. For a hint of light on your subject that still allows the overall scene to appear normal, expose the frame for the ambient light (the subject will look dark) and fire the flash to light the subject (**Figure 16.5**). This may take some experimenting with flash output and shutter speed, but it will be worth the effort. Make sure you modify the flash output with a softbox, diffuser, or a bounce to give the light a softer, more attractive quality when you can't find softer, more attractive models.

16.5 NFL's Chris Harris lit with an off-camera flash in Chicago, Illinois.
ISO 800; 1/5 sec.; f/4; 20mm

17. MEMORY AND BACKUP

IN THE DAYS of film we somehow survived knowing that there was only a single copy of our negatives in the world. Maybe the fact that they were a tangible entity made them feel more secure and easier to protect. Maybe it was just because we were used to the idea of having one original from which to make multiple prints. In any case, the days of putting all your eggs in one basket are over. It's not insignificant that with digital photography we can easily make double negatives by backing up our files. As soon as you finish shooting, you can make as many copies as you want to ensure that you never lose your images. This ability is a huge step forward for the preservation of our art and our memories—so take full advantage and find a backup system that works for you!

What Works for Me

Whether I'm on the road or at home, I always make sure to keep at least two copies of my RAW files. The easiest way to streamline storage on the road is to travel with more than enough memory cards so I never have to format my cards during a trip. I like to carry 32 gigs for each day. Some days I shoot more, and some days less, but the 32 gig range seems to cover it.

If you're shooting video, wildlife, weddings, or anything else where you will spend all day shooting in burst, you'll need to do some calculations to figure out how much memory you could potentially need. Your memory usage will also vary based on your camera—higher-megapixel cameras write larger RAW files, allowing fewer images on each card.

Each time I fill up a card, I lock it so I can't accidentally format or erase my images, and then put the card in a secure, waterproof card case. I make backing up my photos a daily priority, something I take care of each night before bed. I don't like to waste a lot of time in my hotel room looking at photos when I could be out experiencing, so I have a fairly streamlined process that works for me. One by one, I load the cards into my Chromebook (more on that in a bit) and back them up on an external hard drive. On very long trips, when it becomes impossible to maintain one card per day, I use a second hard drive to back up each card twice. RAID-style drives are quicker and easier on the road, but if something physically damages the drive you could lose everything. I keep two copies, no matter what. I also keep the two copies separate from each other—memory cards stay with me in my camera bag and hard drives

stay in the hotel. It's a simple enough system, but by no means the only option.

There are many products on the market to help you protect your work on the go, but whichever you choose, be certain to double up!

Memory Cards

There are several things to consider when purchasing and using memory cards:

- **Brand:** Seemingly every day a new manufacturer of memory cards pops up on the market. Crazy low prices might encourage you to try a company you haven't heard of, but when it comes to memory, it's best to stick with the established manufacturers. I like SanDisk and Lexar. When purchasing any cards, be sure to read reviews online. Most SD cards are solid and well built, but I learned the hard way that sometimes the little black dividers on the back of memory cards are made of flexible plastic and can get bent when inserting the card into a reader (**Figure 17.1**).

17.1 A bent prong made me panic after an important shoot.

- **Size:** A massive memory card may seem convenient, but to me it feels like putting too many eggs in one basket. If you have a card write error, or some sort of physical damage occurs, you'll be happy you were using smaller memory cards and therefore lost fewer images. I try not to purchase cards larger than 64 GB. The exception to this is if you're shooting with a 50- or 100-megapixel camera, then you'll need massive cards to accommodate your massive files.
- **Storage:** Memory cards are best kept in specially designed cases with snug-fitting card slots. Avoid keeping loose cards in your bag or tucking a memory card in your pocket. Waterproof and shockproof are both great qualities in a card case.
- **Erasing cards:** It's not a good idea to delete pictures one at a time in camera. The absolute best way to erase a card is to format it. Try to avoid switching cards between different cameras without formatting in between. Cameras each have their own file creation hierarchy, so switching around can confuse the camera and cause issues with formatting. The cleanest format will always be with the camera that wrote the image files.
- **Testing:** Once in a while memory cards have factory defects. Before any big shoot or a trip, it's a good idea to take cards out for a test shoot. Shoot with them, back up the images, and format the card again. If it all goes smoothly, then you're good to go.
- **WiFi:** There are some memory cards on the market that allow you to back up as you shoot to a laptop or other device. These would be a good idea if you're concerned about having time to manually back up at the end of each day. Some cameras also have an internal WiFi function for the same purpose.

- **Double card slots:** Some cameras now offer two card slots, allowing you to make a backup copy right in camera. If you have that option, it will definitely streamline the rest of your backup process.

Computing on the Road

I used to travel with an eight-pound, 17-inch, fully loaded Microsoft laptop. After lugging that monstrosity around for a couple years, it didn't take much convincing for me to streamline to a more mobile option. For me, road editing isn't a priority, so I can easily get away with the 10-inch Chromebook Flip by Asus (**Figure 17.2**). It has quickly become one of my favorite travel accessories. There are a variety of offline apps like Snapseed and Pixlr for photo editing, and for any more involved edits, I can use Lightroom mobile.

My Chromebook is light, durable, and doubles as an e-reader, saving valuable space in my luggage. It's great for watching movies on a plane, and I can pair it with my phone to use my data plan when WiFi isn't available. Best of all, if it gets damaged, lost, or stolen, I'm dealing with a couple hundred dollars replacement cost, rather than a couple thousand for a high-end computer. I travel with enough expensive, sensitive gear that it's nice not to worry about keeping a pricey laptop safe.

Because Chromebooks don't have a ton of internal storage, traveling with one does necessitate backing up on a hard drive, rather than the computer itself, but it's a small price to pay for such a useful, versatile computing option.

Hard Drives

External hard drives are amazingly portable these days. You can easily carry terabytes of storage with you in a device the size of a cell phone. For travel photography, you want to select hard drives that are rugged and don't need to be plugged into an outlet. I've had a lot of luck with Seagate's Backup Plus and Lacie's Rugged Series.

If you're hoping to cut computers out of the equation, there are a few companies who make hard drives with SD card slots for direct, computerless backup capabilities. Whichever you choose, protect your hard drive with a secure, durable case, and avoid bringing your home backup drive filled with past trips and shoots on the road with you.

Online Storage

Cloud storage is a fantastic option at home, or if you have fast, consistent Internet access on your travels. Unfortunately, off-the-grid trips or journeys to far-flung places make online backup unrealistic. Add to that massive file sizes for RAW images or video, and it's generally a much safer bet to rely on physical backups.

17.2 Here I am in my backyard, working on the outline for this book. There's no need for a heavy or expensive laptop when portability is your priority.

18. SURPRISING ESSENTIALS

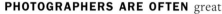

PHOTOGRAPHERS ARE OFTEN great improvisers. We're used to pushing ourselves to look at things creatively when we shoot, so by natural extension, we're often good at finding creative solutions for common problems. Some of my absolute favorite accessories and camera-bag stowaways are items that were originally designed or intended for non-photographic purposes (**Figure 18.1**). The most useful items are the items on hand, so consider picking up a few of these surprising and inexpensive accessories to take along on your next trip.

Plastic Shower Cap

Every time I travel, I take the hotel shower caps home with me. In a popup rain storm, or on a windy beach, a shower cap is a great disposable rain cover for your camera, plus it's easy to fit in your bag or pocket. Put your lens through the elastic opening and you'll be able to shoot freely while keeping the body protected (**Figure 18.1, item A**). For better visibility, slide the eyecup in place on the outside of the shower cap and tear a small hole to allow clean access to the viewfinder. The eyecup should hold the shower cap in place and keep the hole from getting bigger.

Ear Bulb

Also known as an infant snot suckers or aspirators, ear bulbs are tiny and powerful dust fighters (**Figure 18.1, item B**). They perform the same job as larger dust puffers and are significantly smaller and cheaper. Ear bulbs are available in most drug stores, in one piece or two. I like the two-piece ones because they're easier to clean if any dust or debris gets stuck inside. Ear bulbs can be used to get dust off the front of your lens, or off your sensor, though you should always use extreme caution and avoid touching the nozzle to the sensor!

Badge Clip

Next time you get roped into going to an annoying conference or networking event, remind yourself that you'll be taking home a valuable photography accessory. The alligator clips found on name tags and badges are fantastic for keeping track of your lens cap while you shoot (**Figure 18.1, item C**). Keep the badge clip attached to your camera strap or the strap of your camera bag and you'll have a consistent, convenient location for your lens cap. Badge clips also work well to keep a lens cloth handy.

Gaff Tape

There are loads of reasons why sound, video, and theater techies swear by gaff or gaffer's tape (**Figure 18.1, item D**). Made of woven cloth and available in a variety of widths and colors, gaff tape is strong, water resistant, and heat resistant, and it leaves no residue when removed. Gaff tape is the magic in-field fixer and can help solve many issues, from shoes that rub to broken bag straps or even a battery door that won't stay closed.

I've used gaff tape as a quick fix for a crack in a camera body, and I've used it as a replacement grip when the factory grip on my camera fell off mid-trip. Gaff-tape your phone to the dashboard of your rental car for easy, non-destructive navigation; use small squares of colored gaff tape to label your gear. Buy it by the roll for best value, but tear off a strip of two or three feet and wrap it around a pencil to save space in your camera bag and have an ergonomic pencil grip (**Figure 18.1, item E**).

Jar Grip

This one's not quite as versatile as other items in this list, but when a filter gets stuck on your lens or, even worse, to another filter, you'll be glad to have a super rubbery grip (**Figure 18.1, item F**). In a pinch, rubber bands wrapped around the filter can work as well, but a jar grip is much faster and easier to use.

Q-tips

Most DSLRs rival English muffins with their abundance of nooks and crannies. The world is filled with dust, dirt, and mystery gunk, so if you're going to be out shooting, it only makes sense to bring a cheap and easy cleaning tool. Avoid using a Q-tip anywhere but the exterior of your camera and accessories.

First-aid Kit

Photographers will generally do anything to get the shot. If you're anything like me, photographic off-roading could mean skinned knees, blisters, splinters, scratches, and cuts. I keep a couple of sealed single-use packets of Neosporin, a few adhesive bandages, ibuprofen, and tweezers in a pouch in my camera bag. Bonus points for anti-itch cream, sunscreen wipes, and bug-repellent wipes.

Microfiber Towel

Sometimes, despite all your preparation, you or your gear get soaked. A travel-sized microfiber towel is lightweight, amazingly absorbent, and dries quickly. Wrap it around an expensive lens in your bag for extra cushioning and it will be waiting for you when you need it.

Multi-Tool

For car-based travel, I always keep a Swiss Army Knife or a Leatherman in my camera bag. When I fly, I switch to a credit-card-style multitool so I don't have any issues with TSA regulations. Both types are a huge help when you want to tighten a screw, or pop a bottle of beer on your travels.

Bike Lock

On road trips and travel days, I tend to keep my Pelican case in my car much of the time. I may stop and carry some gear with me for shorter hikes or excursions, but usually the Pelican stays put. To deter thieves, I like to not only lock the case itself, but run a flexible bike lock through the handle of the case and attach it to a strong anchor point in the trunk. You can bike-lock your gear to a radiator or bedpost in hotel rooms for added security while you're out.

Snacks

So much of my photographic success is food based. It's easy to lose track of time while you're out shooting, and low blood sugar is no fun. I like knowing that I have a tasty treat in my bag to keep myself going. Treat yourself like a toddler and get in the habit of keeping a couple of contained snacks or granola bars handy. Replace them as you go so you never have to scramble before a shoot to pick up snacks or reach for one and suffer the disappointment of an empty snack pocket.

Water

No matter the climate you visit or how thirsty you may or may not feel, drink lots of water! For many of us, this is easier said than done, but with dehydration comes slowed reflexes, fogginess, and confusion. Drink plenty of water to keep a clear head—if not for the sake of your health, then for the sake of your images and your expensive gear!

18.1 These items weren't designed specifically for photography, but they've all come in handy on my excursions.

19. POWER ON THE GO

WHETHER YOUR TRAVELS carry you out of the state, overseas, or off the grid, you'll want to have a simple and convenient power solution for maintaining your gear on the go. As with all other travel gear, the best power solutions are compact, versatile, and easy to use.

Keeping Your Camera Running

For starters, it's a good idea to purchase a couple of extra batteries for your camera before a big trip. You can save money by picking up compatible off-brand batteries, but I have found that they hold an inferior charge over time. I recommend sticking with the batteries manufactured by your camera brand. It's better to spend a little money up front for a more reliable product. That said, all batteries can eventually go bad, regardless of manufacturer, so make sure your batteries are in good working order before a trip.

All cameras utilize battery power differently. Some are great at "going to sleep" to save battery life between shots, whereas others constantly drain power. My Canon tends to be great when it comes to battery life, but

I avoid certain settings and features that drain the battery quickly:

- GPS can be a big battery drain because your camera is constantly trying to triangulate itself. If I don't specifically need GPS data for my shots, I keep it turned off.
- Live View is a battery killer. As a DSLR user I have the luxury of an optical viewfinder, which uses no additional battery power, but if you're shooting with a mirrorless camera, you may have more significant power usage issues. Consider carrying extra spare batteries to make sure you can keep shooting as long as possible.
- Turn off automatic image review to keep your screen from showing off every single shot after you take it. It will save you significant battery life over the course of the day, and if you want to look at your shots they're still available at the touch of a button.
- Turn off your camera when it goes back in your bag. Even if your camera is "sleeping," getting jostled around in your bag may cause it to wake back up and use power. If my camera is out of my bag, then I keep it

turned on for quicker shooting; if it's put away, then I turn it off. Just remember that many cameras reset bracketing and other custom settings when they are switched off, so you'll have to manually reapply those settings when you switch the camera back on.

- If your battery is on the verge of death and you want to get a couple more shots before it goes, use manual focus and turn off image stabilization to help minimize the power required from your camera to shoot.
- Very cold temperatures will drastically reduce battery life. Keep your spare batteries in a shirt pocket or an interior coat pocket to use your body heat for better battery life. Even if a cold battery seems dead, sometimes putting it close to your body's warmth will get some more life out of it.
- Be sure to create a system for yourself so you'll be in the habit of recharging your camera batteries at least once a day. All the dead batteries in the world will do you no good when you want to go out and shoot.

Adapters and Converters

For many international destinations, you'll need not only an adapter to fit foreign outlet shapes, but potentially need a power converter to make sure your gear is receiving the appropriate voltage of current. In the United States, devices are intended to use our 110-volt system, but many are designed to accept anywhere between 100 and 240 volts. Check your camera battery and laptop chargers to see the accepted voltage range before you travel. You may be able to get away with using just an adapter rather than a power converter as well, but if not, it's best to plan ahead and find a converter that suits your charging needs.

Maximize Outlets

American hotels have figured out that we need roughly eighteen outlets in every room to charge our plethora of devices. Foreign hotels are often a different story. I travel with a small power strip with surge protection. I like being able to charge multiple camera batteries, my phone, and my laptop at the same time if necessary. Because electricity can be spotty in some of the places I visit, I like the added security of knowing a power surge or short won't damage my gear.

Power Packs

For charging phones and other small devices, portable power packs can be a great asset while traveling. I'm always a big fan of knowing I can recharge without being tethered to an outlet, especially when I'm trying to maximize my travel time for shooting. Because most power packs feature only USB ports, they aren't a realistic solution for charging camera batteries.

Car Charging

While traveling, it's generally a good idea to top up your charges when you have the opportunity, rather than waiting until all your batteries are drained. Recharge every night at your hotel, but if you'll be traveling by car at all, pack a car power inverter to allow you to use any of your traditional chargers on the go. I use a CyberPower power inverter (**Figure 19.1**) that allows you to use the cigarette lighter as a regular three-prong outlet and a USB charger.

Solar Charging

For longer off-the-grid journeys, solar charging has recently become a much more viable option. A variety of solar-charging kits are available in the $150–$600 range, depending on how quickly and how many devices you need to charge. Because solar-charging systems aren't usually functional if you're actively moving or hiking, they are most effective when set up at a campsite with plenty of all-day sun. Most kits will come with a single solar panel or a panel array and a power pack to store the power and transmit it to your devices. Solar technology is rapidly improving to become lighter and more portable, so shop around to find the best system for you.

19.1 Car charging like a pro.

20. STRAPS, CAMERA BAGS, AND CASES

I LEARNED QUICKLY that when I hit the road, I need to be comfortable and organized to create my best work. You can find a ton of carrying and storage products on the market, so many photographers go through a few camera bags and straps in the process of finding the one that best suits their needs—I certainly did! Don't let all your hard work and planning go to waste with a setup that's unsustainable for long days of shooting. With some strategic gear selection, you'll be prepared for any adventure and free to focus on shooting.

Straps

You buy a brand-new, super amazing, super expensive camera. You open the box and fill with excitement as you pull each accessory out of the box and remove it from its little plastic packaging. It's all so new, so clean, and so thoughtfully designed—all except for the factory camera strap, which is the photographic equivalent of using a piece of rope as a belt. Sure, it "works" for my grandfather, but it's ugly and uncomfortable and strangers may point and laugh.

Factory camera straps draw undue attention to you while you travel—they literally spell out the make and model of your camera—making you an obvious target for theft. Because the factory straps are so short, they're only wearable around the neck (uncomfortable) or on one shoulder (unsecure). Eventually camera companies will catch on and provide a better default product, but in the meantime you have so many third-party options to choose from.

Crossbody or sling straps are industry favorites. They provide security and beneficial weight distribution, and most have been designed with lots of features for increased functionality. Companies like JOBY and BlackRapid have even taken the contours of the female body into account and offer crossbody straps designed for women (**Figure 20.1**). Very often they have expandable sections of strap that allow you to bring the camera from your side to eye level without tugging the whole camera strap around you.

Frequently, crossbody or sling straps attach to the camera's tripod mount rather than the strap keepers on the sides of your camera, which can complicate matters when using a tripod. Fortunately, there are many adapters and plates on the market that will allow you to connect a screw-mount plate and a screw-mount strap at the same time.

If you like to keep your camera handy and ready to go, then a hand or wrist strap might seem like a no-brainer. They're a great option for lighter-weight cameras, but for full-size DSLRs a hand or wrist strap can cause some definite fatigue over the course of the day. I like to stay mobile and prefer to keep my hands free when I travel, but I love that my camera feels better supported in my hand while I shoot with a hand strap. For me, the happy medium is to keep a hand strap on my camera as well as the crossbody strap. The hand strap is there when I want it, but it's not my only camera gripping option. I just tell myself that it's not weird to have two straps on one camera.

For serious shooters and wannabe gunslingers, the next level of camera-strappery comes in the form of camera harnesses and holsters. As more photographers work and travel with multiple cameras, strap manufacturers have come up with some great ergonomic ways to comfortably shoot with two cameras. Many photographers love the weight displacement of two-camera shoulder harnesses, but if you're hiking with a backpack on, you have limited real estate in the shoulder and side regions. Camera belts are a great way to take some weight off your shoulders while carrying your camera and keeping your hands free, though you should use extra caution in crowded situations.

Whatever type of strap you end up using, pay attention to the materials used and read user reviews. Focus on ergonomics, breathability, padding, and functionality over flashiness or price and you'll be a happy traveler.

Camera Bags

Just as factory camera straps can make you a target for thieves, camera bags and backpacks that blatantly look like camera bags and backpacks are asking for trouble. There are so many brilliantly designed camera bags with fantastic padding, room for laptops, and homes for all your tiny, delicate accessories, but at the end of the day, if they have an identifiable photography gear manufacturer logo on them, they draw way too much attention for travel.

As I mentioned in lesson 13, "What Do You Really Need?", I love modular camera pouches or inserts that can be used with any non-photography backpack. I have the flexibility of using different-sized backpacks for different trips or situations, I have more choices in style and design, and non-photography bags are generally much less expensive. My go-to camera inserts (**Figure 20.2**) were sadly discontinued by the manufacturer, but there are tons of similar top-access padded inserts on the market in a variety of sizes and styles.

If you prefer to use bags or backpacks specifically designed for photography, then you still have an overwhelming range of options. Whether you prefer the ergonomics and distribution of a backpack or the easy access and flexibility of a messenger or shoulder bag, there are a few things to keep in mind when looking for the best choice for travel photography:

- Bags made of waterproof (or at least water-resistant) fabric offer a sense of gear security that is worth the cost.
- Access zippers on the back side or in an unexpected location will help keep your gear better protected.
- A mesh or foam back panel will be your friend on long or hot days.

- You can never have too many cinch straps. I use cinch straps to carry my tripod, extra water bottles, muddy boots, even additional bags.
- Mobility is key, so look for a bag with a slim profile that can still accommodate necessary non-photographic items like keys, wallet, snacks, or a tablet. Bonus points for a water bottle pocket.
- Cover any blatant photography company logos with black gaff tape (quick and dirty) or decorative patches (pieces of flair) for theft deterrence.

Cases

Before I owned a Pelican case, I fantasized about Pelican cases. I imagined rugged off-road adventures with an incredibly sturdy, hardcore Pelican case by my side (**Figure 20.3**). I pictured motoring from ship to shore in a dinghy with a delightfully waterproof and

20.1 Look at that happy, relaxed, and comfortable photographer with her ladies' JOBY strap.

20.2 Camera inserts make any bag work as a camera bag.

20.3 Look at that sexy, rugged Pelican in the Spanish cork forests.

buoyant Pelican case at the ready (**Figure 20.4**). In my mind, ownership of a Pelican would lead to a more exotic photographic life. The cases are that amazing.

For getting to your destination with maximum security and gear protection, there is no better option than a Pelican case, but for active shooting on a hike or the street or at a museum, they are wholly impractical. There are harnesses that allow you to wear a Pelican like a backpack, but you'll still need to stop, take it off, lay it down, and open it up to access your gear.

If you choose to go the Pelican or hard case route on big travel days, get the wheeled carry-on size 1510 or 1535 and employ a modular camera insert system like I do. You'll get the best of both worlds—waterproofed security and ease of mobility.

20.4 Even if the dinghy sinks, the Pelican will float and keep my gear safe.

21. THROWAWAYS, ACTION CAMERAS, AND CELL PHONES

ONE OF THE many beautiful things about photography is that it lends itself very well to experimentation. For all the photography rules in existence there are just as many rule breakers—people who aim to push their gear and the art form to its limits. From the more tame experimentation with motion blur to the "hey, what do you think would happen if I dropped this GoPro to Earth from the upper atmosphere?" kind of freestyling, there's no shortage of ways to expand your art.

This kind of experimentation is a great way to bring new life to your images and discover techniques that you enjoy. So though I wouldn't recommend dunking your ultra-expensive 4K camera in a bucket of bleach to see what happens in the resulting images, it's a good idea to keep a couple of cheaper "throwaway" cameras or accessories in your bag to play with. In your travels you'll find that the best camera is the one you have with you, so even on days filled with messy or extreme activities, bring along a camera in some form to document your experiences.

Throwaways

Most of us have an old, obsolete point-and-shoot or DSLR sitting in a drawer somewhere. It's time to reclaim that outdated technology. There are loads of camera hacks and DIY websites with ideas for what to do with an old camera. Consider converting a camera you don't need to infrared for a totally unique perspective on the world (**Figure 21.1**).

Photograph precarious situations without worrying about your good gear. Experiment with creating light leaks by removing the lens from the body during a longer exposure. Buy a cheap plastic lens or a cheap filter and scuff up the front element a bit to play with interesting texture overlays or light refraction. Cover an old filter with vaseline to get a dreamy, ethereal look. The possibilities are endless.

Sometimes the best photos are the ones with the most personality, so give yourself permission to utterly destroy an old camera in the pursuit of experimentation and give it a whirl.

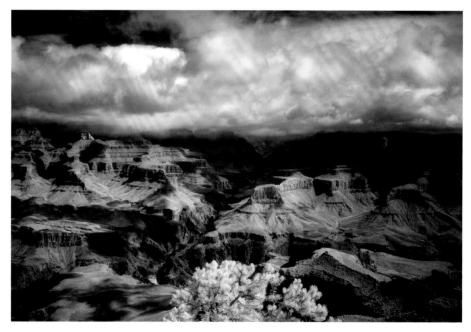

21.1 The Grand Canyon in infrared. Photograph by Tim Karas
ISO 200; 1/500 sec.; f/8; 720nm; Infrared Conversion

Action Cameras

If you're looking for a way to capture your adventures while keeping your hands free—or at least less encumbered—investigate adding an action camera to your gear collection. Action cameras are often very durable, waterproof, ultra-wide angle, and can shoot video, stills, or time lapse. You can even find action cameras that record 360° video. The most commonly known action camera is a GoPro, but it's definitely not the only option on the market.

I've strapped an action camera to the roof of my car, I've mounted one to a pipe on the grid of a theater, and I've clipped a camera to my helmet while ziplining through the jungle (**Figure 21.2**). Sometimes it's nice to know that you can keep documenting in more extreme situations—even if you're unlikely to print and frame the resulting images.

Action cameras will provide a lot of great behind-the-scenes footage of your adventures, which you'll find useful later for remembering important details, sharing your experiences with friends and family, and saving a record of how you achieved your shots. With action cameras there isn't much room for compositional adjustment—you can't zoom or change aperture settings—so make sure you feel good about the composition before you start an hours-long time lapse!

Cell Phones

Cell phone photography has come a long way. Early cell phone cameras had one or two megapixels at best, but at this point, my phone has twice the megapixels of my first DSLR! In fact, I specifically selected my past two phone models for their photographic features. It's crazy how much power they've packed into phone cameras, and when you consider all of the accessories on the market for phones now, you can easily plan to use your cell phone as your backup camera on your travels.

21.2 I'm a hands-free jungle documentarian with my helmet camera. Monteverde, Costa Rica

Share Your Best Action Photo!

Once you've captured your best action photo, share it with the *Enthusiast's Guide* community! Follow @EnthusiastsGuides and post your image to Instagram with the hashtag *#EGAction*. Don't forget that you can also search that same hashtag to view all the posts and be inspired by what others are shooting.

Consider relying on your phone for locations where a full-sized camera isn't allowed or isn't realistic. Worried about bringing your DSLR to a crowded market with a reputation for theft? Use your phone's camera instead (let's be honest, you weren't going to leave your phone behind anyway). With clip-on lenses, flashes, and constant video lights, you can practice all kinds of photography with a cell phone. Still worried about traveling with your nice new phone? When you upgrade, keep your old phone to use as your travel phone. They were only going to give you $40 for the trade in anyway.

My favorite use for my phone's camera while I travel is to create a series of reference images. When Polaroid technology was first invented, many serious film photographers welcomed it immediately. They took full advantage of the opportunity to instantaneously see how a place or a subject photographed in certain lighting conditions. For me, a phone camera can be used in much the same way. When I turn off my DSLR's GPS function to save battery life, I use my phone's camera to take an image with location data tagged in it (**Figure 21.3**). Using my phone, I also shoot pertinent signs, create behind-the-scenes snapshots of my camera setup, and record photospheres or video clips to give the locations I shoot some context. I may never share these reference photos and videos with anyone else, but they create a useful record for me.

Because I keep Google Photos set to automatically back up my phone photos, they'll upload to the cloud, where I can search through them later by location, date, or subject matter. If you're like me and you struggle

21.3 Reference cell phone photos with GPS coordinates are easy to find in my Google Photos account.

with your digital photo filing system for RAW files, then the ability to search Google Photos to remember when a particular shoot took place is a massive benefit.

When I use my phone to shoot images that I hope to use or share, I don't use the phone's native camera app. For best results, I prefer to use an app with some manual camera features and the ability to shoot images in RAW. Google Camera is Google's official camera app with lots of adjustable settings and features, but it doesn't come automatically installed on all Android phones. Take a look in your phone platform's app store and check out some of the camera apps on the market. User reviews are a great way to figure out which apps will give you the best bang for your buck or if there is a free app worth trying.

Cell phone photos are very easy to edit on

the road, which makes them an ideal tool for updating your social media while you travel. Google Photos has an editing function that allows you to fine-tune settings like Exposure, Contrast, Highlights, Shadows, Warmth, Tint, and Vignette. It also has a few automatic filters you can apply quickly and easily to your images. For features that give you even more creative control—such as spot removal, double exposure, blur, smooth, or sharpen—I am a big fan of Pixlr (available for Android and iPhone), but Adobe diehards can use Lightroom and Photoshop Mobile for more familiar controls.

Whether you choose to experiment with your cell phone camera, an action camera, or an old point-and-shoot, the best camera truly is whatever camera you have with you! Keep one camera or another on hand throughout your travels and you'll be good to go!

22. KEEP YOURSELF AND YOUR GEAR SAFE

SO NOW THAT you are totally loaded up with a travel gear wish list, let's talk about protecting your investment when you travel. You need to think about a lot of things before you depart on a journey—from researching location safety and history of petty crime to creating best practices to physically protect your gear from the elements. Keep in mind as you travel that you may be targeted not only because of your gear but because you are a tourist. For the most part, staying safe is about staying smart and staying aware, but there are a few other ways to hedge your bets for safety.

Travel Days

The first potential point of friction for your gear is the security line at the airport. When I pass through security, I make sure my gear is well organized so I can take a quick visual inventory and know if anything is missing or damaged. I *never* check my gear, but if for some reason you have to, make sure you're using a hard-sided, Pelican-style case with plenty of padding and a TSA-approved lock. If I have to check my case for any reason, I always remove the most expensive or irreplaceable gear and carry it on the plane in hand.

When checking bags, visually inspect your gear in detail once you have arrived at your destination airport and make sure to take pictures with your phone of any damage. If you find damages, fill out damage claims forms on site. Do not leave the airport without filing any necessary paperwork.

If you are traveling internationally, double-check not only the regulations in your home airport but the destination airport as well. The TSA seems to change their regulations on a near-constant basis, so before you head to any airport, double-check whether they will require you to provide proof of purchase for your gear, access to your bodily cavities, or custody of your first-born.

When I travel internationally, I make sure to carry a printout of all the gear I'm bringing from home. Occasionally customs and immigration will require you to provide an itemized list with purchase dates and serial numbers to prove you haven't purchased any of your gear abroad. Your life will be so much easier if you already have that information compiled on a spreadsheet.

If you are heading to an area notorious for harassing photographers, you can make things even more official by purchasing a Carnet (an official document that serves as a sort of passport for your gear). This will allow you to travel internationally through 87 listed countries without any concern of import/export tariffs on the gear you already own for a period of twelve months. Carnets sound like an easy fix, but because they are somewhat expensive to obtain ($250–$500 depending on the value of your gear), they may be more trouble than they're worth. Like all things photographic, a bit of research will let you know if a Carnet is a good idea for your particular travel destinations.

Above all else, use common sense and your personal discretion to keep your gear safe on travel days. No matter how much a location boasts its safety or lack of crime, never leave gear unattended. I have seen thefts occur in seconds on trains, and we've all heard of unfortunate smash and grabs happening to parked cars. Take any necessary precautions to keep your gear protected.

Gear Upkeep and Safety

In many ways, the natural world is out to get you. Heat, humidity, insects, sand, and dust are all legitimate concerns when traveling. We'll talk a bit more about the many creative ways nature can kill you later (see lesson 44, "Nature Is Dangerous"), but for now, let's discuss how it can seriously mess up your gear.

Heat can be a massive issue for sensitive photographic gear. Cameras are intended to operate within a certain temperature range (check your camera manual for specifics), but even if the ambient temperature seems low enough, things like direct sunlight and heat from within the camera itself can become an issue. Because most cameras are black, they

have a real tendency to absorb heat from the sun. An overheated camera can malfunction and produce images with increased noise levels (**Figure 22.1**).

In hot environments, limit the amount of live view and image stabilization you use to reduce the operating temperature of the camera. In direct sunlight, be sure to cover your camera with a white cloth or towel between shots to reflect some of the sunlight from being absorbed by your camera.

Humidity and rapid temperature changes can cause a variety of issues for your gear. To help avoid most humidity-related issues, keep a small pack of desiccant in the main compartment of your camera bag. Dry off any excess moisture with a microfiber towel before putting your camera away to make the desiccant more effective. Over the course of a long trip in a humid environment, your desiccant packs may become saturated and unable to absorb more moisture, so consider keeping a few backup packs ready to go in an airtight bag.

Anyone who has taken their camera outside from an air-conditioned hotel room to a hot environment has experienced a foggy lens and surface condensation (**Figures 22.2** and **22.3**).

22.1 This photo is super noisy, even at ISO 200. I was shooting in 120°F heat.

22.2 Flower with lots of condensation, Virgin Gorda, British Virgin Islands.
ISO 100; 1/250 sec.; f/4.5; 50mm

22.3 Condensation on my lens at a NASA facility in Mississippi.
ISO 100; 1/500 sec.; f/3.5; 8mm

To avoid temperature fluctuation issues, give your gear a few minutes to acclimate to a new temperature before you start shooting. If you plan to hop in and out of a car to photograph along a road trip, forego the personal comfort of air conditioning and open the windows instead. You'll be ready to stop and take photos at any point without fog or condensation.

Tiny insects can be a major nuisance when traveling to certain climates. Many nature and wildlife photographers have shared horror stories about miniscule ants and other bugs getting inside their cameras and causing irreparable damage. If you are traveling to a location with a particularly active insect population, check the seals on your gear regularly. Be sure to tightly close battery and memory card compartment doors and consider covering potential access points with gaff tape for an extra level of protection. When lenses are not in use, replace the front and back lens caps to keep bugs from working their way inside. On a recent trip to Nicaragua, I suffered an onslaught of teeny ants in one of my bags. Fortunately, they missed my gear entirely and only got into my Xanax prescription. I was super lucky and they at least died happy.

Dust, sand, dirt, and pollen can also cause you some gear drama. Get in the habit of inspecting and cleaning your gear at least once a day to keep any nastiness from accumulating. Camera armor is an option to help protect the exterior of your gear, but most options on the market are made of silicone. As the former owner of a silicone phone case that was regularly covered in lint, fuzz, and mysterious wads of hair, I have personally avoided covering my camera in silicone at all costs.

Thieves are a real issue all over the world. Trust the advice of locals on what locations are safe and what places might be a bit more dicey. Do your homework. When you're in crowded areas, keep your camera strap securely across your body and keep a hand on your lens. The sneakiest thieves can detach an expensive lens from your camera without you ever knowing. There are any number of scams and techniques pickpockets use to get at your gear quickly and efficiently. Keep your eyes open.

Humans, even the most well-intentioned, are often the biggest danger to your gear—a lesson I learned the hard way. Once on a trip I made the mistake of haphazardly repacking my gear once I was done shooting. It had been a long day and I was ready to use the bathroom, grab a bite, and take a moment to catch my breath before heading home. Unfortunately, a very intoxicated friend decided to throw my camera bag at me and the bag hit a tiled floor with a major thunk. Granted, there's not a foolproof way to protect your gear from drunk people, but if I had packed my bag as carefully at the end of the day as I do at the beginning, there would have been considerably less risk to my expensive gear. Think twice before letting anyone else handle your gear. Few people will be as careful as you are.

Regardless of how careful you intend to be, always insure your gear for the maximum replacement value. I've seen so many photographers travel without gear insurance and suffer thefts or damage, and have to turn to crowdfunding to replace their gear. If you can afford to travel, then you can afford to insure your gear. Don't be that guy who gets screwed in the long term by a stupid mistake and has to publicly beg for help. Build gear insurance into the budget for your trip. Insurance is your friend. Please don't travel without it.

Your Physical Safety
On a family trip to Ottawa in July 2011, my husband, my parents, and I were walking back to our hotel after lunch. The skies were oddly dark and though it had been quite windy moments before, all of the flags and banners suddenly went slack. Four or five blocks ahead there appeared an enormous wall of dust and debris—think sandstorm—and the four of us were pelted with grit and gravel. I had my camera out and could have easily stayed in the open to document the crazy weather, but smarter heads prevailed (my husband's fight-or-flight instincts are legit), and we ran to shelter in a nearby restaurant.

Moments later the storm with the force of an F1 tornado ripped past us, carrying patio furniture, debris, and massive decorative stone planters with it (**Figure 22.4**). The storm ravaged the stage at the nearby Ottawa Bluesfest and caused many injuries, one death, and major infrastructural damage to portions of the city.

Sometimes when we travel we are presented with amazing photographic opportunities that require putting ourselves in the way of potential physical harm. Unless you're an adrenaline junkie or a war correspondent, the photo potentials aren't worth it. Do what you can to keep a cool head and protect yourself.

For my first major solo trip, my biggest source of intimidation wasn't keeping my gear safe—it was the concept of my personal safety. I had all kinds of people coming out of the woodwork of my life worried about a petite woman on the road alone. It was easy to begin feeling overwhelmed and convinced

that the world was out to get me. I learned soon enough that it wasn't.

The most important thing I did to keep myself safe was to stay clear headed and aware. Both my husband and my parents had a general itinerary so they could feel secure in my whereabouts. I used good judgment when it came to not hiking alone in bear country and traveled with bear spray just in case (**Figure 22.5**). I kept my eyes open and when anyone got a little too friendly or attentive I made sure to stay in well-populated areas.

Over 45 days of travel through crowded cities, desolate wilderness, and everything in between, I stayed alert and paid careful attention to my surroundings. Follow the same practices you would to keep yourself safe at home, and if something makes you uncomfortable, speak up and take immediate action to remedy the situation. Your gear isn't worth your personal safety, so whether you're under threat by a mountain lion, a too-friendly creeper, or a bandit with a gun, forget your gear and keep yourself safe. That's what insurance is for.

22.4 A massive pile of furniture and debris lie where we had been standing only moments before. It may not look that threatening, but imagine that pile flying toward you at 100 mph. Sparks Street, Ottawa, Ontario, Canada **ISO 1600; 1/25 sec.; f/4.5; 22mm**

22.5 Woe to the bear that takes me on while I'm armed and dangerous with my bear spray.

4

SEE THE LANDSCAPE

CHAPTER 4

Although landscape photography may seem like the easiest or most obvious variety of travel photography, creating an impactful and unique photograph takes practice and a plan. Each type of landscape presents its own challenges and rewards, so whether you're embarking on a tour of the African plains, or a cruise through the Caribbean islands, you'll have your work cut out for you. By thinking about a clear subject and dynamic composition, learning to make the most of your gear, and seeking out the most dramatic conditions, you'll be well on your way to creating fantastic landscape images.

23. WHAT MAKES THIS PLACE SO SPECIAL?

LANDSCAPES HAVE THE potential to affect a photographer deeply. Hopefully in your travels you've experienced, at least once, the sensation of standing in the midst of wonder and perfection. With camera in hand you examine the world around you and can't decide where to begin—it's all too beautiful and amazing to contain in an image. Maybe you've hiked to some incomparable overlook or have found yourself in the middle of a forest alive with light, sound, and color. You feel an immediate emotional response to what you see but have no clue how to capture it. Can it even be captured effectively?

While assisting on a photography workshop in Utah, I had experienced countless breathtaking views. I visited and traveled through landscapes unlike anything I'd seen before—massive sandstone arches, deep craggy canyons stretching on for miles, and a sense of something very prehistoric at every turn (**Figures 23.1** and **23.2**). The final day of the trip, after being wowed so many times already, Utah took things up a notch. We hiked through somewhat challenging terrain along a minimally marked trail to visit Corona Arch. As we grew closer to our destination, climbing in altitude through an increasingly rocky and momentous topography, I was visited by a familiar sensation. There is an awe and sense of spirituality that comes to me in some natural places—a

feeling that I have transcended my normal level of awareness and tapped into a direct emotional conduit with nature.

I'm sure I sound like a hippie, but I'm also sure you've felt something similar in the natural world. There's a sudden shortness of breath, a rush of energy and happiness, and perhaps a little, totally understandable, wateriness in your eyes. I call this powerful feeling the "Elation of the Landscape," and the goal is to harness it in your photographs.

When we travel, we are often more open to this sort of emotional response because we've deliberately left behind our day-to-day worries. We've separated ourselves from our normal lives and actively aim to embrace the new and the impressive. John Muir, the original tree-hugger, grasped the importance of the natural world long before our technology and busy, messy lives reached the intensity of the modern era. He wisely explained, "Few places in this world are more dangerous than home. Fear not, therefore, to try the mountain passes. They will kill care, save you from deadly apathy, set you free, and call forth every faculty into vigorous, enthusiastic action."

When you venture into a landscape that touches you, man-made or wild, the best way to capture the elation it gives you and its essence of place is to determine first what makes it so special.

As I felt this familiar sensation in Utah, I fought the urge to start shooting right away. I allowed myself to take in my surroundings and feel the full emotional effect of the landscape. I carefully studied the rock formations, arches, and clouds. I listened to the distant thunder. I watched the way the changing light played on the rock walls and scrubby trees. I took the opportunity to venture off on my own to have a few private moments—alone with my thoughts and the way the landscape made me feel. When my pulse slowed and the rush of discovery began to calm down, I carefully composed my images with a greater sense of the scene around me (**Figures 23.3** and **23.4**).

By the time you arrive at your destination, you likely have a sense of why you chose to travel to that area or region. Immediately seek out the place or activity that drew you. Bring your camera, but allow yourself to marinate in the location. Shed your home-based worries, and slip into the energy of your surroundings. Relax. Breathe. Observe. Let the power of the place soak into your skin to reward yourself for making the effort to get there. As you soak it all in, remind yourself why you came and what you want to see or feel or capture.

Once you've acclimated to the destination's energy, give yourself permission to play and explore. Look up, look down, look

23.1 Dead Horse Point, Moab, Utah
ISO 3200; 1/160 sec.; f/18; 35mm

23.2 Mesa Arch Viewpoint, Canyonlands National Park, Moab Utah
ISO 2000; 1/160 sec.; f/16; 45mm

23.3 Corona Arch, Moab, Utah
ISO 125; 1/4 sec.; f/22; 18mm

23.4 The view from Corona Arch, Moab, Utah
ISO 125; 0.4 sec.; f/22; 18mm

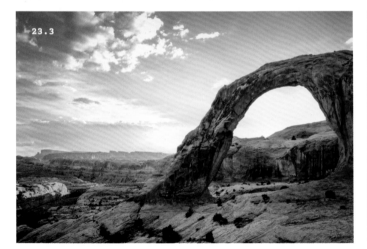

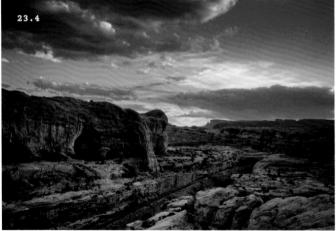

underneath. Follow your whims. Seek the unique. Make yourself an expert of your surroundings. If you're in a state or national park, read the map, read the brochure, read the signs. Understand what makes this place special, not only to you, but geologically, ecologically, and culturally.

Some places have an obvious source of uniqueness, and that uniqueness is what will help create lasting impact in your photographs. We don't visit Niagara Falls because it's a dime a dozen—we visit to take in the power of the water, the energy, and the vastness. The best photos of Niagara Falls will in some way celebrate and encapsulate that powerful energy and scale (**Figure 23.5**). You'll never hear the roar or feel the mist on your face while looking at a snapshot, but with a strong enough photograph, you'll think you do.

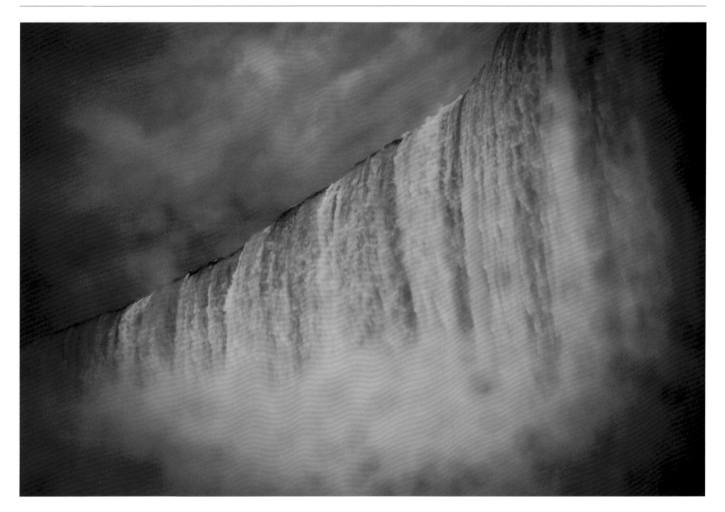

23.5 Niagara Falls, Ontario, Canada
ISO 250; 1/125 sec.; f/22; 42mm

24. INTO THE WOODS

FOR A PHOTOGRAPHER, woods can be one of the earth's most amazing and mysterious landscapes. Because they are so immersive in their sense of atmosphere, they create an environmental sensation unlike any other landscape. There's a dizzying sensory overload. You hear animals, birds, and movement but can't necessarily spot the sources of the sounds you hear. You witness the repetition of pattern in all directions around you and feel small in comparison to the arboreal giants that surround you.

There is a depth and a scale to the woods that make them so incredibly enchanting—but also terribly frustrating to photograph. Many photographers have experienced a beautiful and memorable woods walk, only to come home and find their camera filled with flat, uninteresting images that feel upsettingly underwhelming. Even the most magical lighting conditions can be difficult to shoot without a plan and a strong grasp of the technical.

There are an infinite number of ways to photograph any woods scene ranging from the narrow to the broad. The only limit is your imagination.

Gear Selection

Whether you shoot in high-altitude coniferous forests, or the rainforests of the equator, choosing the right lens is one of the most important steps in successfully photographing woods. A lens with a long focal length can cause you to lose the sense of height and depth of a forest, whereas a very wide lens can leave you with too much clutter and a lack of clear subject. There is no one perfect lens for woods photography, and almost any lens can be used with great success in the woods—it's just a question of using the right lens for the right situation.

Wide-angle lenses are great for providing an overall sense of a forest's vastness (**Figure 24.1**). You're far more likely to effectively capture the height of old-growth trees with a focal length of 35mm or wider.

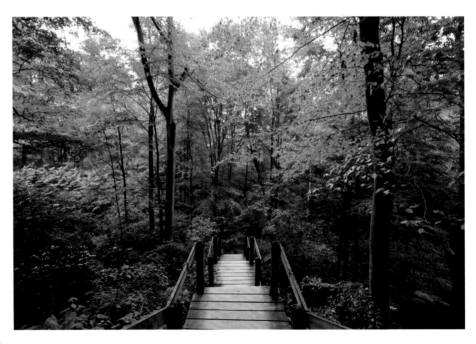

24.1 A wide-angle view of the woods in Brown County, Indiana
ISO 800; 1/80 sec.; f/4; 10mm

24.2

24.3

Try shooting directly above you with an ultra-wide-angle or fisheye lens to capture the treetops converging above you (**Figure 24.2**) or get close to the base of a tree and look up to get a unique take on the tree's height (**Figure 24.3**). If you have the opportunity to view the forest from the treetops—like on a rainforest canopy tour—shooting downward toward the forest floor with a wide-angle lens can offer a similar sense of scale from a whole new perspective (**Figure 24.4**).

Zoom lenses are very helpful for isolating small portions of the forest for shape, interesting light, or color (**Figure 24.5**). What a wide angle does to highlight scale, a zoom lens can do to highlight detail and nuance. To capture a forest's depth, try standing farther from your subject (like a particular tree or group of trees) and using a lens with a longer focal length to visually compress the perceived depth of the subjects in the photo (**Figure 24.6**). The viewer's eye will be less overwhelmed and unsure of where to look, and more capable of perceiving the details and the beauty of the image.

24.2 Portola Redwoods State Park, San Mateo County, California
ISO 100; 1.3 sec.; f/5.6; 22mm

24.3 Fall color in St. Germain, Wisconsin
ISO 400; 1/250 sec.; f/5; 33mm

24.4 View from the treetops, Monteverde, Costa Rica
ISO 100; 1/400 sec.; f/4; 17mm

24.4

24.5 Kankakee River State Park,
Bourbonnais, Illinois
ISO 100; 1/160 sec.; f/6.3; 189mm

24.6 Olympic National Park, Washington
ISO 1000; 1/125 sec.; f/5; 90mm

Special Considerations

Creating the right exposure can be difficult in an environment as nuanced as a forest or jungle. Regardless of the time of day or extent of cloud cover, the light will be mostly filtered through the trees—resulting in a complex array of shadows and hotspots. What looks beautiful to the eye can be difficult to capture in camera without a clear idea of how to shoot and an understanding of the limitations of your camera's dynamic range.

One way to approach complex lighting conditions is to bracket your shots to create an HDR (High Dynamic Range) image. Most cameras have the ability to program three, five, or seven photographs taken in rapid succession with a slight variation in exposure. When I bracket shots, I make sure I'm in Aperture Priority Mode to ensure that the aperture and depth of field don't change from exposure to exposure. Instead, the camera varies the shutter speed slightly to achieve the necessary under- or overexposure for your sequence. The bracketed images will need to be combined in post-production, but this technique will allow you to capture detail in the highlights and the shadows of your scene.

Conversely, you can use your camera's limited dynamic range for artistic effect. One of my favorite woods techniques is to underexpose the image to make shafts of light the most prominent feature in the composition (**Figure 24.7**) or to let rim lighting or backlighting drive the image (**Figure 24.8**). You could also deliberately overexpose the scene to capture a richer depth of color in the midtones and shadowy areas. The bits of sky visible between the trees will be blown out, but the woods themselves will feel as vibrant as they do in real life (**Figure 24.9**). This works especially well in autumn when capturing the color changes in the leaves. Just remember that in any forest the brightness perceived by your eye is still quite dim for your camera, so be prepared to shoot with a higher ISO or use a tripod.

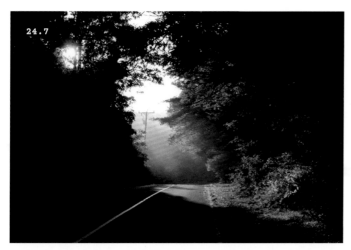

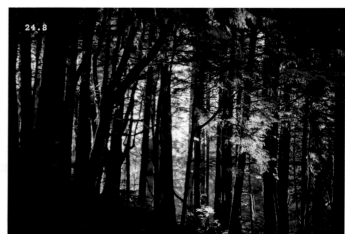

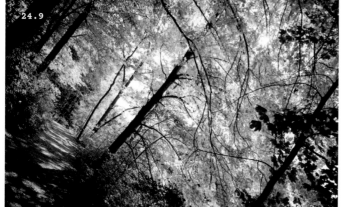

24.7 Falmouth, Massachusetts
ISO 500; 1/200 sec.; f/10; 61mm

24.8 Olympic National Park, Washington
ISO 2000; 1/80 sec.; f/5.6; 59mm

24.9 Indianapolis, Indiana
ISO 100; 1/500 sec.; f/4; 20mm

Intentional Composition

Ultimately, even the best use of gear and effective exposure can't create a visually compelling image alone; that's where composition comes in. Woods can be visually chaotic—rarely in nature do we find trees in straight lines or predictable patterns—so I love utilizing the negative space of a board-walk or trail to draw the viewer through the image and help provide a sense of balance (**Figure 24.10**). Similarly, a shallow depth of field can help cut down on the visual chaos by limiting the information your viewer has to sift through (**Figure 24.11**).

On a breezy day, I like to take longer exposures to capture the sense of movement and depict some of that magical woodsy atmosphere. Details and clutter morph into a pleasing array of color, shape, and movement (**Figure 24.12**).

Not all woods walks will feel inherently photogenic. It may seem contradictory to find the beauty after a forest fire (**Figure 24.13**)—or even during a controlled burn (**Figure 24.14**)—but with a little time and some ingenuity even the starkest woods scene will reveal its own enchanting qualities.

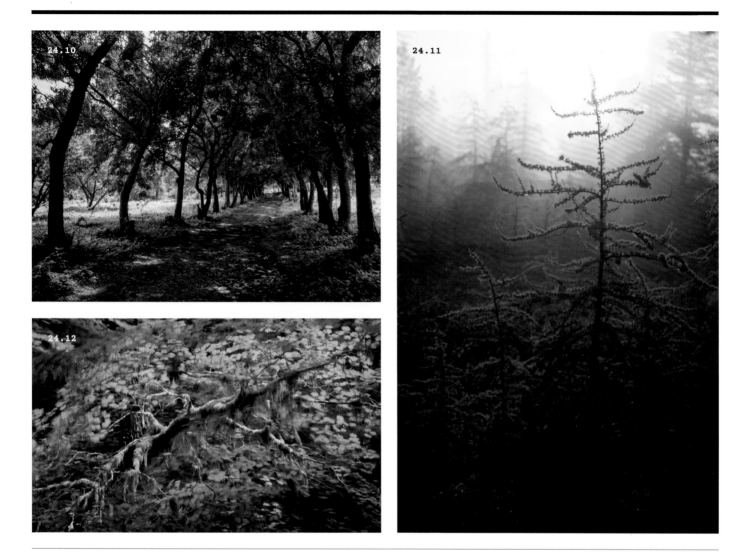

24.10 Ometepe, Nicaragua
ISO 6400; 1/160 sec.; f/18; 18mm

24.11 Mer Bleue, Ottawa, Ontario
ISO 125; 1/640 sec.; f/5.5; 85mm

24.12 Spanish moss, Olympic National
Park, Washington
ISO 125; 1 sec.; f/32; 85mm

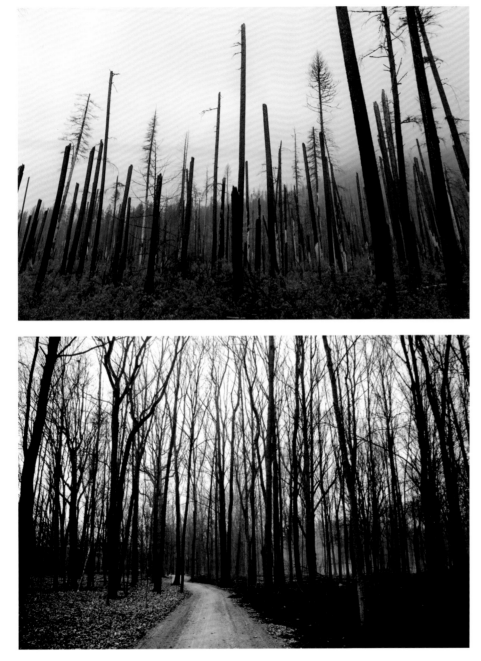

24.13 Glacier National Park, Montana
ISO 320; 1/50 sec.; f/4; 17mm

24.14 Des Plaines River Trail,
Libertyville, Illinois
ISO 100; 1/200 sec.; f/5.6; 17mm

WHO DOESN'T LOVE a good seascape? It doesn't matter if I'm shooting palm trees and pelicans or snow on the sand, I think a water view is pretty hard to beat. By the sea you'll find amazing details, abundant patterns, beautiful light, and a constantly shifting landscape—a photographer's dream! Don't be daunted by the practical woes of potential sea spray, blinding reflections, and sand in places that should ideally remain sandless. Your efforts will be rewarded with some of travel photography's most popular subject matter!

Gear Selection

Your first impulse upon arriving at a beautiful beachy vista may be to grab your widest lens and shoot the full expanse. The trouble is, without some fantastic atmospheric conditions or total solitude, the wide shot is the easy shot—the low-hanging fruit. Add to that the potential beach debris in the form of speedoed sunbathers (see additional low-hanging fruit) and you may have some serious Photoshopping in your future.

Before you fall into the more obvious vista captures, consider cropping in tighter to isolate smaller elements and scenes that reflect the depth and height of the view rather than just the width of it (**Figure 25.1**). Some of my favorite beach shots utilize a narrow and vertical orientation to better frame the available environmental elements (**Figure 25.2**). Practice narrowing your focus to be more selective and see what other photographers might not see. Explore the shells or the sand at your feet with a macro or zoom lens (**Figure 25.3**). Shoot the froth of the breaking waves or the shadows of the trees (**Figures 25.4** and **25.5**). Break the scene down into a series of smaller images that work together to tell a bigger story.

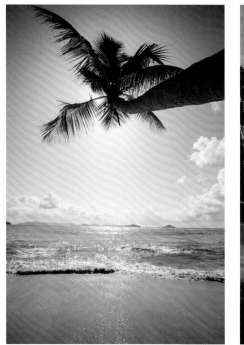

25.1 Mahoe Bay, Virgin Gorda, British Virgin Islands
ISO 100; 1/4000 sec.; f/3.5; 10mm

25.2 Spring Bay, Virgin Gorda, British Virgin Islands
ISO 400; 1/400 sec.; f/11; 85mm

25.3 Nail Bay, Virgin Gorda, British Virgin Islands
ISO 160; 1/1000 sec.; f/3.5; 50mm

25.4 Dennis, Massachusetts
ISO 800; 1/800 sec.; f/10; 300mm

25.5 Nail Bay, Virgin Gorda, British Virgin Islands
ISO 160; 1/640 sec.; f/1.8; 50mm

Afterward, if you do decide to go wide, you'll have more ability to do so with deliberate intention—to hone in on a more refined shot. When shooting the full wide-angle scene, make sure to engage with elements in the foreground (**Figure 25.6**) or shoot along the water line (**Figure 25.7**) to keep your photos from feeling like monotonous bands of sand, water, and sky.

Special Considerations

With the possible exception of a snow-scape, there is no landscape more reflective and challenging than a bright, sunny beach. Light-colored sand and plenty of shiny water throw all kinds of glare at you and will likely trick your camera into underexposing your photos. Even if you use exposure compensation (deliberately overexposing to achieve what amounts to proper exposure), your camera is unlikely to be able to capture the full dynamic range of the highlights and the shadows.

Fortunately, you have a couple of options to help capture what your eyes see. If you want to go the fully automated route, you can use the Auto Lighting Optimizer (Canon) or Active D Lighting (Nikon) to help capture a greater dynamic range in camera. The results aren't perfect—these settings basically push the highlights and the shadows more toward the middle tones—and will still require some adjustment in post-processing. For more complete exposure control and even more post-processing work, you can bracket shots and crank out an HDR photo later on. Or you can choose my somewhat snobby, purist preference and capture the correct exposure in camera by using filters.

At the beach my two favorite accessories are a circular polarizer and a graduated neutral density filter. Your polarizing filter will help cut glare by reducing reflections on atmospheric haze, allow you to get truer color from the water, and pop your skies like no one's business (**Figure 25.8**).

25.6 Monomoy Island, Massachusetts
ISO 400; 1/800 sec.; f/16; 10mm

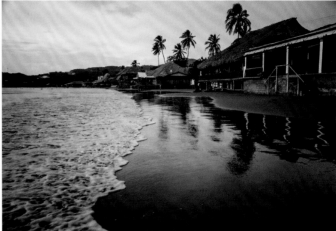

25.7 San Juan del Sur, Nicaragua
ISO 200; 1/160 sec.; f/4.5; 18mm

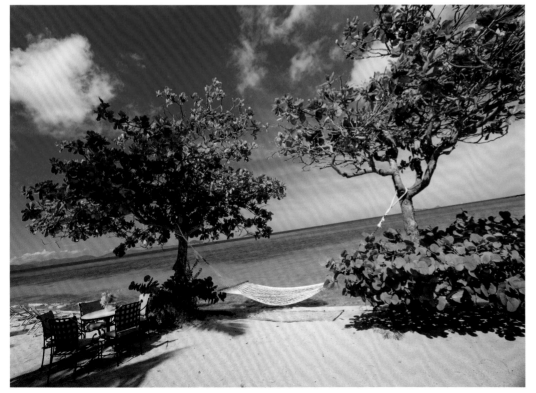

25.8 Mango Bay Resort,
Virgin Gorda, British
Virgin Islands
**ISO 320; 1/640 sec.;
f/5; 10mm**

25.9 An example of poor usage of a polarizer—also, a super odd composition. Forgive me, I was young. Cape Cod National Seashore, Massachusetts
ISO 200; 1/500 sec.; f/5; 10mm

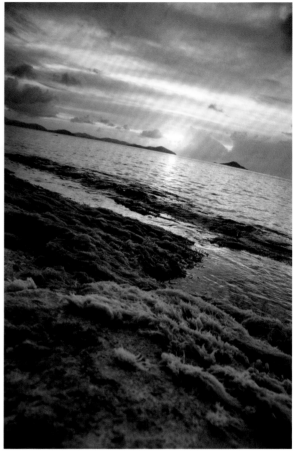

25.10 Mahoe Bay, Virgin Gorda, British Virgin Islands
ISO 500; 1/100 sec.; f/7.1; 17mm

During harsh midday sun, a polarizer will allow you to photograph the tidal pools that are often teeming with life by cutting through the reflections and revealing all the crazy critters within.

Be aware, however, that a polarizing filter is not magic. There are caveats. For example, you shouldn't use your polarizer with abandon when the sun is low in the sky or you will get weirdly dark patches of sky from many angles (**Figure 25.9**). You also will need to compensate in the direction of overexposing your images because a polarizing filter does cut the amount of light that reaches the sensor. If you buy a cheap polarizer, your image clarity may suffer from increased lens flare and ghosting. You wouldn't wear Crocs with a tuxedo, so don't combine good glass with bad filters.

Sunset is my favorite time of day at the beach—especially if you're facing west—the colors in the sky come alive and the water can reflect the colors beautifully. At sunset I always rely on my graduated neutral density filters. They are amazingly helpful at balancing the differences in brightness above and below the horizon. If you find yourself struggling to get those rich, sexy sunset colors in the sky without totally losing the detail to darkness on land or on the water, then do yourself a favor and experiment with a graduated neutral density filter (**Figure 25.10**). Game changer.

Intentional Composition

Because so much of my travel photography has been beach-centric, I am always searching for new ways to create unique, impactful images. Once you've exhausted the details and classic wide shots from the shoreline, experiment with different perspectives.

I love the opportunity to wade into the water (keep an eye on the approaching waves lest you drown your gear) to shoot from a low angle across the water for a foreground filled with color, pattern, and reflection (**Figure 25.11**). Shooting from a boat can also achieve this perspective with the added difficulty of constant movement from sitting on top of the waves. When you're shooting from a boat, the longer your lens, the more your composition will be affected by the motion from each wave. If you're shooting over 50mm, use faster shutter speeds and try to anticipate the motion as you shoot (**Figure 25.12**).

When shooting from the shore, take advantage of the constant movement of the tides. Play with long shutter speeds to blur the waves for a sense of tranquility, or short ones to freeze the crashing waves and sea spray into an image that embodies power.

Unless you're shooting in a chain of islands, many coastal scenes will feature a fairly flat, smooth horizon. Shake things up a bit—put the horizon at the very top of your frame, or, if you have dramatic skies, at the very bottom (**Figure 25.13**). It's a big misconception that the horizon has to be horizontal in your photos. When carefully composed, an angled horizon can help draw the viewer through the frame (**Figure 25.14**). Push yourself to experiment and explore—your photographs will be stronger for the effort.

25.11 Nail Bay, Virgin Gorda, British Virgin Islands
ISO 100; 1/250 sec.; f/4; 75mm

25.12 Timing is everything when I photograph from a fast ferry in Sir Francis Drake Channel, British Virgin Islands.
ISO 125; 1/6400 sec.; f/5; 150mm

25.13 Sunset from Virgin Gorda, British Virgin Islands
ISO 160; 1/1600 sec.; f/4.5; 28mm

25.14 Spring Bay, Virgin Gorda, British Virgin Islands
ISO 100; 1.6 sec.; f/22; 17mm

26. SNOWBOUND

IN MY HONEST opinion, winter is the worst time of year and cold climates are my personal frigid hell on earth. If the beach is my happy place, a snowbank is my stab-me-through-the-eye-with-an-icicle-because-it-can't-possibly-get-any-worse-than-this worst nightmare. Sadly, I am not yet wealthy enough to spend all winter flying from luxurious tropical paradise to luxurious tropical paradise. Luckily, I was born into an era of down coats, convertible mittens, and toe warmers, so I push past my icy misery, bundle up, and go shoot! Can you feel the enthusiasm? Because I'm trying really hard here.

Gear Selection

The best lens for shooting in cold weather and snow is the most versatile lens. There are technical reasons—I've read that changing lenses in cold weather can potentially lead to condensation and damage to the interior of your camera. For me, the reason to pick a lens and stick with it is much simpler. Cold fingers are less precise and more likely to drop things.

A good zoom lens will give you the greatest flexibility without requiring you to dig in your bag, swap gear, or expose the inside of your camera to the elements. If possible, choose a fairly fast zoom lens. Some of my favorite subjects in the snow are macro shots of frost, icicles, and other snowy details (**Figure 26.1**), so it's helpful to have the ability to shoot with a shallow depth of field. Anything between f/1.8 and f/3.5 can work beautifully. Whatever lens you choose, make sure that your diopter is dialed in so you can accurately focus by hand. Autofocus gets slow and clunky if your camera gets cold enough.

Lens hoods are a must-have snow day accessory. They'll protect the front of the lens from water droplets and falling snow (i.e., fluffy water droplets) and will help prevent any unwanted lens flare caused by sunlight reflecting off snowy surfaces.

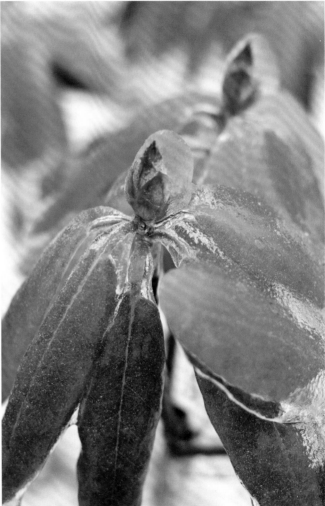

26.1 Rhododendron encased in ice, Paris, Illinois
ISO 250; 1/320 sec.; f/2.8; 50mm

A polarizing filter is a great accessory to carry when shooting snowy scenes in bright sunlight—literally every surface will be painfully reflective, so a polarizer will help bring back the contrast and detail on surfaces and help pop the sky (**Figure 26.2**).

Because I so thoroughly loathe the cold weather, the most important gear considerations for me aren't purely equipment based. My go-to outfit for time spent shooting outdoors involves warm/waterproof boots, multiple pairs of warm socks, leggings, pants, thermal bib overalls, long-sleeved shirt, sweatshirt, down coat, infinity scarf (no ends to get tangled on gear or blow in front of your lens), two hats, and gloves/mittens (usually two pairs). I'm certain this outfit looks goofy as hell, but it allows me to navigate past my wintery angst and stay out for a couple of hours at a time. I like to keep warmers in my pockets so I can keep my fingers from falling off in between shots.

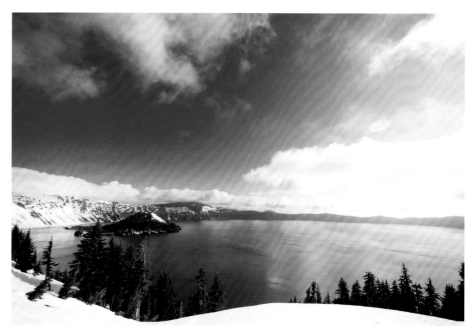

26.2 Crater Lake National Park, Oregon
ISO 160; 1/2000 sec.; f/3.5; 10mm

Special Considerations

The biggest potential source of frustration when photographing in the cold is the temperature. The second biggest potential source of frustration is the camera thinking it's in charge. In very bright scenes—such as a landscape filled with snow—the camera's sensor has a hard time determining accurate settings. More often than not, you'll have to override what your camera believes the best exposure to be. In snowy scenes, I tend to deliberately overexpose by between one and two stops. It seems counterintuitive to make a bright scene even brighter, but in an abundantly snowy scene, the camera has a tendency to underexpose, resulting in very dark images (**Figures 26.3** and **26.4**).

While I generally shoot most landscapes with Auto White Balance and then tweak color later in post-processing (oh, the beauty of shooting RAW), I usually set the white balance manually on snowy days. Very often the camera pushes snow scenes toward a blue cast. Although that can be used effectively in small doses to evoke a feeling of coldness, I usually prefer a warmer look that is closer to how the scene appears in real life (**Figures 26.5** and **26.6**).

Unfortunately, there is no perfect color temperature/white balance that will work across all snowy situations. Be careful to make slight and incremental adjustments to avoid overcorrecting blue snow into yellow snow—and, as I hope you've learned by now, if the snow is yellow, don't eat it.

Because snow is so bright and reflective, you'll generally be able to shoot freely without needing to boost your ISO or slow down your shutter speed to get enough light in your shot. In a heavy snowstorm, you'll be able to freeze the falling snow in place, adding atmosphere to your shots. Consider using a tripod and a slightly longer exposure to capture streaks of falling snow (**Figure 26.7**)—don't keep the shutter open too long or the falling snow won't register in the image.

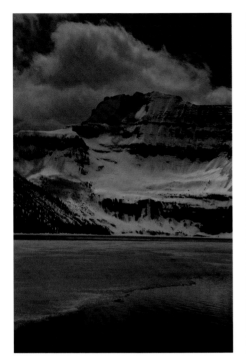

26.3 This shot was perfectly exposed according to the camera. It's much too dark. Waterton Lakes National Park, Alberta, Canada
ISO 125; 1/1250 sec.; f/14; 41mm

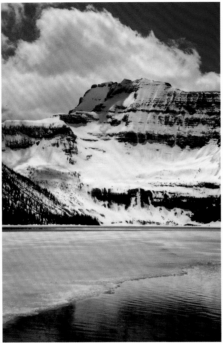

26.4 Here's the same shot with a little Lightroom love. I increased the exposure significantly. Waterton Lakes National Park, Alberta, Canada
ISO 125; 1/1250 sec.; f/14; 41mm

26.7 Because it was snowing heavily and the flakes were really big, I was able to get away with a faster shutter speed. Normally I'd shoot falling snow between 1/80 sec and 1/25 sec. Chicago, Illinois
ISO 125; 1/320 sec.; f/3.2; 50mm

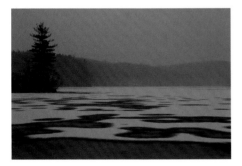

26.5 Here's the shot straight out of camera—underexposed and with a blue cast. Kensico Reservoir, Kensico, New York
ISO 125; 1/125 sec.; f/13; 45mm

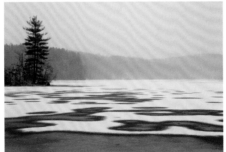

26.6 Same shot with color and exposure correction. Kensico Reservoir, Kensico, New York
ISO 125; 1/125 sec.; f/13; 45mm

Intentional Composition

When you approach snowy landscape, the first thing you should consider is where to walk—or more specifically, where not to. If you're lucky enough to happen upon a fresh, unmarred field of snow, it would be a shame to mess it up by tromping about. Shoot the wide scene first. Exhaust all the full-scene possibilities before trudging in the scene for closeups or detail shots.

If there are other photographers around, remember the golden rule—don't be a jerk. Do the courteous thing and make sure you won't be in their way or mess up their shots by walking into the scene. Unfortunately, many photographers won't be as considerate as you are. Plan ahead. Before a big snowfall, I like to determine where I'll be shooting and show up during or just after the snow stops falling. If there's an overnight snow, I go out at sunrise. Whatever it takes to capture the untouched scene.

Because snow tends to unify the the landscape under a smooth, monotone surface, I like to seek out sources of contrast—like trees, fences, or statues. A well-placed person in a colorful parka can help break up the monotony and make your photos pop. Snowscapes are at their most dramatic when the sun is low in the sky and the shadows are long (**Figure 26.8**).

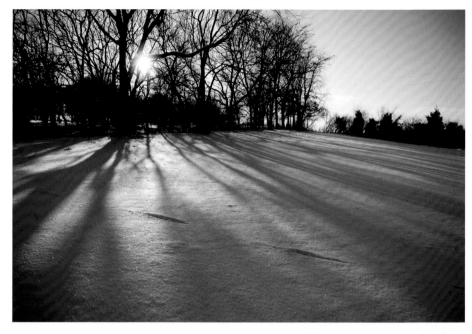

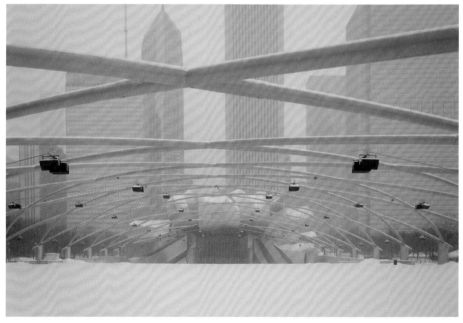

26.8 Paris, Illinois
ISO 200; 1/1250 sec.; f/5.6; 17mm

26.9 Pritzker Pavilion, Chicago, Illinois
ISO 100; 1/100 sec.; f/4; 17mm

If you do go out shooting in the midst of a snowfall, the lighting will likely be even and flat from the cloud cover, so you'll have to rely on subject matter and framing to bring interest to your images. Try visiting a marsh, beach, or forest for more unique snowscapes. Cities will often become totally deserted as people (the smart ones anyway) opt to stay indoors, providing you with the perfect opportunity to capture traditionally busy places under rare peaceful conditions (**Figure 26.9**).

Many types of landscapes lend themselves very well to black-and-white photography, and snowscapes are a prime example. Strong contrasts in natural elements like stark tree branches and abundant negative space can be artfully employed to create dramatic black-and-white photos. While you shoot, pay careful attention to shape, contrast, and detail to ensure that your photographs will look their best when converted to black and white (**Figures 26.10** and **26.11**).

The goal is to deliberately shoot for black-and-white conversion rather than employing grayscale to "save" a blah image. That said, black and white is always a great option if you haven't managed to get out in time for the freshest snow. In cities especially, snow turns brown pretty quickly, so a black-and-white conversion is a good option when the snow isn't looking so fresh.

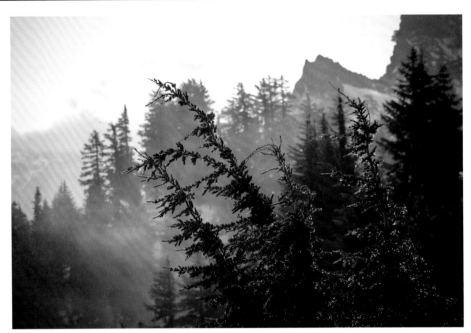

26.10 Crater Lake National Park, Oregon
ISO 160; 1/500 sec.; f/5.6; 75mm

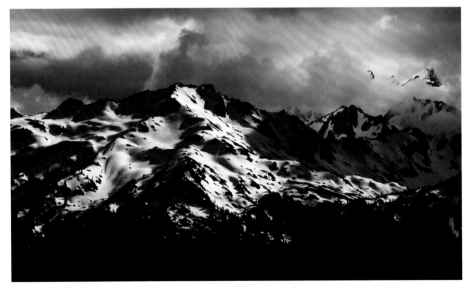

26.11 Hurricane Ridge, Olympic National Park, Washington
ISO 125; 1/125 sec.; f/16; 190mm

27. CROSSING THE DESERT

I WAS SO excited to be able to squeeze in a day trip to White Sands National Monument during my solo travel project, America by Rail. I left El Paso early that morning, picked up my friend Mark in Las Cruces, and we continued on to White Sands, arriving around lunchtime. Our first stop was the visitor's center to get some maps and information about the park. I chatted briefly with a park ranger who, seeing the camera on my shoulder, very pleasantly informed me that I was visiting at the wrong time of day. "You won't get any good shots," she insisted, "the light is too bright. It's all wrong for photography. Come back at sunset."

My first inclination was to trust her at her word. I wanted to kick myself. I had researched this trip like crazy but the only

27.1 My absolute favorite photo from White Sands was taken at "the wrong time of day." White Sands National Monument, New Mexico
ISO 160; 1/3200 sec.; f/4.5; 10mm

27.2 I'm glad I didn't listen to the curmudgeon at the ranger station. White Sands National Monument, New Mexico
ISO 160; 1/5000 sec.; f/4.5; 10mm

27.3 Taken during the "right time of day," this shot is certainly cool, but not my favorite. White Sands National Monument, New Mexico
ISO 160; 1/1600 sec.; f/4.5; 22mm

way I could fit White Sands into my itinerary was to visit in the midday sun. I left the visitor's center deflated as we drove further into the park toward the iconic white dunes. Never one to give up without a fight, I grabbed my gear and decided to go for it and do my best with the time I had there.

I opted for a circular polarizer to help cut the strong reflections off the white sand and bring some color and contrast back into the landscape. After the first few minutes spent getting my settings dialed in, I came to realize that the park ranger was a monumental moron. Was the light harsh? Certainly. Did that preclude all photographic opportunities? Certainly not! Shooting with the sun directly overhead had its challenges, but it also reduced the landscape to more dramatic blocks of color, shape, and form (**Figures 27.1** and **27.2**). It was totally possible to

create beautiful images under those conditions. In fact, when I rearranged some plans so that we could stay at the park through sunset, I found that I preferred shooting that landscape in the midday sun (**Figure 27.3**).

Deserts are full of challenges, but there's no right or wrong way or time of day to photograph them. Explore and attune yourself to the landscape and you'll find all kinds of photographic opportunities. More importantly, don't let the haters get you down.

Gear Selection

As you approach photographing the desert, you'll find that many of the same principles of shooting on the beach or in the snow apply. At midday, the sun will be harsh and reflective on any color of sand. As I just mentioned, my circular polarizer was indispensable for cutting through the glare

and reflected light (**Figure 27.4**), but a graduated neutral density filter could also be very helpful—with one slight adjustment. Instead of placing the shaded portion of the filter above the horizon to darken the sky, try turning the filter 180 degrees to darken the bright sand. Depending on where the sun is in relation to your camera, you may want to experiment with stacking both filters to get the benefits of each. Just keep in mind that you will have to compensate toward overexposure with stacked filters, and some obvious vignetting will occur in the corners of your frame. You can counteract the vignetting by zooming in slightly (with a variable lens) or in post-processing.

Any lens can be used with great success in the desert, whether you shoot wide to capture the full scene or zoom in to focus on details (**Figure 27.5**).

27.4 To get the intense colors and strong contrast in such a reflective setting, I relied on my circular polarizer. The angle of the sun caused some exaggerated color in the sky, which I adjusted in Lightroom. Imperial Sand Dunes, Niland, California
ISO 100; 1/250 sec.; f/6.3; 10mm

27.5 Details in the sandstone. Park Avenue Hiking Trail, Arches National Park, Moab, Utah
ISO 2000; 1/125 sec.; f/11; 30mm

Just remember that sand is your camera's nemesis, so if you do change lenses in the field, be sure to do so carefully and quickly inside your bag.

Heat is likely to be an issue as well. Keep in mind that direct sun on your camera can lead to overheating and increased noise in your images. Leave the lens cap on and drape a lightly colored cloth or microfiber towel over the camera between shots to be safe. If you use a tripod, try to keep the legs fully extended until you're in a less sandy area. Brush them off carefully before collapsing the tripod to avoid trapping sand in the joints.

Special Considerations

Even the slightest breeze can cause the sand to blow and the dunes to change shape. I visited California's Imperial Sand Dunes on a very windy day and was totally enchanted with the way the way grains of sand caught the light as they blew from the crests of the dunes. I was determined to capture this effect in a still photograph, which I quickly discovered is not so easy. Unless you have a lot of movement from the wind (think sandstorm), a longer exposure will blur out the small wisps of movement and they won't show up clearly in the image.

Instead of showing the motion with shutter speed, I positioned myself with the sun at my side so that the sand was blowing from a brightly lit crest of sand dune across the shadowy side of the dune (**Figure 27.6**). The strong sidelight caught the wisps of blowing sand, and they became more visible in contrast against the shadows below them.

27.6 Imperial Sand Dunes, Niland, California
ISO 100; 1/160 sec.; f/14; 300mm

Heat Distortion

Heat distortion, which occurs when heated air rising from a hot surface meets the cooler ambient air, can wreak havoc on your photograph's clarity and your camera's ability to autofocus. The farther you are away from your subject, the more pronounced the heat distortion will be because you are literally shooting through more waves of hot air. If you're shooting in the desert or another hot landscape and are having issues with image sharpness, heat distortion is the likely culprit. Try shooting earlier in the day when the surface of the road or ground is much cooler or move closer to your subject. Unless you like the exaggerated look of wavy vertical lines and soft focus, avoid shooting across hot surfaces like roads or the hood of your car whenever you can.

Strong sidelight is beautiful in the desert. It clearly defines the shapes of the dunes, patterns in the sand, and shadows from any scrubby trees or cacti. For that reason, golden hour is an ideal time to shoot in the desert, but with some creativity, you can make beautiful photographs in full sun. When shooting with the sun overhead, try shooting from a lower perspective toward the sun. Compose images of cacti with strong backlight to catch a fringe of light through the spines (**Figure 27.7**). Deliberately work lens flare into your shot to evoke a sense of heat and brightness (**Figure 27.8**). Want to push the sense of heat even farther? Shoot along a hot road or across a hot desert landscape with a telephoto lens and you'll definitely capture some great atmospheric heat distortion.

Long stretches of deserted desert roads are great to photograph in full sun (**Figure 27.9**). Use a polarizer to cut the reflection off the hot asphalt and take the rare opportunity to stand in the middle of the road. Just keep an eye and ear out for traffic, use a spotter if possible, and please don't get smashed because it would ruin your photograph.

Share Your Best Desert Photo!

Once you've captured your best image featuring the desert landscape, share it with the *Enthusiast's Guide* community! Follow @EnthusiastsGuides and post your image to Instagram with the hashtag *#EGDesertTravel.* Don't forget that you can also search that same hashtag to view all the posts and be inspired by what others are shooting.

27.7 Saguaro National Park, Tucson, Arizona
ISO 100; 1/250 sec.; f/6.3; 10mm

27.8 Imperial Sand Dunes, Niland, California
ISO 100; 1/200 sec.; f/6.3; 22mm

27.9 Kofa National Wildlife Refuge, Yuma, Arizona
ISO 100; 1/400 sec.; f/3.5; 10mm

Intentional Composition

If you crave gorgeous negative space, then the desert is the place for you. The desert's lack of water often means an inherent lack of clouds, so the skies will be wide open for silhouettes, stark contrasts, and clear, blue negative space (**Figure 27.10**). Even if the focus of your image isn't the negative space, the smooth openness of the sky will serve as a nice contrast against heavily textured sand dunes or a landscape filled with scrubby brush.

Pay careful attention to the details so you can use them to your advantage and avoid any potential pitfalls. For example, footprints show up just as clearly in sand dunes as they do in the snow. Think about your photographic ambitions at a site before you go tromping around marring an untouched surface. Stay off the most dramatic sand dunes so they remain intact for your shots (**Figure 27.11**). Though human footprints can look sloppy in an image, I always search the ground around me for signs of other visitors on a smaller scale—lizards and snakes leave very uniquely patterned tracks that can make a really interesting abstract shot (**Figure 27.12**).

27.10 Park Avenue Hiking Trail, Arches National Park, Moab, Utah
ISO 400; 1/160 sec.; f/13; 53mm

27.11 Behold, the glorious lack of footprints. Imperial Sand Dunes, Niland, California
ISO 400; 1/4000 sec.; f/4.5; 18mm

27.12 Mystery critter prints. Arches National Park, Moab, Utah
ISO 1600; 1/160 sec.; f/13; 22mm

Other details to consider are the ripples in the sand and strata in rock around you. These can serve as wonderful leading lines (**Figure 27.13**) or as the subjects themselves (**Figures 27.14** and **27.15**). The cracked earth of a dried riverbed provides a totally different kind of desert texture opportunity (**Figure 27.16**). Keep your eyes open for the millions of small components that make up the scene, and your collection of images will be more representative of the full desert experience.

27.13 Sandstone strata. Corona Arch, Moab, Arizona
ISO 1250; 1/160 sec.; f/13; 18mm

27.14 Imperial Sand Dunes, Niland, California
ISO 100; 1/100 sec.; f/14; 300mm

27.15 White Sands National Monument, New Mexico
ISO 160; 1/5000 sec.; f/4.5; 18mm

27.16 Badlands National Park, South Dakota
ISO 125; 1/400 sec.; f/5.6; 30mm

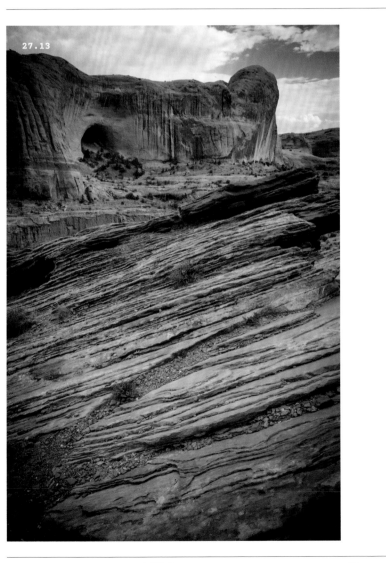

28. MOUNTAIN'S MAJESTY

FOR ME, THE Elation of the Landscape is most clearly felt in the mountains. I'm not totally sure when I first experienced mountains in person, but I do remember examining a specific photo on the cover of a cassette tape over and over again. The photo showed a range of mountains stretching into the distance with what has come to be one of my absolute favorite visual effects: atmospheric perspective. I also remember the first time I stood on the highest point for miles and watched the shadows of the clouds slide across the rolling landscape. The way the light changed from moment to moment in the valley below me was totally entrancing. I think those mountain-based influences were what set me on the path to becoming a photographer, so I often make an effort to include them in my images.

Gear Selection

So you've traveled to a breathtaking mountain range. The air is clear, the views are epic, and your camera is ready. How do you begin to capture such a massive scene? Examine the landscape before you. Are you on the very edge of the precipice, or is there a foreground ready and willing to provide the foundation for your photo?

In situations with very little foreground, I prefer to jump right into a longer lens and find nuanced images with tighter crops of distant peaks (**Figure 28.1**). Find the patterns

and details that best sum up the majesty of what lies before you. Set your camera on a tripod and experiment with slight adjustments in direction or focal length. Just remember that mountaintops are generally very windy, so plan to weigh your tripod down with your backpack if possible, or keep a firm grip on it at all times to get the sharpest photos and avoid potential equipment tragedies.

If I'm standing farther back from the edge, or have another peak relatively close to help span the gap to the distant mountains, I often shoot with a wider lens. Allow the foreground and any trees in that area to help create a frame for the distant view (**Figures 28.2** and **28.3**). Pay careful attention to the foreground, the middle ground, and the background of the image to make sure you aren't wasting any valuable photographic real estate. Search for man-made elements, people, or animals that can help provide a sense of scale for the scene (**Figure 28.4**).

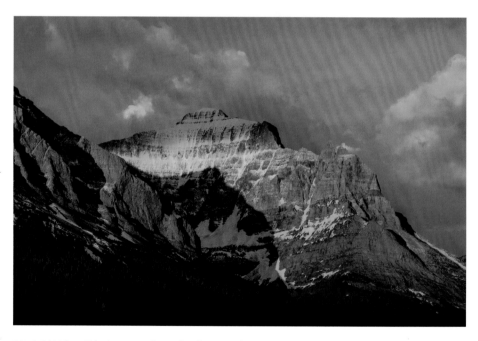

28.1 Little Chief Mountain, Glacier National Park, Montana
ISO 400; 1/80 sec.; f/9; 50mm

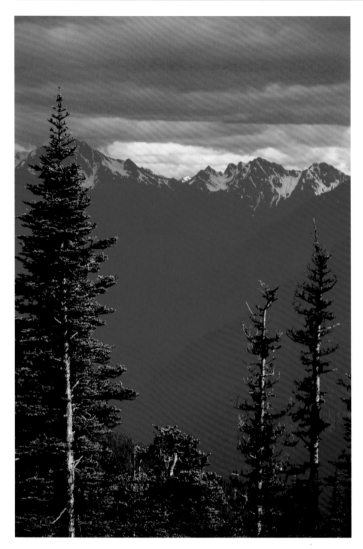

28.2 Olympic National Park, Washington
ISO 400; 1/125 sec.; f/18; 130mm

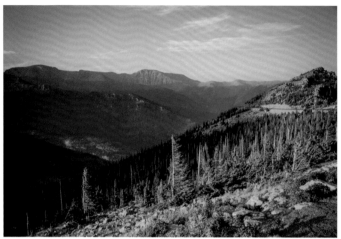

28.3 Rocky Mountain National Park, Colorado
ISO 100; 1/320 sec.; f/4.5; 20mm

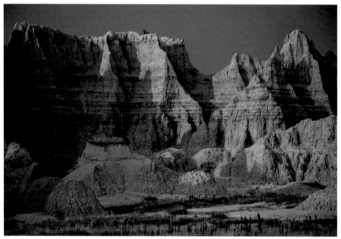

28.4 Two bighorn sheep provide scale for these rock
formations in the Badlands, South Dakota.
ISO 100; 1/320 sec.; f/5.6; 85mm

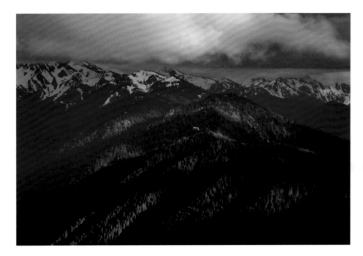

28.5 Hurricane Ridge, Olympic National Park, Washington
ISO 1600; 1/160 sec.; f/32; 85mm

28.6 Mesa Arch, Canyonlands National Park, Moab, Utah
ISO 2500; 1/160 sec.; f/16; 18mm

Special Considerations

Because the weather in the mountains changes so frequently, you'll likely have to make regular adjustments to your settings. As clouds blow into your scene, recheck your metering settings to be sure you aren't accidentally over- or underexposing your shots. Mountains are very contrasty, often filled with deep shadows and the bright reflections of snowy peaks, so expose for the middle and bracket if you're worried about losing details in the highlights or shadows.

In a particularly difficult lighting scenario, such as a brightly lit lenticular cloud over a mountaintop, I'll deliberately underexpose a bit to be sure I captured the full gradient of whites in the cloud. In my experience, it's much easier in post-processing to bring detail back to the shadows than in blown-out highlights, and my favorite characteristics of clouds are the textures and nuances.

A sunrise or sunset in the mountains is beauty in the extreme, but altitude issues and obstructions can severely limit duration and intensity of color. Do your research ahead of time so you can figure out exactly where and when the sun will rise or set. Remember that solar timetables will be based on when the sun breaks the horizon rather than when the sun is visible up in the mountains.

Well ahead of sunset but during the golden hour, seek out interesting side light conditions. Strong side light in the mountains can create unique patterns and draw out the dimensions of the mountains in ways you might not otherwise notice (**Figure 28.5**). As the sun begins to dip further out of sight, focus your energy and attention on the moment when the sun is just about to disappear behind a distant peak. That's when the light will be at its most dramatic. Shadows will be cast, colors will change, and if you shoot toward the sun at somewhere around an f/16 or narrower you'll be able to capture beautiful starburst effects (**Figure 28.6**). Keep in mind that anytime you shoot into the sun the rest of the landscape will be thrown into underexposure. Graduated neutral density filters can be tricky to use when the visible horizon isn't a straight line, so pay close attention to your results as you shoot and bracket as needed.

Intentional Composition

One happy side effect of elevation is the presence of waterfalls, so any trip to the mountains will likely offer waterfall photography opportunities as well. Waterfalls could very well be their own lesson, but because many of the principles are the same when shooting waterfalls as shooting at the beach, I'll skip to the key points:

- Use a neutral density filter and a tripod to slow your shutter speed and achieve the white flowing water effect.
- The closer to the water you are, the more compelling your image will be. I regularly stand in the middle of streams and slow(ish) rivers to shoot waterfalls.

- Check the front of your lens periodically for water drops—they can be Photoshopped out, but they're a pain in the butt you can easily avoid.

Sometimes waterfalls will be far off the beaten path and will require some work to reach (**Figure 28.7**). Other times you'll find yourself gazing across a valley and see a massive beautiful waterfall on the peak opposite you (**Figure 28.8**). Either way, they are well worth the effort and are a valuable part of the mountain photography experience.

In any mountain range, my favorite photographs contain a condition that I briefly mentioned earlier in the lesson. I've heard it referred to as atmospheric perspective and aerial perspective, but the title that photographer John Hedgecoe gave it is my favorite and perhaps the most descriptive: receding layers of tone (**Figure 28.9**). Think about the romantic vistas of the Hudson River School artists and you'll have the perfect example of distance perceived as a gradient of color. The effect is breathtaking, and it is the easiest way to harness the majesty of the mountains in a photograph.

28.7 The hike to Weisendanger Falls in the Columbia River Gorge involves eleven switchbacks with an elevation change of 700 feet. Tiring, but worth it. Hood River, Oregon
ISO 100; 4 sec.; f/29; 21mm

28.8 Waterton Lakes National Park, Alberta, Canada
ISO 125; 1/160 sec.; f/6.3; 85mm

28.9 Hollywood Hills, Los Angeles, California
ISO 100; 1/165 sec.; f/5.6; 250mm

Receding layers of tone can be captured under most lighting conditions and with any lens. They don't require any special settings or gear, and only require that you notice them and find a way to effectively frame them in your image. They look equally beautiful in color as they do in black and white. They can be a single component of a larger image, or the subject of the image itself (**Figures 28.10** and **28.11**). By any name, they will elevate your photographs and help demonstrate the full beauty of the mountainous landscape.

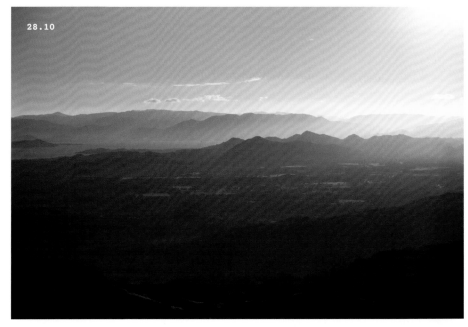

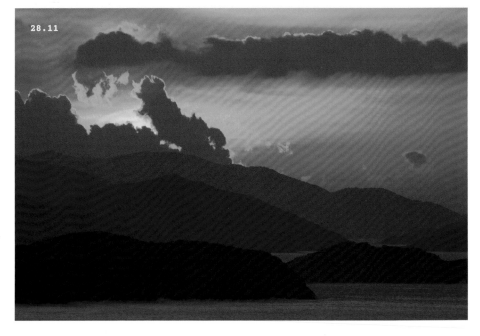

28.10 Monteverde, Costa Rica
ISO 100; 1/2000 sec.; f/5.6; 85mm

28.11 The western view from Virgin Gorda, British Virgin Islands
ISO 100; 1/80 sec.; f/8; 290mm

29. THE GREAT WIDE EMPTY

WHEN MY HUSBAND and I moved back to his hometown in the Midwest, I quickly discovered that I felt out of place in the vast monotony of the prairie landscape. The term "flyover country" suddenly made a lot of sense. We would drive for miles in a straight line and the view wouldn't change at all. Being used to the topography of the Northeast, I preferred a more erratic landscape—larger swaths of woods with hills or mountains. Anything to break up the view a bit.

I did enjoy summer nights surrounded by fireflies or fall mornings once the fields of soy had turned silver and gold, but winter was a rude awakening as the dominant color wilted into the browns of dead grass, cut crops, and bare branches. Next came the gigantic blanket of white after the first big snowfall reflecting an unending white overcast sky above it. Naturally, I felt uninspired and fell into a creative lurch. It wasn't until the arrival of the intense spring storms that I learned just how beautiful the prairie can be. I fell in love with enormous cloud walls, sudden hailstorms, wildflowers, and constantly changing intense light—the prairie was reinvigorated and offered epic photographic opportunities in every direction.

When spring turned to summer and we began the cycle of seasons in my second year in the Midwest, I knew where to look to find the interesting and the beautiful. Not every wide-open vista can get your creative juices flowing. The "Great Wide Empty," as I've come to call it, is one of the more challenging landscapes to shoot, but if you know what to look for you'll be well on your way to finding the beauty in it.

Gear Selection

Although any lens can work well for shooting a flat, open landscape, the vastness of the prairie is its most iconic feature and a wide-angle lens will highlight that quality most effectively. I often shoot in the 10–20mm range, but with such a wide lens, you have to make sure that you are purposefully filling the frame and avoiding too much dead space (**Figure 29.1**). That may feel difficult at first—a wide-open scene with a wide lens can make it difficult to identify a specific subject in an image. Your photos may feel more like an unfocused, uninteresting snapshot, but with practice and intent you'll get the hang of shooting wide.

Next, try using a telephoto lens to crop down on the landscape. Find an area with interesting light, or a clear subject and reduce the world to your frame (**Figure 29.2**). You don't always need to have a horizon. In fact, if you can get up in the air to shoot—like from a tall building, a grain elevator, or an overpass—you can create beautiful abstract studies of the landscape.

Special Considerations

In the prairie, you can successfully employ a full range of apertures. Typically, you'll be able to see for miles. Capture the vast depth of the scene with a narrower aperture, anywhere between f/11 to f/22 (**Figure 29.3**). Just remember that a lens's most extreme apertures are typically the least sharp. You can easily look online to find which aperture will be sharpest for each of your lenses or just focus on the the middle range of available apertures for your lens. To ensure that most of the landscape (from the foreground on) will be in focus, focus on something one third into the depth of the landscape.

Whenever possible, I like to keep my ISO below 800—noise is my biggest pet peeve—so when I'm shooting at something like f/11 or f/22 I rely on a tripod to make sure I'm getting the the crispest shot regardless of shutter speed. With a tripod and slower shutter speed, you can start to capture the slight movements in the crops from wind (**Figure 29.4**), which can add interest and energy to your photos.

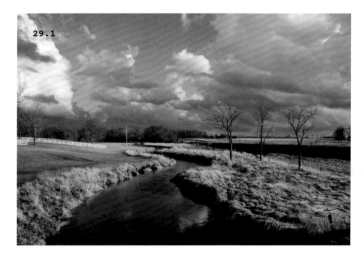

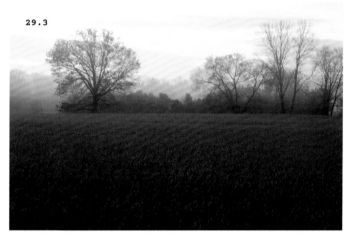

29.1 Paris, Illinois
ISO 100; 1/125 sec.; f/11; 22mm

29.2 Paris, Illinois
ISO 640; 1/80 sec.; f/5.6; 41mm

29.3 My former backyard, Paris, Illinois
ISO 100; 1/25 sec.; f/11; 41mm

29.4 Edgar County, Illinois
ISO 100; 0.3 sec.; f/32; 85mm

For a shallower depth of field, get closer to your subject and use a wider aperture between f/1.4 and f/4. You can imply depth and distance by allowing the areas in the background of your image to fall out of focus. The easiest example of this is shooting in a field of crops. The repeating patterns can help define your shot and imply a vast distance with no discernible endpoint. Focus on the closer plants and shoot along a neat row of crops, or over the tops of a field of wildflowers (**Figure 29.5**).

Intentional Composition

As most prairie landscapes will feature a very flat, even horizon, it's imperative that you deliberately create dimensionality and interest in your images. Find ways to break up the monotony of the landscape with a well-placed barn, stand of trees, or a river (**Figure 29.6**). Set the subject as a receding row of power-lines or fence posts. Utilize converging train tracks to demonstrate the distance and draw you through the image (**Figures 29.7** and **29.8**). Endeavor to make the flatness and visibility a strength in your photographs.

For a long time I kept my photographs in their original aspect ratio. I put constant work into making the scene fit into the 2:3 frame shape of my crop sensor camera. I always felt like I was butchering my images by printing to fit a standard frame size or to post on Instagram back when you were locked into a square format. Then Bill Ellzey, a photographer whose work I greatly admire, told me that he believed it was silly to force a scene into the ratio that your camera happens to be. He shoots for the image he envisions, planning the crop points at the time of shooting.

Bill helped me understand that not every image will look best as a perfect rectangle. You have to make the adjustments to your photographs that allow them to stand on their own. Sometimes that means shooting with the plan of cutting down the sky or trimming the sides. Ratios be damned—just get the shot that works.

This idea will become abundantly clear to you on a day on the prairie with a boring empty or overcast sky. To capture the width of the scene, you shouldn't have to be locked into the height as well. You can achieve the full width by making a panorama, but if you're not concerned with extreme resolution shoot the land so it works for you and crop the sky down in post-processing (**Figure 29.9**).

29.5 Paris, Illinois
ISO 100; 1/160 sec.; f/3.5; 10mm

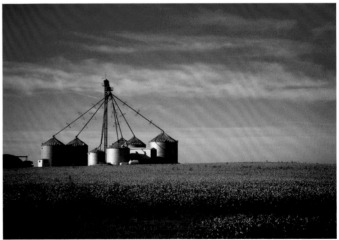

29.6 Dudley, Illinois
ISO 100; 1/800 sec.; f/5.6; 50mm

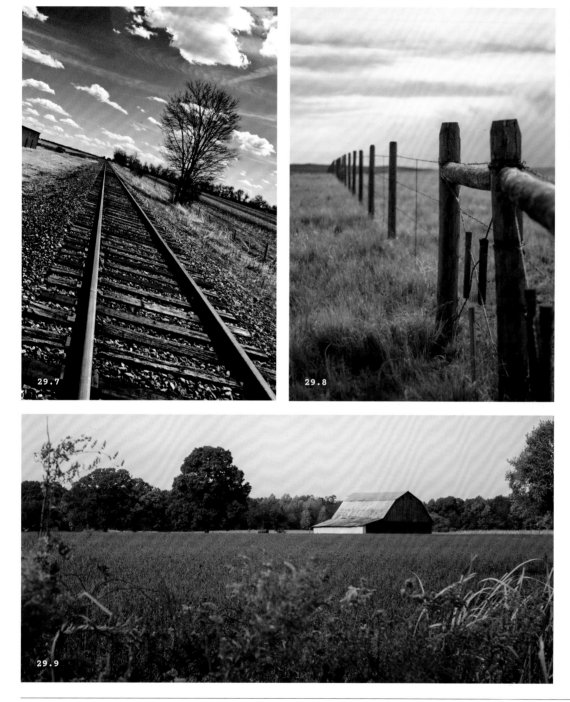

29.7 Paris, Illinois
ISO 125; 1/500 sec.;
f/7.1; 26mm

29.8 Browning, Montana
ISO 100; 1/5000 sec.;
f/1.8; 50mm

29.9 Charleston,
Illinois
ISO 160; 1/1250 sec.;
f/5.6; 50mm

Finally, one of the greatest benefits of the Great Wide Empty is excellent visibility for sunrises and sunsets. The sun stays with you for longer than in the mountains, and if you're lucky enough to shoot during harvest season, the dust in the air will amplify the colors and give you a hell of a show (**Figures 29.10** and **29.11**). Find a location with an interesting subject to silhouette or help ground the image and enjoy the view.

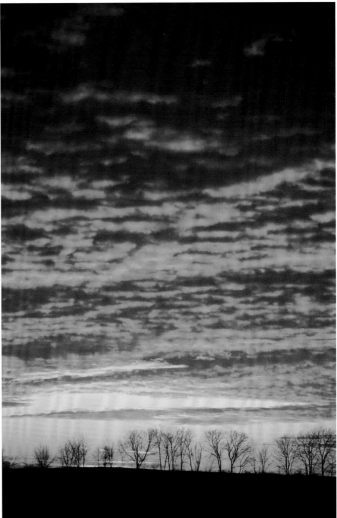

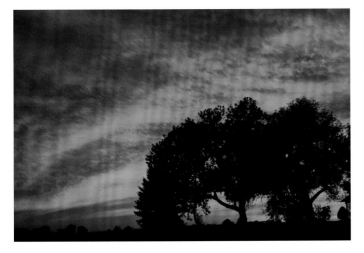

29.10 Paris, Illinois
ISO 500; 1/200 sec.; f/5; 35mm

29.11 Paris, Illinois
ISO 500; 1/320 sec.; f/5.6; 85mm

5

FIND THE DETAILS

CHAPTER 5

As you travel, what often stands out most during your experience and in your memories are the obvious—the castles, the cathedrals, the canyons, and the cliffs. These are the big attractions, the icons that take your breath away. Now, think back on your favorite journeys and focus on the little things that collectively helped shape your experience—colorful murals on walls, the unique regional fabrics and textiles, bright mosaic floors, or the abundant local flowers. These are the vital details that help embody culture and define sense of place. Focus your camera toward these elements and you'll discover that they are far from trivialities. They are the spices that flavor your experience.

30. TEXTURES AND PATTERNS

LOOK AT A photograph with an interesting texture and it might give you the impulse to touch it. Examine a photograph filled with pattern, and your brain may start to extrapolate that pattern or perceive movement in it. Both sensations are common and heighten the connection between photograph and viewer. We have an innate level of comfort with what we can touch and visually understand, so images with texture and pattern draw us in and make us pay attention.

Photographically, textures and patterns are one and the same. If I asked you to think of a distinct pattern, you might imagine plaid, checkerboard, or paisley. If I then asked you to think of a distinct texture, you might imagine sandpaper, tree bark, or velvet. You can imagine not only how each of those textures look, but how they would feel under your fingers because you've probably touched them before. Yet in a photograph, texture is relegated to a single flat dimension. You wouldn't touch a photo of velvet and expect it to feel like velvet. You expect it to feel like a sheet of paper or the screen of your computer. Because of that lack of dimensionality, you can expect to photograph textures and patterns in much the same way—the only variations exist in scale and regularity. To that end, I *would* suggest that we move forward referring to textures and patterns as the combined term "pattexturns" (I just came up with that right now), but that feels a little ridiculous so I'm going to refer to them simply as Patterns (with a capital P) and you'll know I mean both.

Regardless of where your journeys take you, you'll find that Patterns are universal. They appear throughout history, across cultures, in religious and secular art, in the natural, and in the man-made. By building photographs around Patterns as the subject, you'll add a new depth to your travel photography and engage your viewer in a new way.

The Ideal Lens

When photographing Patterns, gear is probably the least important part of the equation. Patterns as a subject won't dictate what lens to use—instead you'll find yourself choosing a lens based on the scale of that particular Pattern. If you wanted to photograph the Pattern of sandpaper, you'd need to use a macro lens or even a microscope to draw out the dimensionality of the grain. If you wanted to photograph the Pattern of a dry riverbed, you could use any lens from a wide angle to a telephoto depending on the scale you were trying to show (**Figure 30.1**).

If you wanted to photograph the Pattern of a mountain range, or the repeating Pattern of waves cresting across a coral formation from above (**Figure 30.2**), you would best isolate the landscape to the area of the Pattern with a longer focal length. Determine which lens to use by deciding what the boundaries of your frame should be to most effectively highlight the Pattern before you. Try out multiple options. See what works for you.

30.1 Toadstool Geologic Park, Harrison, Nebraska
`ISO 125; 1/1600 sec.; f/7.1; 28mm`

30.2 Virgin Gorda, British Virgin Islands
ISO 100; 1/250 sec.; f/5.6; 85mm

Angle and Perspective

Many times, the most obvious or comprehensive view of a Pattern is the overhead, or flat, frontal view. When photographing floor tiles, cobblestones, a brick wall, or peeling paint, you'll get the best sense of the overall Pattern when the front of the lens is parallel to the Patterned surface (**Figures 30.3** through **30.5**). From this perspective, it should be relatively easy to get the full Pattern in crisp focus regardless of the aperture and resulting depth of field (DOF).

Things get considerably more interesting when you shoot a Patterned surface from an angle. Moving the front of the lens to a 45- or 90-degree angle from the surface can instantly produce a more dynamic image by creating greater perspective (**Figure 30.6**). Angled shots will help draw out dimensionality (**Figure 30.7**), a sense of endless repetition (**Figure 30.8**), and perspective through converging lines (**Figure 30.9**).

When shooting Patterns from an angle, you can either keep the full depth of the image and Pattern in focus using a narrower aperture in the range of f/8 to f/22 (**Figure 30.10**) or imply the continuation of Pattern through the depth of the image with a shallower depth of field by way of a wider aperture like f/1.4 or f/2.8 (**Figure 30.11**).

30.3 Mosaic Tiles, Temple Emanu-El, New York
ISO 640; 1/60 sec.; f/2.8; 50mm

30.4 Chicago, Illinois
ISO 400; 1/100 sec.; f/5.6; 79mm

30.5 New Orleans, Louisiana
ISO 100; 1/160 sec.; f/5; 41mm

30.6 Marvao, Portugal
ISO 2000; 1/160 sec.; f/5.6; 85mm

30.7 National Portrait Gallery,
Washington, DC
ISO 100; 1/125 sec.; f/5.6; 85mm

30.8 Forest Hills, New York
ISO 400; 1/60 sec.; f/1.7; 50mm

30.9 Met Breuer, New York, New York
ISO 2500; 1/125 sec.; f/7.1; 18mm

30.10 Indianapolis, Indiana
ISO 200; 1/100 sec.; f/10; 73mm

30.11 Minneapolis, Minnesota
ISO 100; 1/200 sec.; f/4.5; 22mm

Varieties of Pattern

Mathematically, a Pattern is the exact replication of a value, or a formula. Patterns require rules and exactitude. In art, the concept of Pattern is much broader and encompasses three distinct categories: Repetition (one object repeated over and over), Motif (a recurrence of multiple objects or elements in a predictable order), and Rhythm (a recurrence of multiple objects or elements in a varied or unpredictable order). For artistic purposes, the key is to recognize that Repetition (**Figure 30.12**), Motif (**Figure 30.13**), and Rhythm (**Figure 30.14**) are equally important for creating compelling images.

Fortunately for me, the dropper of calculus and flunker of statistics, this isn't math. We're seeking beauty, not exactitude. Search for Repetition, Motif, and Rhythm in the world around you and you'll certainly find beauty across any photographic genre from architecture to nature photography. Once you begin to see Pattern everywhere, experiment with interesting ways to frame and highlight it.

30.12 Santa Monica Pier, Santa Monica, California
ISO 100; 1/160 sec.; f/2.8; 50mm

30.13 Los Angeles, California
ISO 500; 1/30 sec.; f/3.5; 20mm

30.14 Michigan Avenue, Chicago, Illinois
ISO 160; 1/1000 sec.; f/3.5; 20mm

You can frame an image to highlight a break in Pattern (**Figure 30.15**), focus on Patterns or conflicting Patterns that seem to move, vibrate, or disorient (**Figure 30.16**), or utilize Pattern to create a sense of harmony or dissonance. Patterns with leading or converging lines can demonstrate to viewers how you want them to move through the image. Patterns can present a new way of looking at something that many would dismiss as ordinary (**Figure 30.17**). They exist in light and shadow (**Figure 30.18**) and often feature important cultural motifs that will help support a sense of place in your images (**Figure 30.19**).

30.15 One open window breaks the repetition. New Orleans, Louisiana
ISO 400; 1/100 sec.; f/4.5; 20mm

30.16 Granada, Nicaragua
ISO 160; 1/125 sec.; f/5.6; 85mm

30.17 Hailstones on a glass table, Paris, Illinois
ISO 100; 1/250 sec.; f/3.5; 50mm

30.18 Santa Monica, California
ISO 125; 1/1600 sec.; f/7.1; 28mm

30.19 Ronda, Spain
ISO 100; 1/400 sec.; f/5.6; 85mm

31. MACRO AND FLORAL

MACRO PHOTOGRAPHY IS typically defined as an image where a small subject is represented larger than actual size (2:1), though 1:2 or 1:1 representation is often considered macro as well. Without focusing too much on the nitty-gritty way that macro scale is determined (it has to do with the distance to the subject, the size of your subject, the size of your sensor, and other horrific math-based concepts), I think we can agree that sometimes the most engaging photographic subjects come in miniscule form.

Macro and floral photography are extremely similar, so this lesson will apply to both subjects. Whether you're seeking to highlight the tiniest lizard of the Costa Rican jungle or the delicate cherry blossoms of Japan, macro photography techniques are an important addition to a travel photographer's arsenal.

Gear and Accessories

You can find a variety of options on the market to help you achieve the visual enlargement of your subject. Many zoom lenses advertise that they can be used for macro, and in many situations they certainly can be, though it's rare to find a zoom lens that will offer 1:1 magnification. I have used a zoom lens quite effectively with tiny subjects—especially subjects that you can't get particularly close to (**Figure 31.1**)—but have had far more success with prime lenses offering a very close focusing distance.

There are quite a few inexpensive lenses on the market that will work admirably on their own for macro photography (**Figure 31.2**), such as Canon's inexpensive 50mm 1.8, or 40mm 2.8, which each cost under $200 and are versatile lenses for many non-macro scenarios as well.

If you are hoping to adapt your current lens inventory to work well in macro situations, you have a variety of options. An extension tube is a useful accessory for many travel scenarios (**Figure 31.3**). It is attached between the camera body and the lens, and it allows the lens to focus closer and obtain an increased magnification.

Extension tubes are relatively inexpensive and are available in a variety of magnification levels. Many have electronic connections that will allow your camera to continue managing the focusing and aperture adjustment features. If you purchase an extension tube without electronic connections (much less expensive), you will want to use a lens with a manual aperture ring or accept being locked into shooting at the widest aperture offered by your lens. There is some light loss with extension tubes, so plan to adjust your shutter speed or ISO accordingly. Despite these small inconveniences, extension tubes can have beautiful results for macro photography and are well worth investigating (**Figure 31.4**).

Another option is a magnification filter. Also referred to as "closeup lenses," these are screwed on to the front element of your lens and are a lot like a magnifying glass. Magnifying filters will often have increased distortion and chromatic aberration because you're introducing another piece of curved glass to the mix, but they can still have pleasing results (**Figure 31.5**). When you first screw on the filter, if you're having trouble getting it to focus, try moving much closer to your subject—closer than you would expect... potentially closer than you feel comfortable with. Keep in mind that you'll need to shoot with a narrower aperture in order to keep more than a sliver of your subject in focus.

31.1 Ometepe, Nicaragua
ISO 1600; 1/160 sec.; f/6.3; 142mm

31.2 Garfield Park Conservatory, Chicago, Illinois
ISO 100; 1/1250 sec.; f/3.2; 50mm

31.3 Vivitar Extension Tube

31.4 Plumeria, Virgin Gorda, British Virgin Islands
ISO 100; 1/5000 sec.; f/1.8; 100mm

31.5 Chicago Botanic
Garden, Glencoe, Illinois
**ISO 500; 1/250 sec.;
f/3.5; 50mm**

Refining Your Technique

When I shoot macro, I have a few specific techniques and settings that I frequently use. These are my personal best practices that I've come to rely on.

- **Focusing:** Focus manually or you'll set up a macro shot and have your AF fight with you and jump around through the image. In macro, AF is frustrating AF.
- **Tripod:** When possible, use one. Tripods allow you to play with your settings while maintaining your composition until you get the shot just right. A tripod will also let you play with focus stacking (taking multiple shots with varied points of focus to be combined in post-processing for a completely in-focus shot at even the widest apertures).
- **Depth of field:** When it comes to macro, aperture isn't the only thing that affects your DOF. Using a longer lens will result in a shallower DOF. Moving the lens closer to the subject will result in a shallower DOF. Shallow DOF in other photographic applications can often refer to a matter of feet, but with macro, shallow DOF is often a matter of millimeters. To keep more of your subject in focus, shoot at an f/8 or narrower (**Figure 31.6**).
- **Lighting:** I prefer even lighting for macro and floral photography. If the lighting is far from even, consider using a fabric diffuser or a ring flash.
- **Wind:** Wind is a macro photographer's worst enemy. The slightest breeze can move your subject out of range or out of focus. To combat this issue, you can purchase special clamps to help hold flowers and leaves in place when shooting, or block the wind as much as possible with your body and shoot with a faster shutter speed.

Composing the Image

Even with the tiniest subjects, the usual compositional concepts apply. Fill the frame with intention, paying attention to each corner and cropping out distractions. If your subject is less than exciting in extreme closeup, consider adjusting the light to make it more dynamic. Backlight is beautiful for making flower petals glow and pop (**Figure 31.7**). Not only will the early hours of the day often provide gorgeous backlight opportunities, but the presence of dew will add beauty and interest to your photos. In the absence of dew, you can always use a spray bottle to get some water drops involved; just try not to leave water droplets on leaves or flowers in the bright sun because they can magnify the light and burn the plant.

31.6 Dragonfly, Cape Cod, Massachusetts
ISO 400; 1/640 sec.; f/9; 300mm

31.7 Falmouth, Massachusetts
ISO 400; 1/4,000 sec.; f/5, 180mm

31.8

One of my favorite techniques in macro and floral photography is to fill the frame by showing only a portion of the subject (**Figure 31.8**). This shifts it from another "oh, look, a flower" shot to a "wow, look at the elegant curve of those stamens" (I promise that sounded less creepy in my head). While you're shooting, consider the shape and form of your subject and how it might look in black and white. Try limiting your DOF and underexposing to throw out-of-focus areas into shadow for a moody and unique macro (**Figure 31.9**).

Just remember that the minutiae of a location are just one portion of the travel story you're trying to tell, and be sure to provide wider contextual shots of your subject as well.

31.8 Sea fan, Virgin Gorda, British Virgin Islands
ISO 100; 1/3200 sec.; f/64; 15mm

31.9 Paris, Illinois
ISO 100; 1/2000 sec.; f/2.8; 24mm

31.9

32. SEE THE ABSTRACT

When we travel, so much of our photographic focus lies in providing information to the viewer. We shoot to explain, to draw parallels, and to make the foreign accessible. In abstract photography, we seek the opposite. We shoot to inspire questions, to confound the viewer, to isolate from context. Abstractions help us look past the obvious subject or idea to find beauty and form in the ordinary. Abstractions keep us guessing.

As you travel, you'll be exposed to an endless collection of new subject material for abstract photography. Anything in the world, from nature to architecture, can be made abstract. Keep your eyes open, and explore the fringes and the negative space for unique juxtaposition, line, shadow, shape, and lighting.

Where to Start?

Abstract photography is one photographic pursuit that relies minimally on gear. Some of my favorite abstract photographs were taken with my phone on a whim when I noticed something unique and interesting (**Figures 32.1** and **32.2**). You can use any camera and any lens to take abstract photos, but some lenses may work better than others, depending on the size and scope of the photograph you have in mind.

A zoom lens can be helpful to create abstracts of architecture (**Figure 32.3**) or from nature (**Figure 32.4**) by zooming in on a compelling shape or form. A longer focal length will allow you to selectively crop to remove the subject's context or nearby distractions. Similarly, macro lenses can help isolate abstractions when your subject is already quite small (**Figure 32.5**). You can make practically any lens work. When it comes to seeing the abstract, your vision and creativity are much more important than equipment.

32.1 Hotel lamp, Port Angeles, Washington
Cell phone photo

32.2 Restaurant bathroom tiles, Madrid, Spain
Cell phone photo

32.3 Chicago, Illinois
ISO 100; 1/160 sec.; f/9; 119mm

32.4 Turkey Run State Park, Marshall, Indiana
ISO 250; 1/160 sec.; f/6.3; 210mm

32.5 Barricade reflector, New York, New York
ISO 400; 1/1250 sec.; f/5.6; 85mm

Share Your Best Abstract Photo!

Once you've captured your best abstract image, share it with the *Enthusiast's Guide* community! Follow @EnthusiastsGuides and post your image to Instagram with the hashtag *#EGAbstract*. Don't forget that you can also search that same hashtag to view all the posts and be inspired by what others are shooting.

Varieties of Abstraction

Experimentation is the best way to get comfortable with creating abstracts. When you travel, all the little details that differ from what you're used to will jump out at you. When something catches your attention, play around with any of these techniques to make compelling abstract photos:

- **Abstraction by size or perspective:** Make something huge look small, make something tiny seem enormous. If you're used to looking down at it, try photographing from a bug's-eye view.

- **Abstraction by movement:** Play with exposures longer than 1/60 while panning or zooming to capture a little blur (**Figure 32.6**) or crazy streaks of motion (**Figure 32.7**). If your shutter speed is fast enough, some subjects may remain identifiable, but things can still seem quite abstract with just a hint of motion.

- **Abstraction by isolation:** Take something totally out of its context. Use the edges of your frame or your depth of field to limit the viewer's insights. This works well with architecture or other man-made objects (**Figure 32.8**).

32.6 Scarsdale, New York
ISO 320; 1/6 sec.; f/5.6; 85mm

32.7 Wilmette, Illinois
ISO 100; 0.6 sec.; f/22; 85mm

32.8 A portion of a statue on a bookcase, Norfolk, Virginia
ISO 800; 1/500 sec.; f/8; 170mm

32.9 Chicago, Illinois
ISO 400; 1/6400 sec.; f/5.6; 47mm

- **Abstraction by reflection:** Reflective surfaces can beautifully distort the normal into the unique and interesting (**Figure 32.9**). Try photographing reflections on smooth surfaces like glass, or curved or irregular surfaces like moving water, to give ordinary objects a new shape. Objects that are unique to your location can provide ideal foreign feeling subjects or reflective surfaces. If you really want to get creative, photograph through a window to capture the reflection and the scene inside for interesting double-exposure-ish abstracts (**Figure 32.10**).
- **Abstraction by blur:** A soft focus or a totally out-of-focus shot can blur subject edges to abstraction. This works well with human or animal subjects (**Figure 32.11**), familiar objects and silhouettes, or points of light (**Figure 32.12**).

Just Have Fun

Abstracts are a photographic free-for-all. Ignore any rules you've been told and go ahead and experiment. Abstracts can be blurry, abstracts can be out of focus, and abstracts can overrule reality and decide what's up or down. When you get the idea that something might make a good abstract, try new techniques, however silly they may seem, to find a new way of looking at the world around you.

32.10 New Orleans, Louisiana
ISO 100; 1/30 sec.; f/5.6; 85mm

32.11 Indianapolis, Indiana
ISO 100; 1/250 sec.; f/1.8; 50mm

32.12 Chicago, Illinois
ISO 160; 13 sec.; f/11; 190mm

33. COLOR AS THE SUBJECT

COLOR HAS REAL psychological effects. It can calm and relax you, or it can make you feel angsty and on edge. I first learned about the power of color when I was ten years old, and I learned it the hard way. We had just moved into a new house and, for the first time in my life, I had my own room. Naturally, I decided that my room would be painted pink. After obsessing over the paint swatches for a couple days, I ignored my parents' very reasonable understanding of how paint works (it never looks as intense on the swatch as it will in real life) and chose a dark pink, almost the color of salmon.

As soon as we finished painting, I realized my grievous error. Time spent in my room now felt like time spent inside a human lung. The pink was reasonable in daylight, but once the glow of incandescent light bulbs took over, it was oppressive. We'd even painted the ceiling pink because, in my limitless ten-year-old wisdom, the more pink the better. Maybe it was the years I spent in an excessively pink cave, or maybe it was the dawn of adolescence, but that bedroom was the beginning of an emo time for me. Never underestimate the influence of human-lung pink, or any color for that matter.

As you travel, you'll come to discover that many locations, regions, and cultures have their own unique color palettes. Sometimes stepping into a new place can feel like walking into a Wes Anderson movie—each color feels purposefully selected for its emotional effect and juxtaposition to the other colors present. Some locations are world famous for their color palettes, like the blue city of Chefchaouen, Morocco; the white walls and blue roofs of Santorini, Greece; or the bright pastels of Curaçao. Other locations have color palettes influenced by religious or cultural beliefs, indigenous plants, and natural local dyes. Whatever the reason for your destination's color palette, successful use of color in your images can bring new dimension, emotion, and interest to your travel photography.

Juxtaposition of Color

Contrast and harmony are two important factors when surveying a colorful scene for a photograph (**Figure 33.1**).

33.1 Primary colors, Tortola, British Virgin Island
`ISO 200; 1/1250 sec.; f/1.8; 50mm`

Contrasting colors (colors that are starkly different or even oppositional to each other) will draw the eye and keep its attention. Complementary colors (found opposite each other on the color wheel) will provide the most contrast: green and red, blue and orange, purple and yellow. When presented together, certain complementary colors can make the viewer feel uneasy, alarmed, or even nauseous. In fact, they teach you in theater lighting to avoid using red and green gels together when lighting a scene because it may make audiences physically ill. Not all contrasting colors are bothersome. In fact, in most situations bright, contrasting colors can induce feelings of energy and excitement (**Figure 33.2**).

Harmony exists in colors that are similar or relatively adjacent to each other on the color wheel. Think blues, greens, and purples; or yellows, oranges, and reds. Most of the deliberate color palettes you see when you travel are more harmonious in nature. I fell in love with the riverside view of Girona for its gorgeous harmonious color palette (**Figure 33.3**). Much of the time, floral or landscape design is based around analogous or harmonious color, so as you tour some of the incredible gardens of the world (**Figure 33.4**), pay attention to the colors and their relationships.

33.2 San Juan del Sur, Nicaragua
ISO 100; 1/250 sec.; f/4.5; 42mm

33.3 Onyar River, Girona, Spain
ISO 100; 1/1600 sec.; f/4.0; 22mm

33.4 Spohr Gardens, Woods Hole, Massachusetts
ISO 100; 1/50 sec.; f/5; 17mm

There are millions of potential color combinations, and much of the time they have been deliberately thought out. As you travel, pay careful attention to colors and how they make you feel or draw your attention. If you notice a particular color popping up again and again in a location, ask a local if there is significance to that color in their culture. If the color is of cultural significance, be sure to feature it prominently in your photos.

Naturally Occurring Color

Not all of the beautiful color palettes you discover while traveling have been deliberately designed. In fact, naturally occurring color can be even more impressive! Fall leaves are so universally loved because of the wide range of harmonious reds, yellows, oranges, and browns. The blues and greens found in the Caribbean are so bold that they stop me in my tracks every time I see them. Some

natural colors are so intense that it can be a challenge to reproduce them accurately in your images.

When you're photographing places with unique and nuanced colors, it's often a good idea to set a custom white balance to accurately capture the color, rather than relying on auto-white balance (**Figures 33.5** and **33.6**). Take a photo of a plain white index card for reference to set your white balance, or get fancy with a special accessory like the baLens cap (**Figure 33.7**). Whatever technique you use, be sure to pay attention to the colors you find and don't be afraid to let them take over your images!

Muted Color

One of the biggest mistakes I see in photography is a tendency toward oversaturation of color. Bright, bold, contrasty colors are gorgeous, but so are monochromatic colors

and muted tones. When I travel, I celebrate the opportunity to capture the softer look of color (**Figure 33.8**). A scene filled with various shades of the same color can force you to pay attention to the details (**Figure 33.9**).

When you shoot, but more specifically when you edit, don't push the vibrance or saturation sliders too much. Embrace the gentler colors and the mood they can create in an image (**Figure 33.10**). The ultimate goal of all travel photography is to tell the authentic stories of the places you visit, so make sure the colors in your images represent what you truly saw along the way.

33.5 Auto White Balance loses the nuance of color for this shot of Necker Island, British Virgin Islands. **ISO 100; 1/1600 sec.; f/4.5; 17mm**

33.6 Here's the same shot adjusted for accurate color.

33.7 The baLens cap helps you set an accurate white balance.

33.8 Lake Quinault, Washington
ISO 400; 1/125 sec.; f/22; 85mm

33.9 Private Estate, Catalonia, Spain
ISO 100; 1/640 sec.; f/5.6; 53mm

33.10 Going To The Sun Road, Glacier National
Park, Montana
ISO 400; 1/60sec.; f/5.6; 85mm

6

THE HUMAN ELEMENT

CHAPTER 6

From the exotic caravans of the Sahara to the questionable New York City food cart on the corner, a photograph with a human subject creates a unique intrigue and an attempt to relate for the viewer. When I travel, I love to meet people and learn about their lives, their families, and their stories. Each human connection I make leads to a richer experience on my journey and opens doors to new and wonderful photographs. Even in the most remote places on earth there are human stories to tell, so regardless of where your travels take you, go out of your way to meet people, make connections, and document it all in photographs.

34. ENVIRONMENTAL PORTRAITS

THE STRONGEST PORTRAITS offer more than a flattering representation of a smiling face. So often we judge images of ourselves and others by how attractive we look in them, but anyone can take a nice photograph of a friend or stranger isolated on a studio backdrop or against a benign wall. When we step into the realm of travel portraiture, traditional concepts of beauty are immediately less important than sense of place, cultural insight, and summation of a moment.

In your travels, the best portraits will utilize setting, atmosphere, activity, and experience—or in other words, the environment of a moment. Whether you're photographing locals in their element or your fellow travelers experiencing the journey alongside you, the strongest, most compelling portraits rely on the environment.

Choosing Your Subject

As you travel, you will naturally gravitate toward certain situations and subjects. Wrinkly old men are a popular portrait subject for many because each crease and line on their faces seems to carry the tales and gravitas of a long, storied life. Plus, in my experience, wrinkly old men are fun to talk to. Others may prefer the innocence found in a child's face, or the elegance and statuesque look of a beautiful woman.

The most important step of creating an engaging environmental portrait is finding a subject with visual attraction. By this I don't mean traditional notions of attractiveness. A man begging on a street corner in rags might possess more visual attraction for you than a gorgeous woman dressed in Gucci. Something made you notice this person as a potential subject. What was it? Was it the color and intensity of their eyes? Was it how they carry themselves? Their clothing? Scott Schuman, a photographer more famously known as the Sartorialist, has made a career of photographing the uniquely dressed real people he happens to find in his travels. Impeccable style and the role of fashion in real life are what draws him. What draws you?

If you're lucky enough to travel with friends or family who don't mind being photographed, you'll potentially find a lot of visual attraction in them because you know them and are sharing the experience. You're seeing the places you travel not only through your own eyes but through theirs. One of my favorite subjects for environmental portraits is my husband, Cassius (**Figures 34.1** and **34.2**). This isn't because I find him to be particularly dreamy (which I do), but because love of travel is such a big part of his personality. He lives for the wild and exciting moments of our adventures, and it shows in his expressions—both facial and physical.

When I photograph Cassius, each image begins as an authentic moment of experience. I don't simply say, stand in front of that vista and smile. I watch his face carefully for the unguarded moments of emotion and experience and do my best to capture them as they are. Sometimes I might say, hold that right there, or do that again and look at me, but there's always an authentic foundation in my images of him.

Letting the Environment Do the Heavy Lifting

As I mentioned earlier, even the most compelling portrait can be improved by making use of an intriguing environment. Sometimes the shot will set itself up right in front of you. You'll find a subject that you want to photograph who is actively engaging with an interesting and unique environment.

During an assignment in Spain, I had the opportunity to take some of my favorite environmental portraits to date while documenting the cork harvesting process. I visited private cork estates and was able to observe the regional differences in the process—from the variations in the landscape and climate, to the attire of the harvesters—and each situation offered unique opportunities to photograph locals in their element. These portraits gain their appeal not just from the beauty of the environment, but from the way the subjects actively engage with it: from a harvester overseeing the progress (**Figure 34.3**), to an estate owner enjoying the fruits of his labors (**Figure 34.4**).

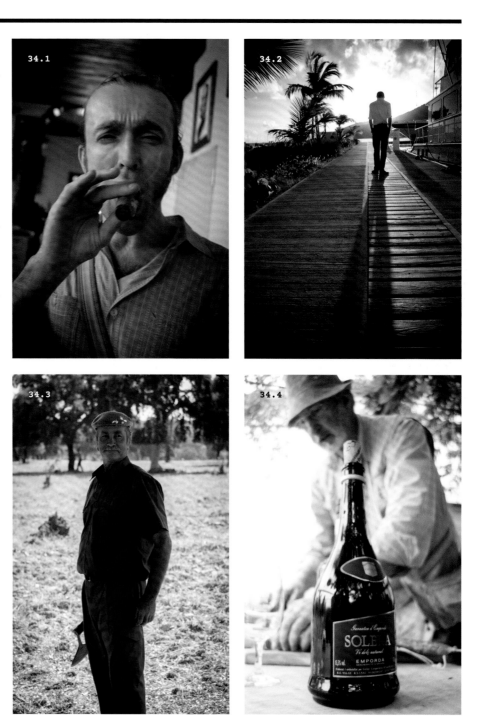

34.1 Smoking a fresh Nicaraguan cigar, Doña Elba Cigars, Granada, Nicaragua.
ISO 100; 1/40 sec.; f/3.5; 24mm

34.2 Scrub Island, British Virgin Islands
ISO 100; 1/400 sec.; f/4; 17mm

34.3 Andalusia, Spain
ISO 100; 1/160 sec.; f/5.6; 81mm

34.4 Catalonia, Spain
ISO 125; 1/80 sec.; f/3.5; 20mm

Along those lines, as you travel, pay careful attention to people performing their jobs for excellent photographic opportunities. Whether you photograph a chef working in a kitchen (**Figure 34.5**) or a fisherman tossing out a net, such subjects are active and engaged in their environment and your photographs will be stronger for it.

One of the most prolific environmental portrait photographers in my estimation is Jay Dusard, who most frequently focuses his camera on capturing the day-to-day lives of cowboys and ranchers. Through intensely detailed images, he keeps the full depth of location in focus, allowing not only the subject's visage but the accoutrements of their profession to speak volumes. A rancher poses with his family in a barn, still wearing the shoulder-length glove used during cattle insemination. A saddlemaker poses in his workshop, framed not only by his finished work, but by the tools and materials that help him craft each piece (**Figure 34.6**). Each of Dusard's portraits feels similarly handcrafted (**Figure 34.7**), as though he surveyed every detail before shooting, while maintaining an authentic environment and an insight into a world most of us rarely get to experience.

As you travel, take a page from Jay Dusard's book and fill each frame with intentional detail that will help provide insights into not only the moment of the image, but the personality, interests, and character of the subject. Connect the subject to their environment through posing, color, framing, or action, and you'll be on track to create some very compelling travel portraits.

34.5 Harry's Seafood Grill, Wilmington, Delaware
ISO 1000; 1/30 sec.; f/3.5; 50mm

34.6 Chuck Stormes, Saddlemaker, Calgary, Alberta, 1988
From *The North American Cowboy: A Portrait*, by Jay Dusard

34.7 Ed Hope and Wade Cooper, ZX Ranch, Oregon, 1981
From *The North American Cowboy: A Portrait*, by Jay Dusard

35. STREET PHOTOGRAPHY

PRACTICING GOOD STREET photography requires a magic combination of stealth and brazenness. Though it's easy to post up across a street and capture a photograph of strangers passing by at a distance, I get all kinds of feelings of nervousness and awkwardness when I want to photograph strangers at a more engaging distance, especially when they figure out what I'm up to! Add to that the complications we discussed in lesson 4, "Cultural, Legal, and Ethical Considerations," of photographing people in different countries and cultures, and it's enough to make you stick to photographing dogs and squirrels. But we must persevere! No one ever made it onto the walls of a museum or the cover of a magazine for photographing a squirrel—okay, I'm sure someone has, but it has to be relatively uncommon. So how do we push past the discomfort to get those Henri Cartier Bresson–worthy decisive moments? Start by stacking the deck in your favor.

Set the Scene

The background or environment is a major consideration for street photography. As you travel, pay close attention to places that might be good locations. Is the area relatively busy? Do people seem to pass through or linger? How is the light? Are there convenient places for you to stand or sit without drawing too much attention?

Heavily touristed areas are perfect for people-watching and street photography—nearly every tourist is focused on the surroundings or each other rather than you (**Figure 35.1**), and there are so many cameras around that yours is unlikely to draw undue attention. Busy outdoor markets are also great and will allow you to photograph people doing their daily chores and interacting with the world.

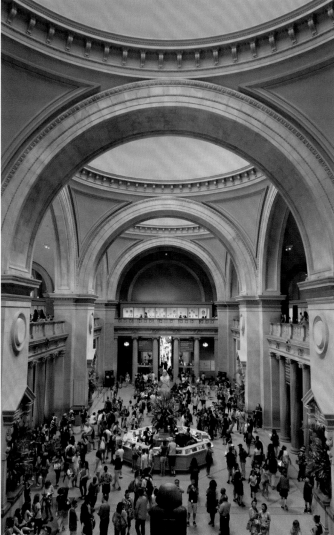

35.1 Massive crowds at the Metropolitan Museum of Art, New York, New York
ISO 4000; 1/160 sec.; f/5; 18mm

As you explore a city or town, look down alleys and narrow streets. You may find an off-the-beaten-path gem waiting for you (**Figure 35.2**).

If you find a location that you want to feature, post up and shoot the location for a while as various people walk through the frame. Many times you'll get lucky and the right person or group will walk through and complement the lighting and background perfectly (**Figure 35.3**). Try to compose your shot in such a way that it gives some information about where you are. Any type of writing will help indicate the local language and give reference for your photo. Style of dress, variety of architecture, the age of the cars—every little detail you include will help tell more of a story.

Choose Your Gear Wisely

Sure, a nice, fast telephoto lens will help you get tight crops of strangers' faces in the crowd, but a lens that big will also draw attention and make you seem pretty creepy, especially if you're sitting in a car. You are not a spy (I assume), and the lady getting her paper isn't your target (let's hope), so take your very reasonable desire for street photography into the light of day. Get closer to subjects with a less threatening lens (**Figure 35.4**) or keep the scene wide (**Figure 35.5**).

The best lenses for street photography are small and light. Subjects are far less likely to think they're about to get murdered when it's just a 35mm lens that is pointed in their direction. Prime lenses will allow you to get your shot quicker because there's no zooming to worry about. If you shoot at f/8 or f/11, you're much more likely to a capture a range of street walkers (no, not that kind) in focus without much adjustment. The more you practice with a particular lens, the more predictable its results will be for you, so grab a 35mm, or even a 50mm, or 85mm, and get to work.

Let's Be Reasonable

There are plenty of people out there who look and act ridiculous, and often ridiculousness makes for good photography. However, make every effort to be a reasonable human being. Maybe don't photograph the old woman whose skirt just fell down around her ankles. Ask yourself if anything good will come of photographing someone who is falling down

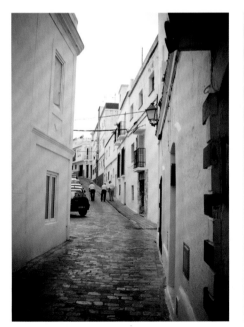

35.2 Tarifa, Spain
ISO 100; 1/60 sec.; f/6.3; 17mm

35.3 Granada, Nicaragua
ISO 100; 1/800 sec.; f/2.8; 24mm

drunk or is obviously not in control of themselves. Make every attempt to use good judgment, and be respectful. If someone obviously does not want to be photographed, then don't take the picture.

I see so many photographers who take pictures of people as if they were objects. They are not just part of the scenery. They are human beings. Talk to them. Thank them. Ask their permission. If possible, get their information so you can send them a copy of the photo you took. People will be less afraid of cameras if they know there's a kind, caring, human being behind the lens.

Share Your Best Street Photo!

Once you've captured your best image featuring a street scene, share it with the *Enthusiast's Guide* community! Follow @EnthusiastsGuides and post your image to Instagram with the hashtag *#EGStreet.* Don't forget that you can also search that same hashtag to view all the posts and be inspired by what others are shooting.

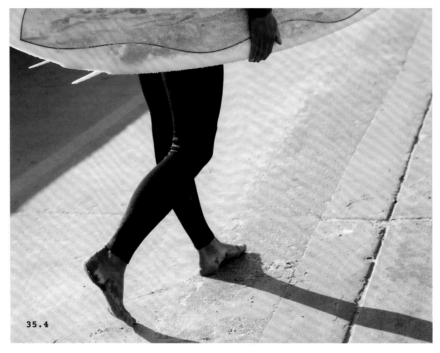

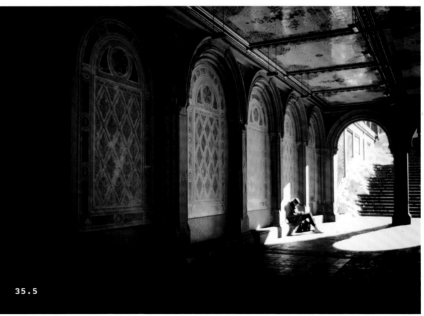

35.4 La Jolla, California
ISO 100; 1/2500 sec.; f/3.2; 50mm

35.5 Central Park, New York, New York
ISO 200; 1/60 sec.; f/5.6; 20mm

36. FESTIVALS AND CULTURAL EVENTS

FOR PHOTOGRAPHERS WHO are less comfortable navigating the potential awkwardness of approaching strangers for photographs, festivals, fairs, and other cultural events can be a great first step. Events offer countless photographic opportunities in a setting where locals accept and expect to see tourists with cameras. Though I've lived in cities my whole life, I rarely feel comfortable doing street photography in the United States. Even though my rights as a photographer are well protected, I often feel weird photographing strangers on the street, which is why I love parades and festivals so much.

Last year, I was able to attend a rare and locally revered event, a festival that was last held over one hundred years ago. The attendees were gripped with an almost religious fervor and an uninhibited hysteria—perfect for photographs. That event was the Chicago Cubs World Series Parade, and it was a hell of a celebration. For the first time in Chicago I felt totally at ease taking photographs of total strangers acting ridiculous (**Figure 36.1**). No one got in my way or asked me to stop taking their picture. Everyone was in such a mood of celebration that they were happy to show off and be seen. Festivals are some of the best people-watching opportunities out there.

Where to Start
Many times the local tourism department will help advertise what events will be taking place over the course of a festival. Find out if there is a festival guide or map to help you find the events that best appeal to you. Typically, culturally relevant costumes, dances, and performances will take place on stages (**Figures 36.2** and **36.3**). Stop by stages several times throughout the day to make sure you're getting a good survey of the events, but don't spend the entire day camped out at one stage. Unless the festival has a specific photography rule (as is the case at many American music festivals), anything that takes place on stage is totally fair game. Take as many photos as you want.

Competitions are a great place to photograph arts, artisans, local foods, and dress. Stop by competition stalls or tents to see what the locals have created. Many times you'll find demonstrations and interpretations of cultural products and customs that you can photograph—just like the 4H tent at the fair back home. Be advised that some artists may be wary of letting you photograph their work for fear of theft or reproduction. Be respectful. Many times a conversation will help them see you mean no harm.

When it comes to massive crowds to photograph, parades are key. Last year, we happened to visit Granada, Nicaragua, during the Hipica festival and parade, a local celebration dedicated to a local patron saint that culminates in a huge parade of floats and horses. The city was flooded with people from all over the region, and everyone was beautifully dressed and ready to celebrate.

If possible, try to stand in the front row of spectators during any parade for clear shots of the parade participants and the spectators' reactions on the opposite side (**Figures 36.4** and **36.5**). People are often excited to pose for you and are less concerned with a camera when they are happy and celebrating (**Figure 36.6**). During the Hipica, there were very few non-Nicaraguans around and we were warmly invited to share the celebration and learn about the local customs.

Keep It Fun
As amazing as festivals can be to witness and photograph, there are also a wild variety of ways that things can go downhill very fast. At festivals with alcohol, people may be really intoxicated around you, which is fun until it isn't. If you're not familiar with the area or if you're by yourself, feel free to have fun and imbibe, but keep it reasonable. Alcohol intensifies things, including disagreements and erratic behavior. Keep a cool head and you'll be able to handle whatever comes your way.

The aspects of festivals that make them perfect to photograph also make them perfect for thieves. Lots of people, lots of distractions (**Figure 36.7**), and the abundance of cash and valuables means a much higher likelihood of being pickpocketed or mugged. Don't go out with more gear than you need

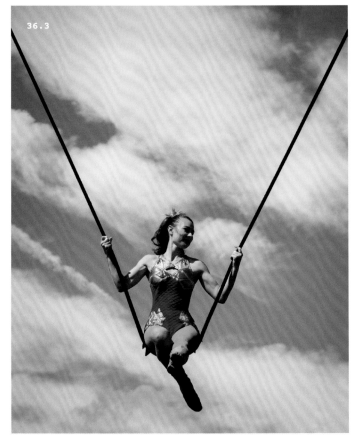

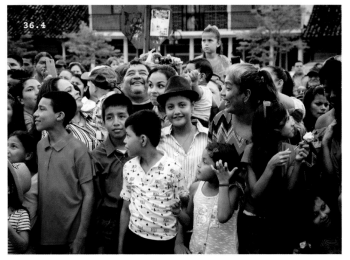

36.1 Wrigleyville, Chicago, Illinois
ISO 100; 1/200 sec.; f/7.1; 37mm

36.2 Cultural performance, Granada, Nicaragua
ISO 1250; 1/125 sec.; f/14; 150mm

36.3 The Flying Wallendas, Kingston, Rhode Island
ISO 100; 1/1600 sec.; f/5.6; 85mm

36.4 Hipica spectators, Granada, Nicaragua
ISO 250; 1/125 sec.; f/5; 66mm

or can keep track of. Be sure to wear your camera strap across your body, and keep a hand on your camera at all times. Stay in well-populated areas. Better to be safe than sorry.

If you're at a particularly messy festival like Burning Man or India's Holi Festival, come up with a plan ahead of time to protect your gear physically from colored dye, liquids, and other debris. Find out ahead of time if there are aspects of a festival that are forbidden to photograph. Make every attempt to be culturally sensitive toward religious practices especially if you don't understand them. If you see a particular portion of a festival or religious event and no one else is taking photos, take that as your cue to stop photographing.

With a little research and an open mind, festivals, parades, and cultural events can be the perfect opportunity to feel closer to the locals in the places you visit. Let them share with your their excitement for their history and culture while taking beautiful, socially accepted photographs.

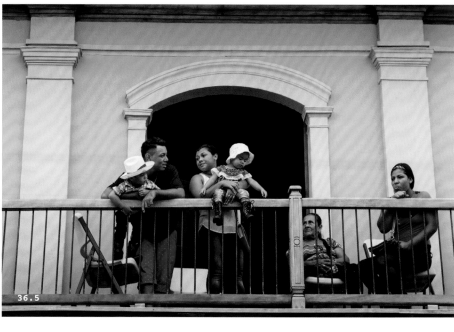

36.5 Hipica spectators, Granada, Nicaragua
`ISO 800; 1/160 sec.; f/8; 59mm`

36.6 Hipica parade performer, Granada, Nicaragua
`ISO 100; 1/250 sec.; f/4.5; 18mm`

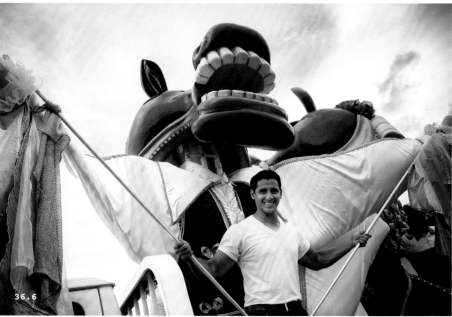

36.7 Second Line performer, New Orleans, Louisiana
ISO 125; 1/100 sec.; f/1.8; 50mm

37. MAKING YOUR SUBJECT COMFORTABLE

WE ENCOUNTER SO many incredible things and experiences on our journeys, but often the people we see help define our experiences best. As humans we can't help but view things through a human lens, so a collection of images that features the varied and interesting faces, clothing, and lifestyles found along your travels will bring a greater interest and depth to your work.

My husband is one of those people who can talk to anyone. Within two minutes of saying hello, he can have even the most stand-offish stranger smiling and sharing some secret joke with him. It's pretty impressive. I am nowhere near as comfortable approaching random people, and for a travel photographer that can complicate matters. It wasn't until my first solo trip—when I literally didn't know anyone I saw most days—that I finally got a little more comfortable approaching strangers for a conversation (**Figure 37.1**). Once you have that conversation going, it becomes much easier to break out the camera.

As you travel internationally, you'll have the added complications of language barriers and differing cultures to navigate. In lesson 4 we discussed potential issues you may have with photographing strangers on a cultural, legal, or ethical basis, so now let's talk about the actual logistics of photographing a stranger.

Your Approach

If you're hoping to have more time with a subject than just a fleeting street-style shot will allow, you'll want to make a connection with the subject. If the subject looks perfect to you already—what she's doing, how she's sitting or standing, and what is in the background—then by all means, grab the shot before approaching her (**Figure 37.2**). Many times those "stolen" moments will feel the most authentic.

If the person catches you taking her picture, don't get embarrassed or run away; go right up to her with a smile and say hello. A good icebreaker is to tell her what it was that drew you to her, like "Your scarf is beautiful; I noticed it from across the street" or "You looked so peaceful sitting there, I had to capture the moment," or "You have such a lovely smile." Then ask her name and how her day is going. Little pleasantries can go a long way to show that you respect your subjects and are

37.1 Two Medicine Lake, Glacier National Park, Montana
ISO 100; 1/1000 sec.; f/4; 17mm

interested in them as people, not just in taking a photo and running off.

If you're looking for more things to talk about, a great direction to take is to ask their advice about the area. Often I'll ask, "Do you have a favorite restaurant around here?" or "What is the most beautiful place in town?" Generally these sorts of questions will send them off on a tangent as they give you lots of insider info about the area, potentially leading to more off-the-beaten-path photographic opportunities for you. Regardless of what you say, when you approach, greet your subjects with a warm smile and open body language. The more standoffish you are, the more standoffish they'll become.

Before I visit a country where I don't speak the language, I make a list of phrases that will be useful in these types of situations. If you're nervous about memorizing them, you can either keep them written down in a notebook in your camera bag or enter them into a foreign language phrasebook in your phone with the help of Google Translate. The latter option is particularly useful when you're not sure of pronunciation. If it seems like someone isn't understanding you, try playing the phrase aloud directly from the app. Useful phrases and words to prepare include the following:

- Hello! My name is _____. What is your name?
- May I photograph you?
- May I take your portrait?
- This is beautiful.
- Smile.
- Look at me.
- Thank you!

If they aren't into it, you'll be able to tell. Whatever happens, be willing to take no for an answer. It is within their rights to avoid having their picture taken.

A Willing Subject

If the subject you approach is happy to pose for you, work quickly and try not to be too demanding. Even a bride and groom on their wedding day get tired of posing for photographs. Start by composing the shot as you initially found it (**Figure 37.3**). Let them stay where they are and make small adjustments by shifting your position. If the lighting is really bad and you just can't make it work, then consider asking them to move a few feet for a better setup.

37.2 Balboa Park, San Diego, California
ISO 125; 1/1250 sec.; f/1.8; 50mm

Photographing with a catchlight in a subject's eyes is one of the easiest ways to bring life and energy into a portrait. The eyes will have a fuller range of color and dimension than if they subject had been sitting in shadow. Many times shooting from above the subject will lead him to look up and get more light into his eyes.

If he's having fun and you feel comfortable asking for more, consider asking him to look in a particular direction or continue performing a task that you may have seen him doing. Continue talking to him or asking questions as you work. The most relaxed expressions will occur when the subject is engaged in something besides the awkwardness of being photographed.

Saying Thank You

When you have gotten your shot, or it feels like your subject is reaching his limit, be gracious and thank him. Show him the back of the camera so he can see how the photos turned out. If you're so inclined, get his contact information so you can send him a copy of the photo, and if you intend to use the images commercially, then be sure to have him sign a model release (more on this in lesson 4).

There will be times when a subject will ask you for money before or after you have taken his photograph. Photographic communities seem to be pretty divided on this topic. Some view it as harmless to pay a subject—he performed a service for you by posing so why shouldn't he be paid? Some view it as an opportunistic behavior that will lead to more demands for money from tourists down the line.

Ultimately the decision to pay or not to pay should be determined by the situation. If the subject is a vendor of some variety, then offering to buy something he is selling is often the easiest solution. If the subject is demanding money, then either give him some money or delete the photo and show him that you have deleted it. In any case, if you've been photographing children, then avoid giving them money or candy. The last thing you want to do is reinforce to children that begging tourists for money or food is a good use of their time when there are so many organizations trying to keep them off the streets and in school.

Like anything else photographic, approaching strangers for photos will get easier with time and practice. Not every image you take will be a winner, but each image you take will help you refine your technique and make you more comfortable for future interactions with potential portrait subjects. With a smile on your face, and a genuine interest in the people you approach, you'll be well on your way (**Figure 37.4**).

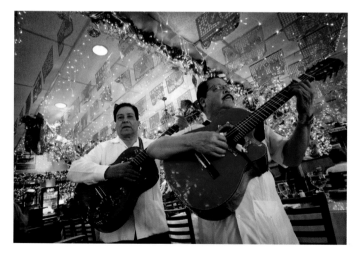

37.3 Mariachi Band, San Antonio, Texas
ISO 800; 1/20 sec.; f/4; 13mm

37.4 Sunset Cliffs, San Diego, California
ISO 100; 1/100 sec.; f/4; 10mm

SOMETIMES THE HUMAN element in a picture is just that: an element. When you find yourself photographing a location or subject that is larger than life, or so incredible it barely seems real, including a person in the frame can help ground the image and make it easier to comprehend. Take a quick look through travel photos on Instagram and you'll see thousands of examples of photographers utilizing people as a compositional element.

However, standing in front of the Grand Canyon and saying to your friend, "Hey, Walter, go stand next to that shrub and look at me," doesn't mean you'll have a wanderlust-inspiring travel shot on your hands. Chances are the only people who will care about that photo are your friend Walter and maybe his mom. Moms love photos of their kids no matter what, but you and Walter will have a lot more luck with more careful placement, directed gaze, selective color, and a few other considerations along the way.

The Setting Is the Subject

Humans are great and most of us are fairly certain that we're the center of the universe. That does not mean, however, that placing a human in your frame automatically makes her the subject of the image. In this lesson especially, the human is a living, breathing prop helping to support the real subject—the setting. With any breathtaking location, a carefully placed human can help define scale, create context for what you're seeing, and help viewers project themselves into the image.

In most cases it's preferable to have the human component either far enough away or facing mostly away from the camera so that she is unidentifiable. This helps in a couple of ways. First, it's less of a big deal when there are tourists around while you're trying to shoot. Second, you don't have to ask them for their permission or get a model release signed or even talk to them if you don't want to! Introverts, rejoice! The goal in this situation is to create a photograph that shows a human experiencing the landscape.

Maybe you've got a pair of hikers far down the trail (**Figure 38.1**) or a photographer exploring the view (**Figure 38.2**) or a random hippie doing yoga on a precipice (I don't even need to show you an example because we've all seen this one by now). Snorkelers and surfers make you wish you were them (**Figures 38.3** and **38.4**). Teeny tiny humans make you realize how big a scene is (**Figure 38.5**). A brightly dressed human can add a spot of contrast in the frame, tie in colors already in the image, or help juxtapose the natural versus the man-made. A human's back, or legs in the foreground, help the viewer step into the world of the image (**Figure 38.6**). The viewer will want to look where the human component is looking, so if you have the ability to direct your human prop, suggest a stance or direct his gaze toward something meaningful.

The Human Form in Abstraction

When making use of a person or people as a compositional element, you don't need the human form to be absolutely clear, sharp, or fully in the frame for it to read as human. People possess a natural tendency to view amorphous forms as familiar, identifiable shapes. Pareidolia is the common phenomenon of seeing recognizable shapes in clouds, faces in wood grain, and Jesus on toast. A large part of the population is going to perceive any vaguely human form as a person, so whether you include a human silhouette, shadow, or just a portion of a human body in the frame, your viewer will still get the message.

This will free you up to take things a little further artistically when using a person as a compositional component. Don't be afraid to slow the shutter speed and capture a vaguely human blur. Try framing a silhouette (**Figure 38.7**), or use a person's reflection in your composition. All of the effects of leveraging a person in frame will still work well with a portion of the human body or a vague outline.

38.1 Griffith Park, Los Angeles, California
ISO 100; 1/800 sec.; f/4; 14mm

38.2 Arches National Park, Moab, Utah
ISO 125; 1/125 sec.; f/9; 10mm

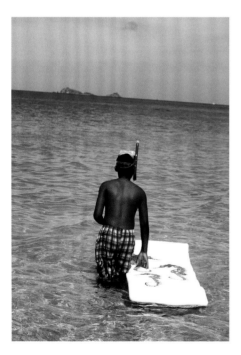

38.3 Mango Bay Resort, Virgin Gorda,
British Virgin Islands
ISO 320; 1/1000 sec.; f/5; 50mm

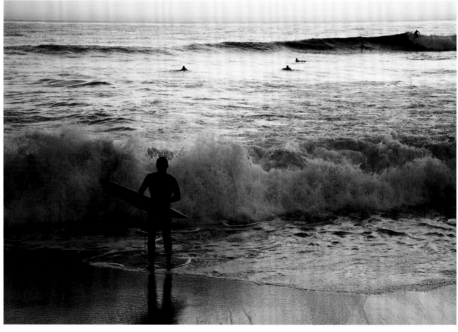

38.4 San Diego, California
ISO 400; 1/160 sec.; f/5; 38mm

38.5 North Avenue Beach, Chicago, Illinois
ISO 100; 1/1600 sec.; f/3.5; 20mm

38.6 Sailing aboard the SV *Lunacy,* British Virgin
Islands
ISO 100; 1/2000 sec.; f/4; 17mm

38.7 Devil's Bay, Virgin Gorda, British Virgin
Islands
ISO 100; 1/1000 sec.; f/4; 17mm

Ultimately, one of the primary goals of creating a photograph is to connect to viewers and make them feel something. There is no faster way to invite your viewer into the world of the image than a well-placed person. Experiment with different angles, proportions, and perspectives, and your images will be stronger for it.

7

LIFESTYLE PHOTOGRAPHY

CHAPTER 7

In the current trend of obsessive documentation, we are photographing more and more of our ordinary daily experiences—from our morning lattes to moments of relaxation by the hotel pool. Things that were never before considered worthy of capturing are now the pillars of content on Instagram. As you travel, you're likely to have many new and interesting experiences that you want to document. In previous eras, these photographs might have been referred to as "photojournalistic," but now, an authentic photo taken in the moment of an experience is referred to as lifestyle photography. Not every image in the lifestyle genre needs to feature a person, but the images do tend to focus on the human experience—the things we do, the places we frequent, the food we eat, and the pastimes we enjoy. More and more publishers of travel photography use these lifestyle photographs as the foundation of an image collection, so they are an important part of your travel photography arsenal.

39. TAKING MOUTH-WATERING PHOTOGRAPHS

NOTHING DEMONSTRATES CULTURAL nuances like local food. Before digital photography, only the most attractive and well-plated food was photographed, and it was only for advertising or memory keeping. Now food is photographed constantly regardless of attractiveness, and oftentimes even the most beautiful food is rendered disgusting and unappetizing if photographed in the wrong way. Google "Martha Stewart gross food photography" and you'll see that even a revered designer and influencer can make good food look like reconstituted, poisonous swill.

Thanks to celebrities like Martha and other cell-phone photographers all over the world, photographing your food in a restaurant has become totally cliché and a likely source of eye rolls from your dining companions and your server. Fortunately, through some simple techniques you can prove the haters wrong and make some worthwhile and delightfully appetizing food images on your travels. Then you get to eat the food, which is my favorite part.

Lighting

A solid 75 percent of the food-photography fails in the world happen because of bad lighting. That bad lighting can come in the form of your cell phone's LED flash; unappealing overhead fluorescents; or generally dim, romantic dining room light. Without a doubt, food tends to look its absolute best in natural light. There are many photographers out there who shoot food in studio settings with fancy studio lighting setups, but the simplest and most universally successful lighting scenario for food is good old natural light.

You will solve most of your color balance issues by photographing your food either outdoors (in even covered shade) or by a window. Many restaurants feature floor-to-ceiling windows, open floor plans, and reflective surfaces. Take stock of your surroundings and be selective when it comes to your location in the restaurant. When I travel, I like to sit by a window or on a patio so I can take in the local activity as I eat—a bonus when it comes to food photography. Make any seating requests before you're taken to a table so as not to be that weirdo who carries each of your dishes to the window for a quick shot before eating.

When I shoot for my food clients, I make every effort possible to shoot outside of the kitchen. Most kitchens are very brightly lit, but often they're lit with an unappealing combination of ugly fluorescents and heat lamps, so if you're lucky enough to get behind the scenes and shoot in the kitchen, consider the following:

- Shoot in RAW. Use a fill flash with a diffuser (bounce it and never do this in a dining room or you'll run the risk of angering other patrons and your server).
- Use a reflector to help fill in shadows.
- Make the shots about the process, not just the dish.
- Get creative (if all else fails, steal the food and snag a few shots outside the kitchen, **Figures 39.1** and **39.2**).

Because natural light is the easiest and most traditionally attractive setup for food, plan to visit the restaurants that most excite you during the day. Lunch rush will usually be less crazy than dinnertime, and you'll have the best conditions for taking really nice food photos.

Composition and Depth of Field

Composition with food photography is just like composition in any other kind of photography. Aim to decisively fill the frame, highlight the textures and details, and let the subject dictate the angle of your shot. There is a real tendency to photograph food from above. Top-down shots are great—they show the whole plate, keep everything in focus, and benefit from even light, though most chefs

have a certain presentation in mind when plating. There usually is a "front" to each dish, so be sure to shoot from the diner's perspective as well. Some dishes will be attractive from both perspectives, but others will be more impressive from one angle or another. Play around with perspectives to find your food's "best" side. **Figures 39.3** through **39.8** show a few examples of the same dish shot from different perspectives. If you aren't sure what will work best, shoot from the front and from above and make the hard decisions later.

39.1 A tasty dessert under ugly kitchen light, Smyrna, Delaware
ISO 1600; 1/80 sec.; f/1.8; 50mm

39.2 Same dessert with window light, Smyrna, Delaware
ISO 160; 1/60 sec.; f/1.8; 50mm

39.3 Lots of texture, but not much context for what the dish is. Scrub Island, British Virgin Islands
ISO 800; 1/80 sec.; f/5.6; 59mm

39.4 Now we can see that the dish is plated in a coconut, which helps give it some Caribbean personality. Scrub Island, British Virgin Islands
ISO 200; 1/80 sec.; f/2.5; 50mm

39.5 A top-down perspective works nicely for this colorful dish. Saba Rock Resort, British Virgin Islands
ISO 160; 1/50 sec.; f/5; 35mm

39.6 This perspective feels more inviting. Saba Rock Resort, British Virgin Islands
ISO 100; 1/200 sec.; f/1.8; 50mm

39.7 Top-down gives you the full benefit of the artistic flourishes. Leverick Bay Resort, British Virgin Islands
ISO 100; 1/80 sec.; f/5.6; 47mm

39.8 Leverick Bay Resort, British Virgin Islands
ISO 100; 1/400 sec.; f/1.8; 50mm

Each dish will also require you to make an individualized decision about depth of field. Do you want shallow depth to focus attention on a specific component or dish (**Figure 39.9**)? Medium depth to provide a glimpse of less important but still present surroundings (**Figure 39.10**)? Deep depth of field to tell the full story of a restaurant, kitchen, or other surroundings (**Figure 39.11**)? A large part of this decision will be influenced by the attractiveness and interest of the location or dining room. No one wants to see a grease-streaked wall behind a hamburger, but a wall filled with local art or historic band posters might provide a great context for the food.

39.9

39.11

39.10

39.9 Leverick Bay Resort, British Virgin Islands
ISO 100; 1/400 sec.; f/1.8; 50mm

39.10 Medium DOF gives this freshly picked fruit a bit of context. Guana Island, British Virgin Islands
ISO 320; 1/50 sec.; f/5; 38mm

39.11 Cocktails on the beach for the win. Tropical Fusion Restaurant, Tortola, British Virgin Islands
ISO 100; 1/500 sec.; f/8; 22mm

40.1 Homemade coffee on the beach, Nail Bay, Virgin Gorda, British Virgin Islands
ISO 320; 1/1250 sec.; f/4; 17mm

40.2 Aquamare Villas, Virgin Gorda, British Virgin Islands
ISO 200; 1/2500 sec.; f/2.5; 50mm

40.3 Even cheap beer looks good poolside. Sunset Watch Villa, Virgin Gorda, British Virgin Islands
ISO 160; 1/800 sec.; f/2; 50mm

40.4 You don't have to be a guest to enjoy the amenities. Bitter End Yacht Club, British Virgin Islands
ISO 100; 1/500 sec.; f/4; 16mm

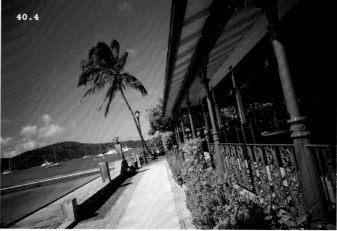

40.5

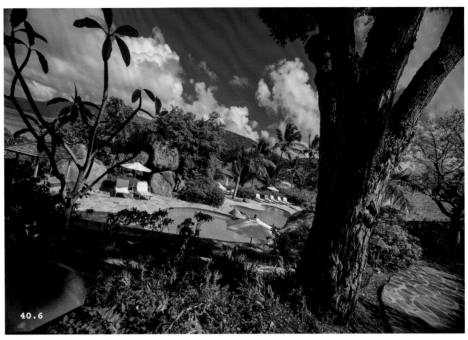

40.6

40.5 Little Dix Bay, Virgin Gorda, British Virgin Islands
ISO 160; 1/1250 sec.; f/4; 12mm

40.6 Little Dix Bay, Virgin Gorda, British Virgin Islands
ISO 160; 1/640 sec.; f/4; 10mm

40.7 Taken from a very unglamorous ferry. Not bad for $2 per person. Ometepe, Nicaragua
ISO 100; 1/400 sec.; f/10; 70mm

40.7

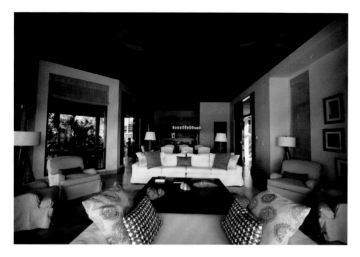

40.8 Aquamare Villas, Virgin Gorda, British Virgin Islands
ISO 640; 1/500 sec.; f/3.5; 10mm

40.9 Aquamare Villas, Virgin Gorda, British Virgin Islands
ISO 640; 1/1600 sec.; f/3.5; 10mm

If You Splurge, Make It Count

If you are staying somewhere really swanky, be sure to photograph the accommodations before you start changing things or leaving your stuff all over the place. Whether I'm shooting for a hotel client or just for my own travel images, I'll photograph the room immediately after I arrive. I stash my bags in the closet and capture all the perfectly set details before I have a chance to mess them up.

Take a variety of wide shots (**Figures 40.8** and **40.9**) and tight detail shots (**Figures 40.10** and **40.11**). When you're compiling all the images from your trip, you'll have a nice set of hotel photos to help tell the story of your adventure.

40.10 Swanky details, Aquamare Villas, Virgin Gorda, British Virgin Islands
ISO 200; 1/200 sec.; f/2.5; 50mm

40.11 Aquamare Villas, Virgin Gorda, British Virgin Islands
ISO 200; 1/60 sec.; f/2.5; 50mm

41. EMBODYING RELAXATION

TRAVEL PHOTOGRAPHS THAT imply relaxation and serenity are some of the most frequently searched and coveted images out there. The images that invoke the greatest sense of relaxation will feature not only relaxation-related subject matter (think spa services, hammocks, or secluded gardens) but will employ a sense of visual balance in the way you shoot the scene.

Relaxing Subjects

A quick Google image search of the term "relaxation" will yield some predictable results—women in impossible yoga poses, cross-legged meditation sessions on the beach, rock cairns, peaceful water features or gardens, and a general juxtaposition with nature. The types of settings that make us feel relaxed seem fairly universal, but pay attention to the prominent colors and you'll find a tendency toward blues, greens, whites, and grays—all natural and earthy colors that relate harmoniously to each other. Shooting along these trends is a great way to get started, but try to find the lesser photographed signs of relaxation as well. Hammocks, porch swings, and other places to recline can help represent a relaxed mood (**Figure 41.1**).

Many of the more obvious "relaxing" subject matter can begin to feel cliched, so try finding ways to photograph moods rather than objects. Something that always makes me feel at peace when I travel is the sense of antiquity and history hinting at all the people who visited before me. I find a sense of relaxation in crumbling and mossy walls (**Figure 41.2**), or places where stone has been eroded by water, wind, or the footsteps of my predecessors over time (**Figures 41.3**).

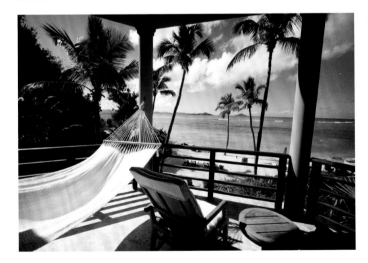

41.1 Aquamare Villas, Virgin Gorda, British Virgin Islands
ISO 640; 1/8000 sec.; f/3.5; 10mm

41.2 Finca el Cortinal, Cáceres, Spain
ISO 200; 1/60 sec.; f/2.5; 50mm

41.3 Relaxation comes easily in a place this peaceful.
Finca Fitor, Catalonia, Spain
ISO 100; 1/80 sec.; f/4; 17mm

41.4 Formal gardens at Houmas House, Darrow, Louisiana
ISO 100; 1/800 sec.; f/1.8; 50mm

41.5 Olympic National Park, Port Angeles, Washington
ISO 2000; 1/50 sec.; f/5.6; 35mm

If your travels take you to settings that feel particularly or unexpectedly relaxing, then endeavor to capture the way they make you feel in your images.

Relaxation Through Technique

Generally, the simpler the image, the more likely it is to provide a feeling of serenity. Crop scenes or subjects down to their simplest aspects through selective framing and zooming (**Figure 41.4**). Seek out visual balance through symmetry. Avoid busy or highly textured scenes that ask the viewer to work too hard when looking at the image. Play with longer exposures to make water soften and flow (**Figure 41.5**), or to show plants blowing in the wind.

Softer edges, colors, and atmosphere will help you capture a greater sense of calm. Consider photographing during blue hour or on overcast days when the light is soft (**Figure 41.6**). Slow things down. Take your time to feel a sense of calm and your images will show it.

41.6 Kankakee River State Park, Bourbonnais, Illinois
ISO 100; 2.5 sec.; f/22; 47mm

8

WILDLIFE
AND ADVENTURE

CHAPTER 8

While slowing things down and feeling serene has its perks, plenty of us want to hit the ground running and get after it. Whether you want to capture all the crazy local wildlife or photograph some impressive sportsing and other types of adventure, there are a few things to keep in mind as you journey on.

42. FAST-MOVING SUBJECTS

REMARKABLY THERE ARE loads of similarities when it comes to photographing athletes and animals. With the exception of sloths and golfers, they usually move quickly and therefore offer limited opportunities to get your shot. Some concepts and settings are going to be universal for all fast-moving subjects, whereas other techniques depend more on the circumstances, variety, and direction of your subject's movement. I shoot animals far more often than athletes, so most of this lesson is based on critters as subjects, but the techniques will work well with all fast-moving subjects, from humans to planes, trains, and automobiles.

General Best Practices

With most speedy subjects, it's a good idea to shoot in Shutter Priority Mode and keep your shutter speed at 1/500 or faster (**Figure 42.1**). If your camera will let you program a minimum shutter speed ahead of time, go for it.

Set your camera to shoot in burst—high-speed burst if the situation calls for it—and make sure you're using a high-capacity memory card with fast writing speeds. The exact speed necessary will vary based on the size of your RAW files and how quickly your camera can process the data. Some action photographers shoot in JPEG to allow their cameras to write the files faster without getting bogged down on longer bursts. I would rather shoot fewer burst images and keep shooting in RAW for the editing flexibility, but the choice is yours.

In most situations, AL Servo or Continuous focusing is the best focusing mode, because it allows the camera to quickly refocus as the subject moves through the frame.

42.1 Red-winged Blackbird takes off, Chicago, Illinois.
ISO 125; 1/2500 sec.; f/3.5; 20mm

42.2 A bald eagle soars with Mount Baker in the background, Port Angeles, Washington.
ISO 100; 1/800 sec.; f/5.6; 85mm

Predicting Movement

When I photograph a bird in flight, or a donkey chasing a smaller donkey, I keep both eyes open to help me spot my subject, and then move my camera with the motion of the subject as I shoot (called panning or tracking). Tracking can be a great way to capture lots of images throughout a subject's range of motion or to keep the subject perfectly sharp with some motion blur in the background (**Figures 42.2** and **42.3**).

Keep in mind that the longer your lens, the faster a fast-moving subject will potentially disappear out of frame. Most of the time, you can keep them in frame by paying careful attention, but this works better with more predictable subjects. Birds don't always fly consistently in one direction—they rise and fall, change speed, dive, swim, and sometimes walk (**Figure 42.4**). Unless you're some kind of animal psychic, the timing of those movements is hard to anticipate. So if you're having trouble tracking a particularly speedy critter, like the nightmarishly fast hummingbird, you may have to change things up a little.

A hummingbird belongs in a special class of magical animals along with seahorses, unicorns, and narwhals as far as I'm concerned. It doesn't fly so much as it teleports. Rather than attempting to outwit or track a magical hummingbird (or a similarly elusive creature), I prefer to prep my gear and prefocus so when a subject flies into my shot I'm ready.

When I find a plant or a feeder that seems to be attracting a lot of hummingbird attention, I set my camera on a tripod and aim at that spot (**Figures 42.5** and **42.6**). I'll choose an aperture around f/4 or f/5.6 so that I can maintain a good amount of depth in focus, and shoot at the highest shutter speed I can manage in the available light. Generally 1/500 or faster is a good place to start. I switch into Manual Focus and prefocus for the flower or feeder. To be certain that your focus will be tack-sharp, you can also turn on live view and enlarge the image on the screen, and then manually focus for more precision. Then all you have to do is wait.

42.3 Chicago Air and Water Show, Chicago Illinois
ISO 100; 1/6400 sec.

42.4 A pelican dives for fish, Virgin Gorda, British Virgin Islands.
ISO 160; 1/640 sec.; f/5.6; 22mm

42.5 Monteverde, Costa Rica
ISO 1000; 1/500 sec.; f/5.6; 300mm

42.6 It's harder to catch a hummingbird with a slower shutter speed, but sometimes it works out. Monteverde, Costa Rica
ISO 100; 1/30 sec.; f/4; 10mm

43. PATIENCE IS A VIRTUE

THE FIRST TIME I went to Costa Rica I had somewhat unreasonable expectations about wildlife viewing. I grew up watching nature documentaries, so I was excited to personally see the abundant creatures of the jungle. But I had no idea just how long most documentarians lie in wait to get footage of their subjects. My early self-guided attempts at exotic animal spotting were fruitless, though I did find two entangled amorous lizards and a couple of crabs.

I quickly learned that much of wildlife photography requires an endless supply of patience—not unlike my early days as a preschool photographer. Just showing up at the recommended locations isn't enough. You have to be willing to put in the time, do the research about your intended subjects' interests and behaviors, and play an often frustrating waiting game. For those of us who don't have endless supplies of vacation days and cash, patience is still important, but there are a few things we can do to improve our chances of finding exciting subjects and photo opportunities.

Enlist the Experts

While the miracle of life that is lizard love was an exciting personal find (**Figure 43.1**), I have had the most luck working with a local guide to find wildlife to photograph. On that first trip to Costa Rica, a half-day hike in the jungle with a barefoot one-eyed Tico yielded

43.1 Wildlife on the ground is much easier to spot if you're an amateur. Puerto Viejo, Costa Rica
ISO 100; 1/160 sec.; f/7.1; 150mm

sightings of multiple sloths (two- and three-toed, though I didn't get close enough to count toes), howler and capuchin monkeys, arboreal snakes, sleeping bats, and a hawksbill turtle. The turtle on land in daylight was a fluke—she had gotten stuck in some fallen palm trees after laying her eggs on the beach, but because we had a local expert on hand to spot her in the first place, we were able to help free her and lead her back into the ocean. No, I didn't get pictures. Yes, it was amazing anyway.

None of those sightings would have been possible without a guide who knew the behaviors, habitats, and signs of the animals nearby. Now I rarely venture into the jungle without a guide for spotting (**Figures 43.2** through **43.4**).

43.2 Howler monkeys are easier to hear than they are to spot. Charco Verde, Ometepe, Nicaragua
ISO 1250; 1/160 sec.; f/6.3; 300mm

43.3 This little dude was seriously camouflaged. Mombacho Volcano, Nicaragua
ISO 400; 1/160 sec.; f/6.3; 300mm

43.4 Without a guide, I never would have known where to find a scorpion in the jungle, nor would I have known to look at him glow under a UV light. Monteverde, Costa Rica
ISO 6400; 1/125 sec.; f/5.6; 85mm

With any kind of wildlife photography—especially in situations where the animals could be potentially dangerous (e.g., the eyelash viper that I wouldn't have spotted that was well within striking distance) or when your presence could potentially harm the animals—a knowledgeable guide is a worthy investment.

Minimize Points of Friction

Most animals are skittish and humans are noisy and smelly. If you're in pursuit of a particularly elusive creature, you'll have your work cut out for you even if you do hire an expert guide. Focus on stepping lightly, minimizing conversation, and turning off all potentially noisy accessories and features (**Figures** **43.5** and **43.6**).

43.5 I wanted to make an environmental portrait of this lizard with a wide-angle lens, so I gradually inched closer to him to line up my shot. Arches National Park, Moab, Utah
ISO 125; 1/125 sec.; f/13; 10mm

43.6 Hiking quietly paid off when a family of coatis ventured close to us on the trail. Tenorio Volcano National Park, Costa Rica
ISO 3200; 1/125 sec.; f/5.6; 85mm

We were carefully searching the treetops for sloths on a jungle night tour in Costa Rica when my phone shouted from inside my backpack, "I'm sorry, I didn't catch that. Did you say something?" Super embarrassing. After being told explicitly that any sound would hinder wildlife viewing opportunities, I had set my phone's ringer and notifications to silent. The general app volume, however, was at full blast. I achieved full idiot status and the sloths remained fully hidden. Turn off the beeping on your camera if you haven't already, and turn *all* volume settings on your phone to silent even if you're out of network.

It's a good idea to try to keep your scent pretty neutral. Perfumes, lotions, and fancy soaps might make you more appealing to other humans, but the animals will sense you from farther away. The only wildlife you'll attract are mosquitoes, gnats, and flies, and they'll make the time you spend waiting for more interesting wildlife pretty miserable. To that end, no matter how dumb you feel, if you're going to be lying in wait in bug-prone areas, wear a netted hat and long pants and sleeves.

Take It as It Comes

Whether I'm waiting for the epic lighting of a sunset or for a family of coatis, I often struggle with self-doubt and fear of missing out. There have been many times over the years when I've worried or wondered if what I'm shooting is less exciting than what I might have found if I'd hiked a bit longer or driven a bit farther down the road. I have to tell myself that it doesn't matter. Sure, there might be something totally breathtaking that I stopped short of seeing because I liked something else along the way. That's just one of the realities of life. You can't be everywhere at once and you can't do everything. You have to make a choice and take it as it comes.

There are no guarantees that waiting in a tree-hide for a month will get you the shot you had hoped for, and you have no way to know if the sunrise was prettier here than it was over there (**Figure 43.7**). Regardless of what could be happening somewhere else, you have to find the beauty and excitement in what lies before you at that moment and work the hell out of it.

43.7 I chose my sunrise spot in the dark, so when it started to get lighter and I found that I'd chosen a topographically flat portion of The Badlands, I made the best of it. The sky wasn't particularly exciting either, so I chose a tighter shot rather than a vista. Badlands National Park, South Dakota
ISO 100; 1/400 sec.; f/5.6; 85mm

44. NATURE IS DANGEROUS

NATURE IS DANGEROUS. Bite your face, crush you with falling rocks, lull you into a peaceful hypothermic demise kind of dangerous. In fact, many things in nature are so dangerous that entire religions were once formed around appeasing nature's angry gods. We as a species used to have a healthy respect for nature and the general understanding that practically anything in it could kill us at any time. It was understood: nature is a BAMF.

So explain to me why a traveler would brush past multiple warning signs and dip even a toe into a boiling acidic pool? Last year a guy from Oregon ventured off the trail for a therapeutic soak in one of Yellowstone's geysers and literally boiled himself to death. Boiled. To. Death. It defies explanation and yet he wasn't the first. He won't be the last. The guys who trampled the Grand Prismatic Spring were lucky they didn't meet the same fate.

The Washington Post reports that over one hundred deaths have occurred in America's national parks every year for nine of the past ten years. These deaths range from more common drownings and falls to exceedingly rare animal attacks. One hundred-ish deaths per millions of visitors each year may seem like a reasonable statistic until you consider that in almost all cases these deaths were totally preventable. In the era of precipice selfies and daredevil challenges, people have become dangerously brazen and cavalier in the pursuit of their next attention-seeking post. The lines of appropriate and respectful behavior in our national parks have been blurred and we're seeing more and more outrageous occurrences (**Figures 44.1** and **44.2**).

Every one of America's national parks reminds visitors on maps, with signs, and at visitor centers to keep a safe distance from wildlife, and yet those rules also continue to be broken. A couple of years ago, on a visit

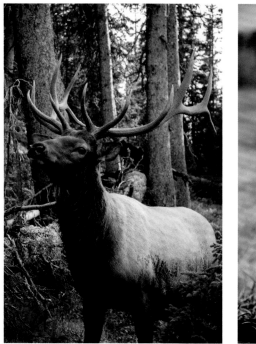

44.1 Several park rangers were around to keep tourists from getting too close to this bull elk, but that didn't stop him from getting closer to me. Rocky Mountain National Park, Estes Park, Colorado
ISO 100; 1/80 sec.; f/5.6; 47mm

44.2 Doesn't this prairie dog seem cute and harmless? Think again, because apparently these little bastards carry the plague. Custer State Park, Custer, South Dakota
ISO 160; 1/500 sec.; f/5.6; 85mm

to Rocky Mountain National Park I saw a crowd forming on a tundra hillside to view a herd of bighorn sheep. Cars were haphazardly parked and abandoned all over the roadway (which at that point is a tight, winding, two-lane road with no shoulder) while their former occupants edged closer and closer to the animals. Annoyed by the traffic jam but interested in the animals, I drove to the next turnout, appropriately parked my car, and took off on foot toward the herd.

Because I drove beyond the bulk of the tourists, I was in the perfect location to photograph. The herd was actively walking away from the swarm of tourists and toward my waiting camera (**Figure 44.3**). I strategically positioned myself with a rocky outcrop between us where I could comfortably and successfully shoot at 200–300mm. The light was beautiful, the vista backdrop incredible, and the animals fascinating. I happily shot for ten minutes, commending myself for my brilliant position in front while everyone else got photographs of bighorn sheep butts (**Figure 44.4**).

Then things got a little uncomfortable.

While I had been distractedly photographing a couple of individual sheep, the animals had been herded closer and closer to me by the crowd of tourists behind them. At this point, I was about one hundred feet away from what I thought was the closest sheep. Nope. Having been fully engrossed in my camera, I hadn't noticed the enormous ram who decided to investigate me, the source of all the strange clicking sounds. I heard a noise from above and looked up to see a terrifyingly large beast looming about eight feet above me (**Figures 44.5** and **44.6**). We locked eyes while the larger herd of sheep kept moving closer, a herd of tourists close behind.

At once, I realized my massive error in judgment. Yes, I had lined myself up for the perfect photographic perspective, but I had also placed myself in the direct path of any animals hoping to avoid dozens of ogling tourists. I played through all of the catastrophic scenarios in my mind: death by head butt, death by trample, death by head butt and then trample. I quickly invented dubious plans to save myself by squeezing between the boulders at my feet or by using my tripod as a bludgeon, all the while waiting for the ram to charge.

This brings me back to my initial statements: nature is dangerous. Nature is a BAMF. With little provocation, nature can squish you like a bug, or melt you like a sugar cube. In my story, nothing so momentous occurred. I was lucky. I slowly backed away from the ram and out of the herd's path, watching in amazement as the sheep and tourist parade continued by (**Figure 44.7**). The lesson for

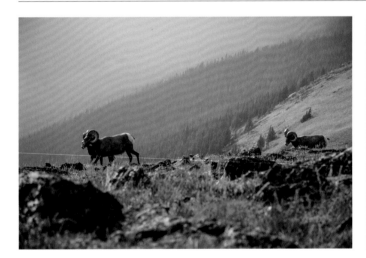

44.3 Bighorn sheep from a relatively safe viewing distance. Rocky Mountain National Park, Estes Park, Colorado
ISO 100; 1/640 sec.; f/5.6; 85mm

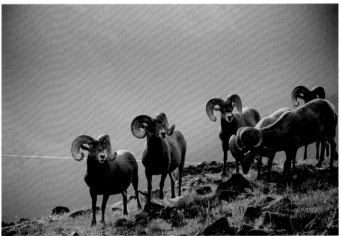

44.4 They're a bit closer now, but I feel okay about it. Rocky Mountain National Park, Estes Park, Colorado
ISO 100; 1/500 sec.; f/5.6; 85mm

me was that yes, the animals were dangerous, but the crowd of people making noise and herding them toward me was the bigger problem.

Secure in our status at the top of the food chain, humans have forgotten that we're soft, hairless animals with mostly flat teeth and fragile bodies. For every trained and seasoned mountain climber, there are three who begin a dangerous expedition outfitted with only hubris and idiocy. So we get gored by bison, tumble off cliffs, drown in rapids, and melt in geysers in these completely preventable accidents. We are putting ourselves and those around us in danger by not giving nature the respect it deserves.

Give nature some personal space. As you travel the world, ignore the impulse to jump fences, break rules, and take risks. Yes, nature is dangerous, but it doesn't have to be.

44.5 This is the face of death by trample and he has the high ground. Rocky Mountain National Park, Estes Park, Colorado
ISO 100; 1/500 sec.; f/5.6; 75mm

44.6 I was shooting at 17mm. This guy is way too close! Rocky Mountain National Park, Estes Park, Colorado
ISO 100; 1/640 sec.; f/4.5; 17mm

44.7 The sheep go on their way. Rocky Mountain National Park, Estes Park, Colorado
ISO 100; 1/250 sec.; f/4.5; 17mm

45. SHOOTING FROM A WINDOW

JUST BECAUSE YOU'RE actively on the move doesn't mean you need to stop shooting. Many times some of the prettiest vantage points are found along the roadway, and pulling over isn't always an option. While you should *never* (please, for real, never ever) take photographs while you are driving with any camera or device, you should keep your camera accessible as a passenger to capture the little unexpected moments along the journey. Getting a crisp, well-composed photograph while hurtling down a road or over tracks or through the sky at a high rate of speed presents plenty of challenges, but these challenges can be overcome with some creativity and clever strategizing.

Reflections

Anytime you shoot through a window, reflections are a potential issue. Though train travel offers lots of unique vantage points as the tracks carry you through private land and incredible wilderness, the interior lights or the sunlight coming through from the opposite side of the train will usually create weird reflections and unfortunate glare (**Figure 45.1**).

When I travel by train, I pull the fabric curtains on the window over my head to create a little reflection-free pocket for my camera (**Figure 45.2**). If you're wary of potential lice or the idea of touching those curtains skeeves you out (I totally get it), you can buy or rig an opaque black piece of fabric with suction cups for similar results. A well-draped sweatshirt can also work in a pinch. Polarizing filters can also work, but if you're shooting through a window that has any kind of tint or coating, a polarizing filter will result in weird rainbow effects or odd striping that will only abate through onerous post-processing (**Figure 45.3**). Smaller reflections can be easily edited out, but pay attention as you shoot so you don't end up creating lots of processing work for yourself.

Reflections in cars can be dealt with by opening the window or by adjusting your angle or perspective slightly. If you do roll down the window, be sure to keep the front element of your lens inside the body of the car to minimize the wind buffeting against your lens.

Obstructions

When we drive we can easily notice a gorgeous view while visually tuning out unfortunate obstructions like power lines, billboards, and other vehicles, but when it comes time to take a photo, you'll have to time your shots carefully to avoid streaky obstructions in the foreground. If you're in a car, you might be able to ask the driver to change lanes to help give you a less obstructed view of your shot, but that doesn't mean you won't still find plenty of trees, brush, and telephone poles in your way.

The smoother the speed, the easier it is to time shots between obstructions, so if you're in a car, ask the driver to hit cruise control or try to keep it consistent. If I'm in a heavily obstructed area with evenly spaced telephone poles, I'll shoot on burst to increase my chances of getting a well-timed shot between obstructions (**Figure 45.4**).

If the obstruction lies on the window itself, like the dirty, smudgy, and scratched windows I always seem to get on airplanes, focus manually to make sure your lens isn't trying to autofocus on the heavily textured window in the foreground. Get as close to the window with the front of your lens as you can and use a wider aperture to make the depth of field fairly shallow. By focusing on something outside the window, you'll be able to throw the scratches and smudges from toddler fingers into soft, blurry oblivion (**Figures 45.5**).

Raindrops on a window are much more difficult to shoot through but can still have some really cool effects. Try focusing past them to get a unique texture in your foreground, or make them the subject of the image itself (**Figure 45.6**).

45.1 Dealing with lots of glare and reflections through the train window. Somewhere between El Paso, Texas, and Yuma, Arizona
ISO 160; 1/200 sec.; f/4.5; 15mm

45.2 There's still some glare, but no reflections. Somewhere between El Paso, Texas, and Yuma, Arizona
ISO 160; 1/160 sec.; f/4.5; 10mm

45.3 Bad rainbow effects. Somewhere between San Antonio and El Paso, Texas
ISO 100; 1/2060 sec.; f/4.5; 10mm

45.4 This image was shot on burst to hedge my bets of getting an unobstructed shot. Pennsylvania Turnpike, Western Pennsylvania
ISO 1250; 1/60 sec.; f/4.5; 33mm

45.5 I was able to manually focus on the tips of skyscrapers to avoid smudges. Chicago, Illinois
ISO 100; 1/160 sec.; f/5.6; 85mm

45.6 Rain on the runway at O'Hare, Chicago, Illinois
ISO 3200; 1/20 sec.; f/5; 41mm

Compensating for Movement

Unless you're on a curving subway track (the Chicago El) or in the midst of turbulence, trains and airplanes are much smoother and more visually predictable modes of transportation than a car. In trains you're essentially on a dolly track, so while your shots may have some obvious movement, it will be smooth, consistent, and singularly directional. In a car, practically everything can make your ride bumpier, from road smoothness to the age and fanciness of the car. The easiest way to ensure smoother shots is to avoid bracing yourself against the vehicle itself. Use your own balance, core muscles, and center of gravity to keep the camera stable and keep your arms free floating. Any amount of contact with the car or train itself will absorb vibrations and mess with your shot. This takes practice, but it's doable.

When it comes to movement in the scene of the image, closer objects will always appear to rush by faster than objects on the horizon. For this reason, it's pretty unrealistic to plan to shoot something crisply in the front half of the field of the image. You'll have the most luck by focusing on something very distant, and you can get away with a much slower shutter speed. You will have a sense of motion in the foreground, but it can be a really cool effect, especially for travel photos. Nothing says "Hey, I'm on the go" like a little bit of foreground blur (**Figure 45.7**).

Give It Some Context

Try shooting with a wider lens to use the window frame to frame your image. There's plenty to shoot outside the window, but the outside view isn't everything. If I'm in the backseat of a car, I like to photograph over the shoulder of the driver to include some context of the vehicle in the frame (**Figure 45.8**). If I'm on a train, I love to shoot at an angle as we go around a bend to get a portion of the train in the shot.

Expose your shot for the lighting conditions outside, and let any people or subjects in the foreground fall into silhouette. Play with including the side mirrors in the shot for interesting juxtaposition (**Figure 45.9**) and to include the view behind you (**Figure 45.10**). Keep in mind that you don't have to hide the fact that you're taking pictures from a moving vehicle. Make the act of movement part of the story your image tells.

45.7 On the train to Ronda, Spain
ISO 250; 1/60 sec.; f/7.1; 33mm

45.8 Driving with Bolivar through Ometepe, Nicaragua
ISO 100; 1/200 sec.; f/4; 32mm

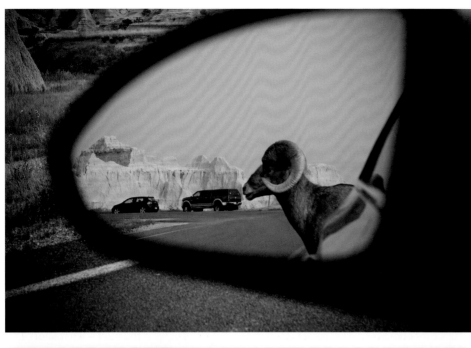

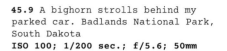

45.9 A bighorn strolls behind my parked car. Badlands National Park, South Dakota
ISO 100; 1/200 sec.; f/5.6; 50mm

45.10 Pennsylvania Turnpike, Western Pennsylvania
ISO 1250; 1/125 sec.; f/5.6; 85mm

46. AERIAL PHOTOGRAPHY

WITH THE EVER-GROWING popularity of drones, aerial photography is having a moment—and for good reason. Nothing changes perspective quite like getting your feet off the ground and enjoying a bird's-eye view. Loads of brilliant drone photographers are out there making some incredible art, but I personally have a hard time letting go of the physical act of taking the photograph. If the perspective of my images is going to be sky-high, then I want to experience that feeling myself—the exhilaration, wonder, and the awe of exploring our beautiful planet from above. To that end, there's no cooler experience than a flight on a small plane or in a helicopter.

Preparing for the Experience

Regardless of where in the world you are, the first step of planning a flight is research. Do your due diligence online to find the most reputable companies and pilots—don't assume that just because they're allowed to operate they have a clean record. Many countries have regulations that are far less stringent than the United States for small aircrafts. If a company seems significantly less expensive than their competitors, there's probably a reason for it. A flight in a helicopter or small plane won't be cheap, so plan to spend some money for a safe and amazing experience.

Some small planes have open cockpits or windows that can be opened for unobstructed photography. In helicopters, I recommend that you opt for the "doors off" experience. Companies often have a slightly higher price for doors-off flights, but it is absolutely worth it. You will have incredible access to some beautiful views and the ability to take wider shots without any obstructions or distortion and reflection issues (**Figure 46.1**).

When I fly "doors off," I prepare my gear very specifically, knowing that I won't want to change lenses, batteries, or cards mid-flight. I want everything I need to be ready to go and safely tethered to me. For instance, if I want to be able to shoot with two different lenses, then I have two cameras ready to go. It's much easier and safer to switch between cameras than to swap out lenses while I'm buffeted by wind hundreds of feet in the air.

Because I don't want to swap out any accessories, I make sure to use high-capacity memory cards and freshly charged batteries. I keep my camera(s) tethered to me with both a crossbody strap and a hand strap. The crossbody lets me feel safer setting a camera down in my lap when switching between camera bodies, and the hand strap gives me more stability while I shoot.

Before we take off, I like to go over the game plan with the pilot—what shots I'm particularly interested in, how close I want him to get to various subjects, and how far I am willing to tilt toward the ground. If you commit to a doors-off helicopter experience, go as far as you can with it, and let the pilot bank the helicopter. You'll get amazing views straight down without the landing skids in your shot (**Figure 46.2**). The sensation of hanging out of a banked helicopter is scary at first, but totally worth it and completely exhilarating. You'll be able to communicate with the pilot over the headset as you fly, but I like to make sure we're on the same page before we take off.

46.1 Virgin Gorda, British Virgin Islands
ISO 100; 1/400 sec.; f/4; 17mm

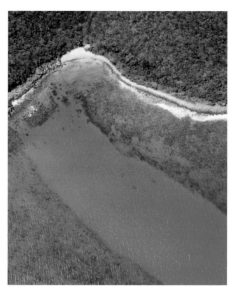

46.2 Virgin Gorda, British Virgin Islands
ISO 100; 1/200 sec.; f/4.5; 30mm

Getting the Shot

If I'm doing a pretty low flyover of a subject, or shooting in a city with a variety of depths to accommodate, then I might switch to autofocus and allow my camera to choose the focus point based on the location and composition. In most other aerial situations, I tend to focus to infinity-ish. I set the camera to auto ISO and shoot in Shutter Priority Mode to make sure I keep my shutter speed fast enough to avoid blur or visible movement in the images. If your camera will allow you to set a minimum shutter speed, 1/200 is a safe bet for the slowest you should potentially go.

Naturally, shooting with a very fast shutter speed will lead you to use a wider aperture. Don't worry about losing clarity or depth of field when shooting wide open. In most

scenarios, your subject matter will be equally far away and there won't be much in the immediate foreground to mess up your focus point. Just remember, if your feet or a portion of the aircraft in the foreground are in focus with a wide aperture, nothing else will be (**Figure 46.3**).

If I'm shooting with two cameras in a helicopter, I'll generally shoot with one wide-angle lens and one zoom lens, but if I'm limited to one camera, I'll just use the zoom. If you're new to aerial photography, a zoom lens will give you a good amount of flexibility without overwhelming you during your flight. You can crop in tight to isolate abstracts or patterns below you (**Figure 46.4**), or zoom out for more of the contextual scene. Just keep in mind that the farther you zoom, the

harder it can be to maintain your composition as the helicopter moves.

Both helicopters and small planes tend to feel pretty smooth as you fly. Movement will be more like the movement on a boat and less like the vibrations on a road. Even so, I generally avoid bracing my camera or my arms against anything and try to keep my body fairly relaxed. The more you tense, the more every little motion will be absorbed by your camera. Keep it loose and relaxed.

When composing my shot from a helicopter or small plane, I like to shoot a mix of perspectives. During a flight I'll get plenty of shots straight down, especially when the helicopter or plane banks to one side (**Figures 46.5** and **46.6**).

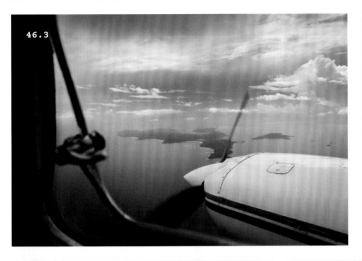

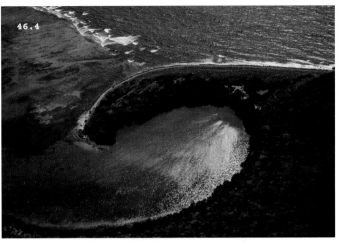

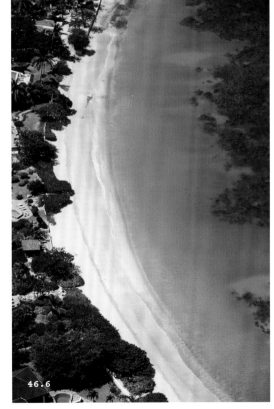

46.3 Flying over the British Virgin Islands in the cockpit of a small plane
ISO 160; 1/2500 sec.; f/4; 17mm

46.4 Virgin Gorda, British Virgin Islands
ISO 100; 1/400 sec.; f/4; 17mm

46.5 The Baths, Virgin Gorda, British Virgin Islands
ISO 100; 1/160 sec.; f/5; 44mm

46.6 Mahoe Bay, Virgin Gorda, British Virgin Islands
ISO 100; 1/320 sec.; f/5.6; 85mm

I also like to take advantage of the unique perspective and change up where I place the horizon in the frame. A horizon toward the top of the frame offers a large sweeping perspective of foreground (**Figure 46.7**), whereas an angled horizon gives the viewer the feeling of soaring. If I'm shooting with a wide-angle lens, I like to get some contextual shots as well that include either my feet or the inside of the helicopter or plane. It's all part of the story!

During a flight I always overshoot. Flights are expensive and are generally over quicker than you'd expect, so I'm constantly searching for different shots. I often shoot in burst or bracket to be certain that I've captured at least one crisp image for each composition. If there's a shot that's particularly important

to me but I don't think I got it right on the first pass, I'll ask the pilot to circle back so I can shoot it again.

Things to Think About

Due to the price of a helicopter flight, many photographers split the cost and go up in small groups. If you're not the only photographer, discuss the plan ahead of time with your cohorts and with the pilot so that you can vary which side of the helicopter gets the best shot. The pilot can make multiple passes from multiple directions to accommodate everyone, as long as you communicate that need.

If you're shooting in a very cold climate, the benefits of doors-off flying may be lost to you. If you're too cold to focus on what you're

doing, or your fingers are too stiff to operate the camera, you won't get the shots you want and you'll be disappointed. Keep the doors on if the weather demands it, and review the previous lesson for ideas about successfully shooting through a window. Even if you're shooting in a hot climate, remember that the temperature will drastically change with altitude, so if you're worried about getting cold, bundle up a bit.

Also, make sure that you don't have any loose articles of clothing or jewelry that could potentially fly off you and into the rotors. Better to go barefoot than lose a flip-flop mid-flight.

Have fun!

Share Your Best Aerial Photo!

Once you've captured your best aerial photo, share it with the *Enthusiast's Guide* community! Follow @EnthusiastsGuides and post your image to Instagram with the hashtag *#EGAerial.* Don't forget that you can also search that same hashtag to view all the posts and be inspired by what others are shooting.

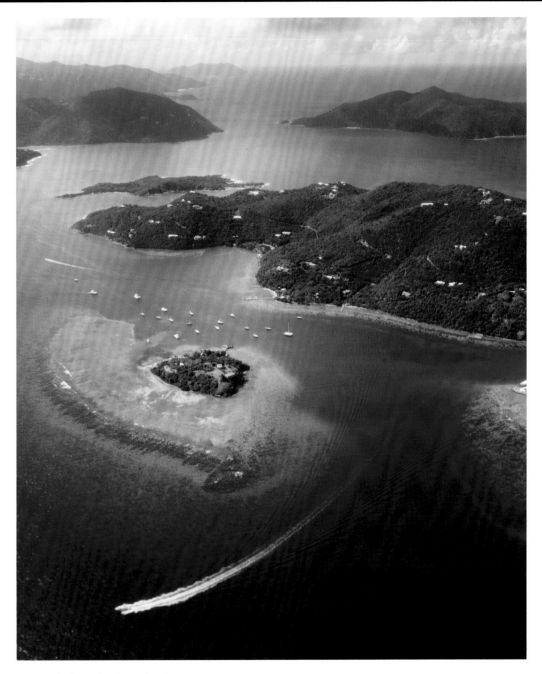

46.7 British Virgin Islands
ISO 100; 1/1000 sec.; f/4; 22mm

9

URBAN PHOTOGRAPHY

CHAPTER 9

I love to visit cities for a clearer sense of the culture, history, art, and values of the places I travel. Even the most mundane everyday activities can provide clues and insight and help shape powerful travel experiences. Wander the streets. Take in the nightlife or focus on the energy. Study the nuances that surround you for compelling photographic subjects.

47. ARCHITECTURE

ONE OF THE most remarkable aspects of international travel is the opportunity to learn about a culture and its history through architecture. Cityscapes are time capsules, telling the stories of the years through line, shape, material, and juxtaposition. From the complexity of a column, to the smoothness of a well-worn stair, every inch of a structure speaks of the past as well as the present.

Whereas the architect works artistically on a grand visual scale, the photographer must choose whether to tell the story of a building through its full form or through the abstract details within. Excellent architectural photography can inspire emotion and the urge to travel just as easily as a stunning landscape, because architecture is one of the most apparent examples of human ingenuity and creativity. What began as a pursuit to put a roof over our heads transformed into complicated feats of engineering, articulate design, and a sense of overwhelming grandeur.

Context

When I photograph architecture, one of my primary considerations is the context of the structure—the historical context of the design, the physical context of the natural surroundings or other structures, the social context of whether the structure was appreciated or reviled. Context is what makes a structure more than just a pile of bricks or a skeleton of steel. Context is why the structure matters and how it became a part of a location's unique story.

Each architectural movement had a specific set of values. Brutalist architects stressed function and rawness over classic concepts of beauty. They worked with rough textures of concrete and emphasized repetition. When I photograph a brutalist structure like the Met Breuer or the Salk Institute, I deliberately

47.1 The Met Breuer, New York, New York
ISO 800; 1/160 sec.; f/3.5; 18mm

47.2 The Salk Institute, La Jolla, California
ISO 200; 1/1000 sec.; f/1.8; 50mm

highlight the context of the brutalist movement. I pay close attention to a structure's most representative features: the texture (**Figure 47.1**), the repetition (**Figure 47.2**), and the right angles (**Figure 47.3**). When I photograph a gothic structure, I pay attention to the ornate details (**Figure 47.4**), the arches (**Figure 47.5**), and the sense of soaring height (**Figure 47.6**).

Physical context is equally important in an architectural photograph. The enormous peaked structure of Alberta's Prince of Wales Hotel echoes the mountains that surround it. By shooting from a distance, you ensure that the viewer gets the full benefit of the mountainous context (**Figure 47.7**). When a structure seems to grow up almost impossibly in the narrow crevice between two other buildings, a successful photo might mirror that context with a tight, claustrophobic crop (**Figure 47.8**). Conversely, negative space is a powerful form of physical context. A structure that seems to pop up out of nowhere should be photographed in a way that makes use of that openness (**Figure 47.9**).

47.4 Girona, Spain
ISO 100; 1/250 sec.; f/4; 17mm

47.3 The Salk Institute, La Jolla, California
ISO 100; 1/800 sec.; f/3.5; 10mm

47.5 Parliament of Canada, Ottawa, Ontario, Canada
ISO 25000; 140 sec.; f/3.5; 10mm

47.6 Almudena Cathedral, Madrid, Spain
ISO 1250; 1/40 sec.; f/4.5; 26mm

47.7 Prince of Wales Hotel, Alberta, Canada
ISO 125; 1/400 sec.; f/6.3; 79mm

47.8 Chicago, Illinois
ISO 100; 1/250 sec.; f/5.6; 50mm

47.9 Wood End Light, Provincetown, Massachusetts
ISO 400; 1/50 sec.; f/29; 22mm

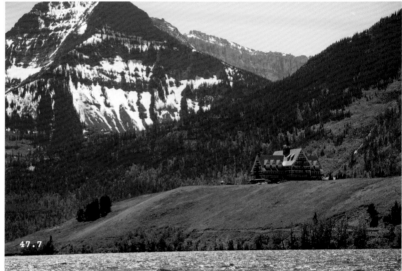

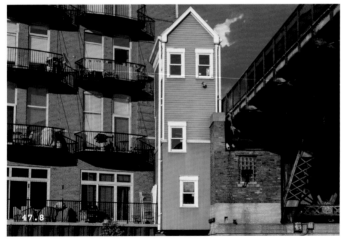

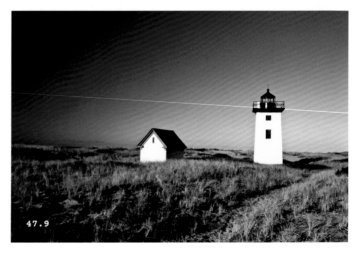

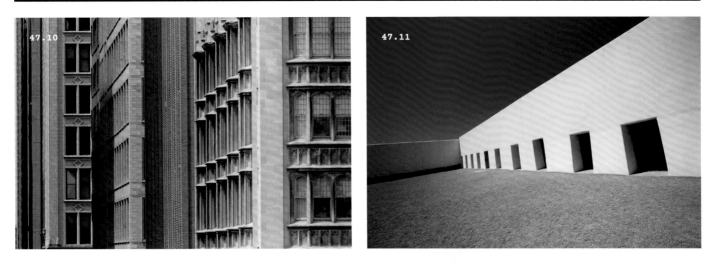

47.10

47.11

Conditions

Because architecture is so nuanced, certain conditions will work better for some buildings than others. A heavily detailed facade will be more apparent with strong side light that creates shadows and defines dimension (**Figure 47.10**). Stark white walls will look more compelling in direct sunlight and with the use of a polarizing filter (**Figure 47.11**). Narrow European streets will have more interesting atmosphere when the sun is low in the sky and casts long shadows (**Figure 47.12**). If you fall in love with a structure, try to revisit it across multiple times of day or in different weather conditions to find the scenario that brings out its personality or provides interesting atmosphere.

47.10 Monroe and Michigan, Chicago, Illinois
ISO 100; 1/160 sec.; f/8; 300mm

47.11 Yuma Territorial Prison, Yuma, Arizona
ISO 160; 1/2000 sec.; f/4; 10mm

47.12 Cáceres, Spain
ISO 100; 1/200 sec.; f/5.6; 85mm

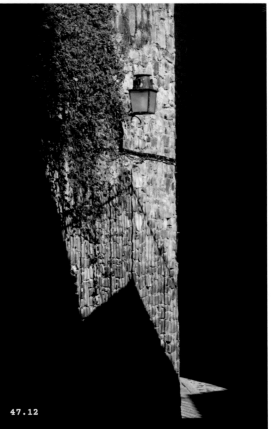

47.12

Perspective

When it comes to photographing architecture, my favorite advice is simple: look up. A day spent exploring architecture should end with a smile and a sore neck. So many times, I'll share a photo that I got while shooting with friends and they'll say, "I didn't see that. Where was it?" Nine times out of ten, my answer is "up." You never know what sort of amazing geometric patterns (**Figure 47.13**), interesting lighting, or bizarre shapes you'll be able to find when you turn your lens upward. Architecture is so impressive because of its scale, so rather than focusing only on the parts of the structure at your eye level, look up.

Once you're in the habit of looking up, you may start to pick up on a common frustration: the appearance of converging lines and leaning buildings. The closer you are to a building or the wider your lens, the more extreme the visual distortion will be. In some photographs, distortion and convergence work well (**Figure 47.14**), but if you're going crazy trying to keep lines parallel and angles perpendicular, then you have a few options: move farther away and zoom in, use a tilt-shift lens, or make perspective adjustments in post-processing. Not every perspective will work with every structure. Experiment with different shooting locations, interesting angles, and swapping out lenses to find what works best for the buildings you want to photograph.

Abstract

Sometimes the most interesting way to study architecture is to examine the smaller portions that make up the whole. Thanks to Instagram, architectural abstracts are more popular than ever. Photographers all over the world are isolating lines, colors, shadows, and repeating elements in interesting and engaging photographs.

Anything can make an interesting architectural abstract, from unique lighting conditions and shadows (**Figure 47.15**) to reflections (**Figure 47.16**) and ornate details. After I photograph the wider images of a structure, I like to focus in on the little nuances that make it unique. A series of abstract images of a building can speak volumes about its cultural and historical context as well.

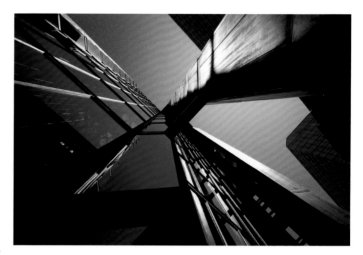

47.13 Bank of Canada, Ottawa, Ontario, Canada
ISO 125; 1/2500 sec.; f/3.5; 10mm

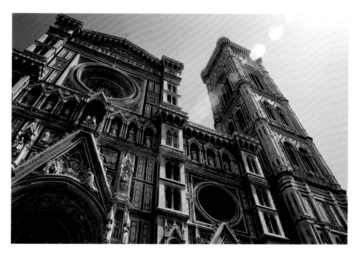

47.14 Santa Maria del Fiore, Florence, Italy
35mm film

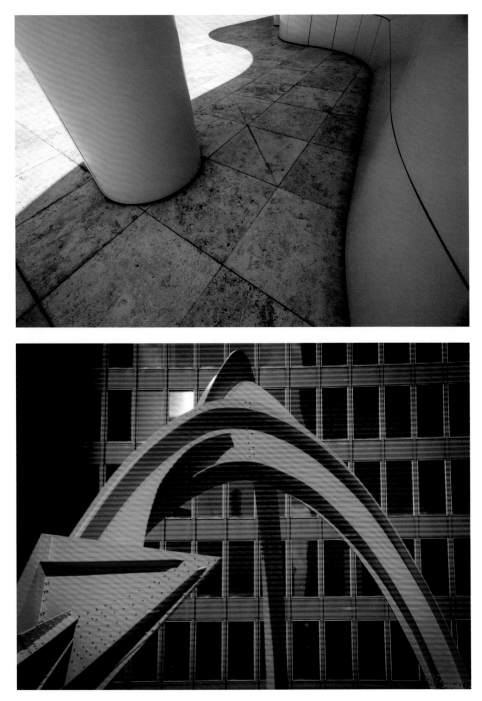

47.15 The Getty Center, Los Angeles, California
ISO 100; 1/500 sec.; f/4.5; 10mm

47.16 Chicago, Illinois
ISO 320; 1/40 sec.; f/10; 70mm

48. CAPTURING THE URBAN ENERGY

ALL CITIES HAVE their own energy and pace. Whether it's the typical rush hours before and after work or a bustling weekend filled with shopping and sightseeing, photographing a location's unique urban energy will help define a city's atmosphere and personality.

To Freeze or to Blur?

Cities like Tokyo or New York immediately bring to mind images of constant movement and frenetic pace: crowded sidewalks and crazy traffic. There is something exhilarating about the urban hustle—the view changes from moment to moment and the photographic possibilities are endless. When I explore a new city, I like to visit the busiest areas to capture a sense of the people and the energy. Places like train stations (**Figure 48.1**), major streets (**Figure 48.2**), markets, and squares (**Figure 48.3**) can almost guarantee an abundance of unique energetic moments. Sit on a bench, or snug yourself up to a building or lamppost to stay in the midst of the action while remaining out of the way enough to photograph the activity.

In a massive crowd, a fast shutter can freeze the movement and allow the viewer to examine all the details. Whether you're photographing a surge of commuters or a drove of tourists, a split-second exposure will give you access to all the little moments that you otherwise might not have noticed. Facial expressions, activities, and interactions will be captured and preserved. When you shoot at a higher shutter speed in crowds, consider taking several exposures for each composition. Tiny changes can make all the difference, and you'll have the chance to pick which shot best defines the moment later on.

Although faster shutter speeds can be effective, a bit of blur can help an image seem more energetic by implying movement and

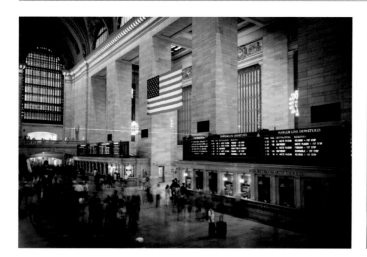

48.1 Grand Central Terminal, New York, New York
ISO 100; 20 sec.; f/7.1; 18mm

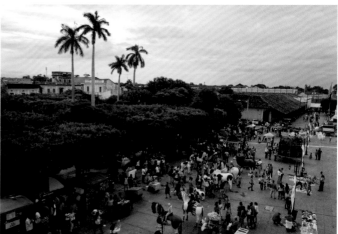

48.2 Granada, Nicaragua
ISO 800; 1/125 sec.; f/14; 18mm

minimizing distractions. If I'm shooting outdoors in bright daylight, I'll use a neutral density filter and a tripod so I can use a slower shutter speed. Shooting indoors and at night will allow you keep the shutter open longer without overexposing, but avoid keeping the shutter open for longer than a second. Longer exposures will blur the movement so much that it begins to feel more like peaceful flowing water rather than busy, erratic city life (**Figure 48.4**). Typically anywhere between 1/60 and 1/15 in daytime, and 1 or 2 seconds at nighttime will be slow enough to capture motion blur without things getting too flowy (**Figure 48.5**).

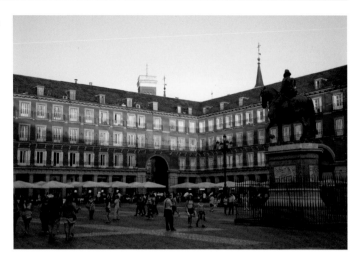

48.3 Plaza Mayor, Madrid, Spain
ISO 100; 1/100 sec.; f/4.5; 30mm

48.4 This exposure is so long the movement is blurred to a point of flowiness. New Orleans, Louisiana
ISO 100; 13 sec.; f/18; 17mm

48.5 This much shorter exposure implies movement while maintaining some detail in the crowd. New Orleans, Louisiana
ISO 100; 2 sec.; f/7.1; 17mm

49. SHOOTING PUBLIC INTERIORS

NO VISIT TO a world-class city is complete without exploring its famous museums, cathedrals, and other iconic structures. As fabulous as the exteriors are, interiors are often the lesser seen, lesser photographed, photogenic jackpots. New York has the Guggenheim. Chicago has Marshall Fields (**Figure 49.1**). The Vatican has the Sistine Chapel. If you're a photographer, it's impossible to visit these places without getting a few shots inside.

Sadly and irritatingly, in this era of heightened security and paranoia, photographers often get hassled in lots of public spaces. Taking photos in train stations, building lobbies, and museums can lead to confrontations with overzealous security guards. Over the years I've been approached lots of times and asked why I'm taking photos, or to stop altogether, even when there are no posted rules against photography. It drives me crazy. I'm all for keeping sensitive information safe and for protecting priceless art, but as I explained in lesson 4, "Cultural, Ethical, and Legal Considerations," photographers have rights. We should do everything we can to protect them and lay the groundwork to get our ideal shots.

I's Dotted, T's Crossed

Before I visit an interior I know I'll want to photograph, I check the location's website for photography rules. If I have enough time before my visit and no rules are posted, I'll send an email or fill out the contact form to find out exactly what the photography situation is. Very often, especially in lesser visited locations, just asking rather than assuming will lead to gaining permission. Many times the rules come with conditions like: No Flash Photography (which is easy to follow), or No Commercial Photography (which is more complicated depending on your definition of "commercial").

If I happen upon a location I want to photograph along my journey and haven't been able to research it ahead of time, I go right up to someone at the front desk or talk to a security guard. With a friendly smile I ask, "Is it all right if I take a few pictures in here?" or something along those lines. In

49.1 Marshall Fields, Chicago, Illinois
ISO 400; 1/60 sec.; f/3.5; 10mm

many tourist locations, it's pretty obvious if photography is okay, because dozens of other photographers will already have their cameras out and shooting. If I find myself in a quiet chapel or another smaller location, I always talk to a security guard, compliment the space, and ask if photos are okay. Making compliments is critical—usually appreciation helps get permission.

If there is a location that I'm desperate to photograph and it's typically not open to the public for photography, I email the location's manager with an explanation of the kind of photographs I want to take, samples of my previous work, and an offer to share the resulting photographs with them (**Figures 49.2** and **49.3**). If I get permission, I always bring a printed copy of any related emails when I visit to help with any confusion, miscommunication, or scheduling hiccups.

During the research phase of my America by Rail project, I was given permission by Amtrak to photograph in all of the train stations on their route. I printed the permission letter, carried it with me, and was actually asked to present it a few times over the course of the trip. The more you can set up in advance, the better.

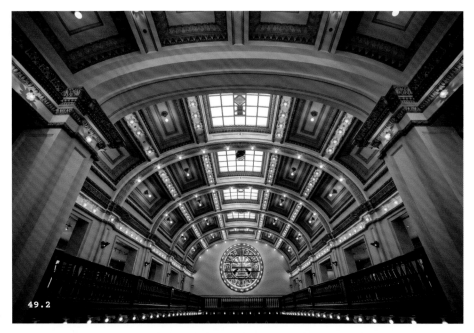

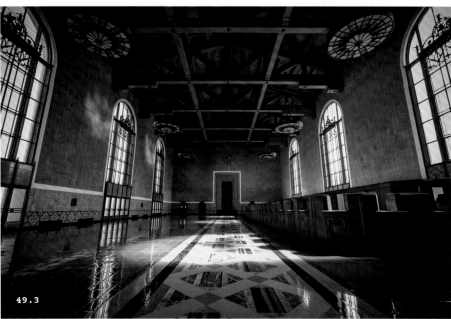

49.2 San Antonio Station, San Antonio, Texas
ISO 200; 1/60 sec.; f/4; 10mm

49.3 Union Station, Los Angeles, California
ISO 165; 1/10 sec.; f/4.5; 10mm

Dealing with Limitations

Inevitably the interiors you're dying to shoot will have a hefty list of rules. In museums the rules might even vary from exhibit to exhibit or artwork to artwork. Typically museums are less concerned with whether you're shooting the physical structures and architecture than the art itself, but you can expect most museums to forbid flash and tripods—both for good reason. Flash can damage the art over time and tripods are a hazard and a nuisance in heavily visited areas.

Unfortunately, museums also tend to be shadowy, with all the art brilliantly lit. If I want to photograph in a darkish location without a tripod and boosting my ISO isn't going to cut it, I either rely on a low profile tripod like my Platypod Max placed on the floor or a railing (**Figure 49.4**) or I sit on a bench and shoot from my lap for support. If all else fails, I lock my elbows to my torso and shoot like a sniper (breathe in, hold the breath, photograph for two to three seconds,

and then breathe out). Regardless of how I shoot in museums, I make sure not to linger for too long in any one spot or impede the flow of foot traffic.

In houses of worship, the primary limitation is usually disruptive sounds and movement, and being respectful to those who are there to pray. Generally, it's a good idea to avoid visiting during services, but even during slower times of day, I turn off my camera's beeps, pay careful attention to what's going on around me, shoot selectively (the sound of shooting on burst echoes like crazy in a church), and walk like a ninja. I usually try to stick to side aisles because they're often less distracting to worshipers, and I avoid going up on the pulpit or bema unless I'm invited.

Shots to Consider

Some architectural interiors are going to be an absolute no-brainer for you. Vaulted or mosaic ceilings (**Figures 49.5** and **49.6**), sweeping open atriums (**Figure 49.7**), repetition of

columns or windows, or intricate details may all call out to you as obvious compositions. In museums, you may feel inspired to photograph the art, but it's unlikely you'll end up using those images (you may not be allowed to anyway). Frame your shots to share your experiences rather than the specific artifacts. Consider instead photographing full rooms or halls (**Figure 49.8**), the way the light plays on sculptures, or reflections in shiny marble floors.

Other museum-goers can be worth photographing, but be careful how you handle yourself. Don't get in anyone's way of enjoying the art, and keep your portrait subjects unidentifiable if possible. Photographers, as artists, should do everything they can to help support the efforts of museums and to perpetuate the appreciation of art. If you do feel that you absolutely must have a photo of a certain piece of art, consider buying a postcard or a print in the gift shop to help support the museum.

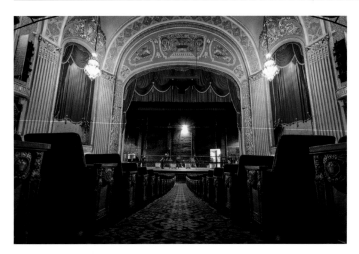

49.4 The Orpheum Theatre during a changeover, Memphis, Tennessee
ISO 100; 6 sec.; f/5.6; 10mm

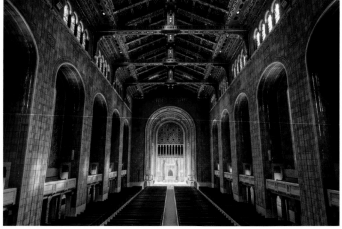

49.5 Temple Emanu-El, New York, New York
ISO 100; 2 sec.; f/6.3; 10mm

49.6 Almudena Cathedral, Madrid, Spain
ISO 640; 1/40 sec.; f/4; 17mm

49.7 Adolfo Suárez Madrid-Barajas Airport, Madrid, Spain
ISO 100; 1/25 sec.; f/5.6; 20mm

49.8 National Portrait Gallery, Washington, D.C.
ISO 100; 1/6 sec.; f/5.6; 20mm

If your subject is a larger scene with multiple light sources (like wider cityscapes, a building with many lit windows, or a busy intersection with traffic/ light trails), then you can work in Evaluative/Matrix Metering. This will allow your camera to take several readings across the frame and find a good exposure setting overall (**Figure 50.4**).

Finally, make sure you pay attention to white balance. Cityscapes will usually have a mix of LED, metal halide, and high-pressure sodium lamps, all of which have different color casts. For the most flexibility, make sure you're shooting in RAW (which hopefully you're doing anyway) and set your WB to Auto White Balance. You'll be able to dial the colors in later on. As you shoot, if things are looking too yellow or too blue, you can set adjust your WB accordingly (lower numbers are warmer, higher numbers are cooler).

Sweet Compositions

Many times it's easy to find killer compositions at night in a city, but if you're feeling stuck, here are a few ideas to get your creative juices flowing:

- **Find reflections:** Seek out a body of water (**Figure 50.5**), a puddle (**Figure 50.6**), or even the hood of a dark car to mirror bright lights, a building, or a whole skyline. Right after it rains can be the ideal time. When the streets are wet they are more reflective, so the pavement will glow with the color of the lights and it will be easier to find puddles. For faster moving bodies of water, it will take a really long exposure to get the waves or motion to smooth out. Totally worth it (**Figure 50.7**).
- **Focus on traffic:** I think light trails are pretty sweet. For the best trails, make sure you're shooting during green lights in areas of low congestion. Headlights and taillights will flow into a smooth line instead of a choppier dotted line (**Figures 50.8** and **50.9**).

50.4 Royal Palace of Madrid, Madrid, Spain
ISO 160; 20 sec.; f/7; 8mm

50.5 Chicago, Illinois
ISO 100; 13 sec.; f/7; 20mm

50.6 Chicago, Illinois
ISO 640; 1/60 sec.; f/2.5; 50mm

50.7 Chicago, Illinois
ISO 160; 30 sec.; f/16; 22mm

50.8 Indianapolis, Indiana
ISO 100; 4 sec.; f/11; 17mm

50.9 Indiana State Capitol, Indianapolis, Indiana
ISO 100; 6 sec.; f/16; 53mm

- **Marquees and neon:** Theater districts and areas with a lot of bars, restaurants, and tattoo shops are great for night photography. Whether you're shooting wide (**Figure 50.10**) or focusing in on a particular storefront or sign (**Figure 50.11**), you'll have loads of interesting material to play with.

- **Seek higher ground:** Visit an observation deck or a restaurant at the top of a skyscraper for a wide, light-filled cityscape (**Figure 50.12**).

50.10 Beale Street, Memphis, Tennessee
ISO 100; 2 sec.; f/6.3; 10mm

50.11 San Antonio, Texas
ISO 500; 1/200 sec.; f/1.8; 50mm

50.12 Chicago, Illinois
ISO 125; 5 sec.; f/5.6; 22mm

10

HOME AGAIN

CHAPTER 10

Welcome home, friend. That was fun!

"Well, what now?" you may ask.

Now you begin the somewhat less exciting, but equally rewarding part of the journey—reflecting on the trip by looking at your pictures and getting them ready to share with the world!

51. RECAPTURING THE MAGIC

THERE IS NO high like the successful photographic capture. You experience the trip of a lifetime filled with new tastes, colors, sights, sounds, and emotions. You fill memory card after memory card with images that are so beautiful, that so perfectly encapsulate the experience you're having, it almost feels like a spiritual awakening. With every shutter click, you think, "This is the shot I came here for" or "This one's destined to be a cover photo." No one has ever seen these sights the way you are seeing them right now. No one has ever thought to capture this perspective. You're an explorer, an alchemist, a virtuoso, and the world has never contained a photograph that will parallel your current visual wizardry (**Figure 51.1**).

The Letdown

You return home from your adventure, wade through neglected emails and piles of credit card preapprovals, restock the fridge, clean the mud off your tripod feet, unpack your camera bag, and begin the task you've been looking forward to during your long trip home—the reveal of your unparalleled artistic majesty on your home computer. RAW files load into Lightroom, thumbnails giving a glimpse of that incredible experience, saturated in color and magic.

You pick one of the many shots that gave you such a boost in the field and pull it up in the developer window. Almost instantly, the magic evaporates. From the initial thumbnail preview to the big screen, something has been lost. You anxiously click through a few more shots, hoping it's a fluke and fill with disappointment as your photographs feel flat, unimaginative, low contrast, and low impact.

Why did the images look so glorious in thumbnail and on the back of the camera? How could something have been so grievously lost in translation from that sacred moment of shooting to this underwhelming moment of review? You question your settings in the field. You question your composition. You might even question your skill as an artist. There is no low like the artist's low of self-judgment, disappointment, and doubt.

For me and countless others, photography is a painfully bipolar experience. When you're up, you're up, and when you're down, you're so far in the dumps you need a shovel. There is so much excellent photography out there that it's easy to feel like you're only as good as your last "well-liked" photograph.

Maybe your impulse is to revisit your disappointing images in Lightroom and jack up the contrast, clarity, and vibrance to attempt to recapture some pizazz. Maybe, you blast through ten, twenty, one hundred images in a rapid-fire editing session boosting all the sliders you can to make those images seem as larger-than-life as they felt in the field. Maybe, in your desperation, you push HDR past the point of decency into the realm of crunchy and off-putting, hoping to recapture the magic that you saw. Maybe you work too long in the only direction you can think of and end up feeling more dejected than you did before. You're not alone.

Give Yourself Some Credit

In the days of film, many of us felt the very same way when we finally got to that moment of truth—reviewing the enlargement. Not every image that looked good on a contact sheet could hold up in a big print, and the odds of success were measured differently. If you could find one or two printable shots on a roll of twenty-four or thirty-six that was worth developing, then you were in great shape. That's an acceptable success rate of 2–16%.

You might spend hours in the darkroom, dodging, burning, filtering, adjusting exposure times, printing and reprinting just to get that one photograph printed exactly how you wanted it. There was an understood level of intricacy and effort for every single image, from the delicate moment in the field when you decided you had a subject worthy of a couple of precious exposures, and the careful adjustment of composition and camera settings, to the hours spent under the red glow

of a safelight perfecting every square inch of print.

Even with that far more measured approach, we had a low expectation of our successful outcomes. Each final photograph was hours, if not days, in the making. Consider now that with gigabytes upon gigabytes at your disposal it is perfectly reasonable to return from a weeklong trip with 5,000 digital exposures, and it's easy to see how hundreds, if not thousands, of those shots are destined to confound and depress you.

The digital camera is a world-changing instrument of access. With a moderate upfront investment, we're no longer tethered to hours of working alone in cramped darkrooms or limited by the fear of wasting expensive film. We are freer and less judgmental of our photographic whims. With little to lose by overshooting, impulsivity overcomes exactitude. We shoot the same scene fifteen different ways, knowing in the field that just one perfect shot is needed, only to go home and wonder why every iteration doesn't stand on its own (**Figure 51.2**).

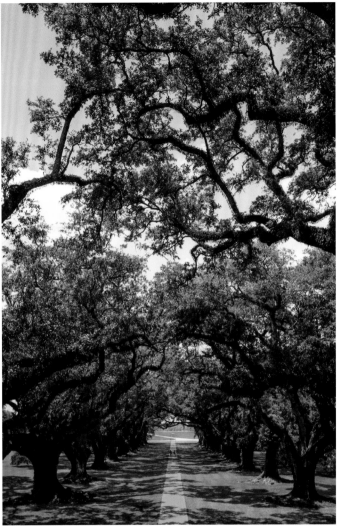

51.1 This is one of my favorite photographs from my trip to Spain and its on the list of my favorite photographs I've ever taken. I felt good in this moment and knew I'd gotten my desired shot. Zahara de la Sierra, Spain
ISO 100; 1/320 sec.; f/5.6; 56mm

51.2 I have ten or so versions of this shot. I don't need ten of them to be perfect. I just need one. Oak Alley Plantation, Vacherie, Louisiana
ISO 320; 1/1600 sec.; f/4.5; 22mm

The old guard of photography gets it. They are the tortoise to our hare. Slow and steady wins the race. One of the most intentional landscape and environmental portrait photographers I know, Jay Dusard, recently said, "So many people use a camera like a shotgun: they bag an image, but they aren't seeing the details that go into it." That very tendency, in large part, is responsible for the way we feel when the images on our screen don't live up to the excitement from our memories.

Post-adventure photo letdown happens to lots of us. For me, the key is curating my work environment and revisiting my expectations. The artistic portion of photography doesn't end when the shutter closes, but sitting in front of a computer is always going to be less romantic than the conditions in the field. Counteract the inherent shortcomings of the desktop setting. The darkroom was this beautiful creative bubble in which you could isolate and focus, while your work was literally the brightest thing in the room. Create a work environment that lets you focus in a similar way.

51.3 Lake McDonald, Glacier National Park, Montana
ISO 100; 1/125 sec.; f/3.5; 10mm

Disengage

I separate my day-to-day life from the photo editing process. Even the most magical rainforest scene can seem flat and lifeless if you're in between loads of laundry while a stack of bills encroaches on your mousepad. You wouldn't have found that rainforest scene nearly as enchanting in the field if you'd been listening to your Internet service provider's hold music at the time.

Multitasking will kill the mood. Stay off Facebook. Put down your phone. Avoid anything that pulls attention away from your editing process. Even when Lightroom lags and you start to feel bored, avoid shifting gears to something else while your images load or process. Stay in the moment.

Set the Stage

I do my very best to mimic the conditions of the place I was shooting when I work at home. Photos of Spain are edited while listening to relaxing Euro coffeehouse music and sipping Spanish wine. Photos of a Caribbean sailing trip get a reggae soundtrack and a mango smoothie. Wedding photos get uplifting love songs and an energizing cup of coffee. I've even listened to dramatic movie scoring by Danny Elfman or John Williams while editing photos of a majestic place like Glacier National Park (**Figure 51.3**). Whatever your subject matter or photographic genre, you were employing every one of your senses when you originally made a photograph, so try to engage multiple senses while editing.

Revive

Think back to how you felt when you were shooting. Read your travel journals, or revisit the brochures you collected along the way. Put yourself back in your own shoes at the moment of each image's creation (**Figure 51.4**). There was clearly something special happening that you wanted to capture. What was it? How did it make you feel? How would you describe it to a person who wasn't there? Take a more exacting roll, drawing out the beauty and excitement from every single pixel. The magic of the photograph isn't lost. The magic is waiting for you, the explorer, the alchemist, and the virtuoso, to revive it.

51.4 On a vast beach filled with beauty, I was taken by this tiny plant sprouting from a piece of driftwood. Ruby Beach, Olympic National Park, Washington
ISO 100; 1/200 sec.; f/4.5; 10mm

52. SUCCESSFUL PROCESSING

MANY PHOTOGRAPHERS WILL spend anywhere from hours to days perfecting a single image. They're painting in light rays, adjusting tiny wisps of color here and there, and looking at an image pixel by pixel. More power to you if you're into that kind of thing. That's a lot. I'm kind of a purist when it comes to photo editing. Usually the longer I look at an image, the more I manipulate it, the less I like it. If I couldn't have done it in a darkroom, then I probably won't do it in Lightroom.

At the end of a journey, I have so many images to review and process that I stick to more basic adjustments. I used to edit every image in Photoshop, but now that Lightroom is so powerful and user friendly, I'll typically work entirely in Lightroom and only occasionally take a photo into Photoshop.

There is, of course, the potential of offending another photographer when you start to talk about opinions on processing. I love plenty of photography that has been heavily processed, but for most of my images, it doesn't feel right. Above all else, I aim to keep my photos honest. Sure, I'll clone out some trash from a beach or add a gradient layer to bring in more contrast and darken a sky, but I never swap out one sky for another. All of my editing is in pursuit of representing what that moment looked like to my eye.

That said, the obvious exception here is black-and-white conversion. I'm not colorblind, so, no, I've never seen the world in black and white. I like black-and-white photographs and that's reason enough for me to veer off from reality in the occasional shot.

There's nothing wrong with a heavier hand in post-processing. If you have found what works for you, then that's fantastic. Go for it.

Work Those Lightroom Panels

- **Basic panel (Figure 52.1):** Go to town on exposure, contrast, tweaking highlights and shadows, whites and blacks, but pay attention to the subtleties. There is a real tendency to oversaturate or overcontrast to attempt to create more impact. Clarity is fine in tiny doses, but too much and things get crunchy, especially with portraits. Photographs shouldn't have to punch you in the face to get your attention. In fact, if they do, you're probably less likely to really explore them. Adjust as much as you want in the Basic panel, but keep it subtle.
- **Tone Curve:** This panel rarely comes into my processing. In Lightroom there are multiple ways to achieve the same effect and, for me, the Tone Curve panel is more of a last resort. The tiniest adjustments have big effects, so short of using this panel to make a slight *S* curve, I leave it alone.

- **HSL/Color/B&W:** I do adjust the HSL sliders for some photos. They are helpful to get more definition, or to replicate the intensity of some colors that may have been muted by your shooting settings or captured strangely in AWB. I never go beyond +/−10 on any slider. The farther you push a slider, the more likely you are to get super weird colors, crunchy borders, and weird ghosting.

 If you're still converting a photo to black-and-white by dropping saturation to zero in the Basic panel, then you need to play around with the B&W panel. You'll get amazing specificity in your shades of gray (**Figure 52.2**). This panel makes it easier than ever to pull details and nuances out of your black-and-white photos.
- **Split Toning:** I use this panel so rarely and when I do, I barely use any saturation. Nothing will make your photographs look Instagrammy quicker than split toning. Use sparingly, then pull it back even further (**Figure 52.3**).
- **Detail:** I don't generally sharpen, but I do use Noise Reduction as needed. Pay close attention to how the image changes as you adjust the slider. You want to use as little noise reduction as possible or the photo starts to look weirdly smooth (**Figure 52.4**).

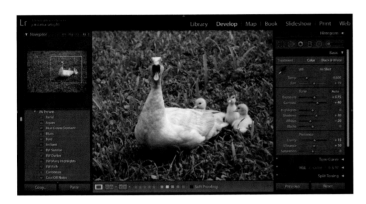

52.1 Adjustments in Lightroom's Basic panel while I work on a photo of a furious Costa Rican duck.

52.2 Lightroom's B&W panel gives me so much specificity when converting my furious duck into a black-and-white image. I can change the luminance of each specific hue to craft the best possible photo.

52.3 Making the furious duck infinitely more frightening using Lightroom's Split Toning panel. This photo is now a psychedelic nightmare.

52.4 With the Noise Reduction sliders maxxed out, furious duck looks oddly cartoonish.

- **Lens corrections:** YES! WE LOVE THIS PANEL! Chromatic aberration is my number one pet peeve in images. When I import photos to Lightroom, I apply a preset on import and the preset both removes chromatic aberration and enables profile corrections. If you notice that your straight lines sometimes have a bit of a curve in your images, then be sure to check Enable Profile Corrections. This is a must especially with architecture photography (**Figure 52.5**).

- **Transform:** Use sparingly. When converging lines and forced perspective are an issue, this is a great tool to use. It's also very helpful for quickly leveling your horizon. Just don't fall down the straight line rabbit hole (**Figure 52.6**). Your lenses will naturally skew your angles a bit. If you're not a commercial architecture photographer, then you don't have to drive yourself crazy making sure every angle is perfect.

- **Effects:** Yeah, I'll admit, I like a little vignette. I used to vignette the crap out of my photos in the darkroom, and I generally add a –15ish vignette to most images. A well-executed vignette will make a photo feel more polished, define the edges better, and help you focus on the subject.

Tools and Masks

- **Crop & straighten:** I mentioned earlier that I used to feel like it was cheating to change the crop on an image in post-processing. I placed a lot of pressure on myself to get the exact framing right in camera. Now I fully acknowledge that not every image is meant to exist in the same ratio. If your photo is going to benefit from a crop, then you should do it (**Figure 52.7**)!

 The same goes for straightening. For the first three years of my career, every single image I took needed to be rotated by 1.5° counterclockwise. It was frustrating as hell and I think my left eye might be askew. I got tired of straightening pictures and paid more attention while shooting to level the horizon. Don't judge yourself for your idiosyncrasies. Learn what they are and adjust accordingly.

- **Spot removal:** Lightroom's Spot Removal tool is pretty epic. As someone who apparently sprinkles rocks and dirt on the front of my lens before shooting, I'm endlessly grateful for the Healing Brush when I edit my photos. If you're worried about being able to find all of the little dust spots on an image, boost the Contrast and/or Clarity to +100. The spots will be more noticeable, and then you can put the sliders back to where you like them after all the spots are removed.

- **Red-eye correction:** I've never used this. Not once. Has anyone?

- **Graduated filter:** Best. Tool. Ever. Want to tone down the disproportionate

52.5 Get rid of chromatic aberration and curved lines easily with Lens Corrections.

52.6 Wide-angle lenses definitely lead to distortion, but a little bit is usually okay. The Full Transform setting squares everything up, but the curves at the top of the image look weird and the ratio is totally different.

brightness in the foreground? Graduated filter! Want to tweak the color temperature just in the sky? Graduated filter! I love graduated filters when I shoot and I love them when I edit.

- **Radial filter:** See above, only now you can filter things roundly! Is the face just a teeny bit too dark in your portrait? Radial filter! Feel like the lens added a weird vignette that you want to counteract? Radial filter! Sweet!

- **Adjustment brush:** Winning at processing specificity. I love being able to make adjustments in very specific areas. The adjustment brush is fantastic—as long as you're using a tablet to edit (more on this in a moment). If you're using a mouse, you have some potentially frustrating times ahead.

Invest in a Tablet and Stylus

I'm willing to venture a guess that some of you are still using a mouse for post-processing. I used a mouse for the longest time and wondered why it took me so long to make small adjustments in Lightroom, but especially in Photoshop. Cloning, patching, shading, lassoing, dodging, burning—all were tedious and frustrating when done with a mouse. Enter Wacom. Life changed. Hours saved. Control improved. Frustration averted. I now look at my mouse with disdain.

I've heard it said that using a mouse for Photoshop is like painting with a brick (**Figure 52.8**). Think about it. As humans we're trained from early on in life how to maneuver a pen with dexterity. Mice, sure we learn those in school (if you're under a certain age), but it's not like we're trained or graded on penmanship with a mouse. It's a sloppy, ineffectual tool.

I'm lucky because I can keep my stylus in my left hand and still use the mouse with my right for ambidextrous nonstop rocking. Even if you do have to switch from the mouse to the stylus for more specific tasks, it's worth the effort. The specificity will floor you and you can get in the game for less than $100. If you want to get really fancy, go for a pressure-sensitive model and get ready for serious control.

On Presets

Presets are pretty sweet. I have about 50 presets that I regularly use. I made them all from scratch based on what I find visually appealing in my images, but there's no shame in buying or downloading free presets.

Generally, presets are best used as a starting point. Try them on for size by hovering over the preset name and watch how they change the look of the photo in the Navigator window. Find whichever preset gets your image closest to what you like; then play with the panels and sliders to finalize and polish the way the photo looks.

Presets are made to enhance and adjust a solid image. They won't save a throwaway shot, but they can help a good shot look great.

Don't Push Too Hard

If you're working on an image or a set of images and you're getting frustrated, walk away for a while. Creativity ebbs and flows. It's nearly impossible to force it. If you're not feeling the editing spirit, don't push yourself. You probably won't love any of the work you do in an uninspired state anyway, and the work you put into shooting deserves your best efforts and enjoyment in editing.

52.7 I decided to crop this image of a howler monkey after the fact because certain parts of the image were drawing focus away from his expressive face.

52.8 The donkey on the left was drawn (from memory) with a stylus. The donkey on the right was drawn with a mouse. Neither will win any awards, but the left donkey is significantly less deformed.

53. SERIES AND COLLECTIONS

YOU WENT, YOU saw, you photographed, you edited. Now what? Think about what your goals are for your images. To publish, to share, to display, or to remember? All of the above? Even if you don't have aspirations of a gallery opening or getting published in a magazine, consider assembling your images into a cohesive and interpretive grouping as a way to complete the travel experience.

Find a Through Line

The best way to start assembling a collection or series of images is to decide what your through line will be. Narrowing your images by theme, concept, or location will help you select which images best support a cohesive vision. Are you trying to teach viewers something? Did you hope to create awareness for a particular situation or issue? Maybe your through line is a single location. Maybe it's a whole journey across a region or a continent. You could focus on a specific subject like food, or architecture, or portraits (**Figure 53.1**). Sometimes the best through line is the common element in all of your images, the photographer.

Whatever your central theme, it's important that you have one and that you feel strongly about it. Passion for your experiences will help you create the most impactful collection.

Thousand-Worders and Fragments

In the very first lesson I mentioned that not every image needs to be worth a thousand words. I stand by that. As you work on assembling your images by through line, you'll find that some images speak volumes on their own, whereas others exist merely to support and provide context or a deeper look. The overall goal is to create a collection that is greater than the sum of its parts. If every image has massive stories to tell, your intentions for the series may become harder to follow. Think back to writing lessons in grade school.

53.1 A series of images depicting the cork harvesting process. Andalusia, Spain

Choose a few photos that hypothesize and several more images that support and enhance each hypothesis (**Figure 53.2**).

Making Sure Everything Fits

Your series or collection will be stronger if each image feels like it belongs in some way with the others. One way to achieve this is through color palette. Fortunately, many locations have a consistent color theme (we talked a bit about this in Lesson 33). A series from the American Southwest might have a warm palette with lots of reds, oranges, and browns across your images (**Figure 53.3**).

53.2 The process of creating a dessert. Wilmington, Delaware

53.3 These images from my trip to Utah inhabit the same color palate and go nicely together.

Share Your Best Series!

Once you've captured and assembled your best photographic series, share it with the *Enthusiast's Guide* community! Follow @EnthusiastsGuides and post your image to Instagram with the hashtag *#EGSeries*. Don't forget that you can also search that same hashtag to view all the posts and be inspired by what others are shooting.

A collection from the Caribbean might feature plenty of bold greens, bright blues and pinks, and deep yellows (**Figure 53.4**). By keeping an eye on the way color plays across your images, you'll be able to form a visually appealing set of images that feel like they go together even if the subject matter is varied.

If you went on a journey that seems to have no cohesive color theme, consider basing a set on stylistic similarities. Did you shoot most of your images with a dreamy shallow depth of field? Is each of your photos fantastically contrasty? Is everything in black and white? Consider grouping images that feel like they inhabit the same stylistic realm (**Figure 53.5**). You may not realize ahead of time that you have certain stylistic tendencies, and by assembling a collection, you'll start to see what your eye gravitates to and how you commonly frame things.

Sometimes juxtaposition of contrasting styles, colors, or elements is the best way to create a cohesive set. Just like an urban skyline, you may find images that are based in antiquity, whereas others scream postmodern, and yet they belong together and support each other. Not every aspect of a location will fit seamlessly. Allow the disparity to shine through in your collections. A series can contain both natural and man-made, luxury and austerity, new and old as long as it supports your through line.

Outlets for Your Collections

After you've created a collection or series and you feel good about it, there are a few ways to move forward. You can write a travel story that works with your images and submit it to publications or publish independently through blogging. You can print each image for display and explore gallery opportunities. You can create a gallery on your website or on social media with the finished collection, or you can make a photo book or album to commemorate the trip. Or you can take things further and add a personal touch by telling the stories behind the scenes...

53.4 A distinctly Caribbean collection

53.5 Each of these black-and-white images focuses on texture and form. To me, they feel like they go together.

54. TELLING THE STORIES BEHIND THE SCENES

YOU ARE ONE of the most compelling aspects of your travel photography. Whether you keep your images private or share them with the world, adding a touch of behind-the-scenes access will help solidify your memories and make the images more accessible. Don't just share the perfect or beautiful moments. Preserve the snafus, the surprises, and the FML moments that made the experience what it was!

Where, How, and What to Share

We seem to be blessedly past the era of inviting your friends over for a two-hour slideshow of vacation photos. These days the way to show off and share is predominantly online. You can upload single shots or whole albums, and your friends or followers can peruse at their own leisure without you looking over their shoulder.

Many photographers, myself included, prefer to keep their personal and professional social media accounts separate. We post polished images to the professional pages, and silly outtake style photos on our personal pages. Seems pretty straightforward. Lately, though, more and more celebrities and artists are sharing behind-the-scenes photos and videos. Followers like to see a little bit of personality. They want an inside look at what it took to make an image. They want an inside look at your process and your adventures.

While I might not post a photo like **Figure 54.1** or **54.2** or **54.3** on my website, I would share it in my Instagram stories or on Facebook (or apparently publish it in my book). Pictures like this tell the story of the journey. They remind the viewer that an actual human being is out there taking these photos and having experiences.

Selfies are huge because they give a glimpse of the artist behind the camera (**Figure 54.4**). Back of the camera shots are popular because they provide a bit of context for the unbelievably cool photo you've taken (**Figure 54.5**). The more you provide a running commentary of your travels through snapshots and written stories, the more people will find you and your images accessible. If they care about you, they'll care about your work.

Consider starting a behind-the-scenes account on Instagram or creating a dedicated page on your website. Keep it light. Have fun. Share the spirit of why you travel and what you've learned along the way.

54.1 When your waiter hears you're traveling alone and fashions a self-defense weapon out of your leftover mac and cheese. Montage, Portland, Oregon

54.2

54.3

54.4

54.5

54.2 Experimenting with a Lensball and my friend Patti. Moab, Utah

54.3 My mom considers having leftovers for lunch. Virgin Gorda, British Virgin Islands

54.4 Just enjoying some donkeys in my car. Custer State Park, Custer, South Dakota

55.5 A look behind the scenes when I shot the photo in Figure 50.12. Chicago, Illinois

55. WHAT COMES NEXT...

IN HIGH SCHOOL and college, theater was a massive part of my life. Anytime I acted in or directed a production, it would become the focus of my life. In the shower, before falling asleep, in between classes, and during boring classes, I was ruminating on the show. I would work my ass off in preparation. Then the show would come and it would be exhilarating. Months of work would culminate in three or five amazing performances; then suddenly it was over. The routine disappeared. Overnight I would go from living and breathing this one thing, to having an uncomfortable amount of free time. Enter the off-putting depression of the post-show letdown. Now, as an adult, I've traded theater for travel, and the post-trip letdown continues.

You pour yourself into planning a journey. You build it up. You get excited. You organize, you book, you pack. The day comes and you go on this amazing adventure. Inevitably, it flies by. You return home exhausted but rewarded for your efforts. You edit, you write, you share, you (hopefully) recapture the magic of the journey. Then it's over and a void appears.

First, this is totally normal. It doesn't matter how long you were traveling or how far away you went; organizing the trip was a big part of your life for a while. You got to escape the day-to-day mind-numbing minutiae for a while. You're gonna feel a little down once it's over. Fret not—there is a cure.

Lather, Rinse, Repeat

Rejoice, for it is time to plan another adventure! Remember back in chapter 2 when we were happily planning a journey? Time to go back and start the process again. Look back on your photos from this most recent trip. What worked? What didn't? What are you proud of? What do you want to improve? Reflect on the experiences you had, the things you enjoyed about your trip, and the things you would change if you could.

Now, when it's all fresh, is the time to start setting up your next trip. Maybe you won't be able to physically travel for a while (damn the man and his limited vacation day allowances), but you can dream and plan and get excited (**Figure 55.1**)!

Review the photographic goals you set for yourself. Did you achieve them? Are you still frustrated by a specific style or principle? Watch tutorials online. Talk to other photographers. Focus on educating yourself so you can really nail it the next time around. If you did achieve your goals, then set higher goals. Plan to take things further. Consider using more elaborate gear, or setting up more complicated shoots for yourself. Onward and upward!

Maybe rather than planning a visit to somewhere brand-new, you'd prefer to explore your last destination in more depth. As the photographer who's been to the British Virgin Islands ten times, I wholly support that. Reconnect with all the people you met during your trip and get recommendations. Share your photos with them. Solidify your new friendships. Make plans to reunite and explore together.

The key is remembering that you will benefit photographically from any trip you take, whether it's to some place brand-new or to a place you know inside and out. Every photograph you take, and every day you spend in a location that is far from home, will give you opportunities to see new things, experience new perspectives, and capture new moments. You have the rest of your life ahead of you. Go forth, have fun, and create.

55.1 San Juan del Sur, Nicaragua
ISO 1600; 1/125 sec.; f/18; 300mm

INDEX